COLEEN GREENWOOD AND KAREN
CREAR

Playing With Fire

The True Story of Fireman Scam

Crear Publishing Ltd

"I can be changed by what happens to me. But I refuse to be reduced by it."

MAYA ANGELOU

Contents

II Part Two

Foreword

Judge Adkins' closing statement at sentencing, April 2020:

"The background to this offending shows frankly jaw-dropping arrogance and cruelty in the way you so persistently and wickedly deceived your victims, particularly Coleen Greenwood."

I

PART 1

JAMES

Chapter 1

The day my life fell apart.

As I watched the departing car drive at speed away from my home, I felt such despair. The Tesco shopping bags were strewn haphazardly at my feet, the contents spilling out and rolling around all over the driveway. A can of pop had landed on the concrete with such force that it had punctured, its foamy liquid spraying everywhere. I stared at it with a feeling of detachment, making a mental note to myself to clear it up later. What a mess, I thought distractedly. My youngest, fifteen-year-old Katie was staring at me in complete confusion as she held her baby brother, Charlie, in her arms.

"What's going on, Mum?" she mouthed at me in bewilderment, her large blue eyes conveying her alarm.

I shook my head at her. I had simply no answer to give. I couldn't understand what was happening. An icy feeling of dread was slowly creeping its way through my entire body, turning my blood cold. Little did I know that the horrendous feeling of dread I was experiencing would be nothing compared to what was still to come. The complete devastation I would feel as time went on would be horrific, as I slowly started to discover the unbelievable magnitude of the deception and

betrayal perpetrated by James Scott – the man I loved, the man I had built a life with, had a child with and was planning to spend the rest of my life with. Little did I know in that moment, standing on my driveway outside the home I shared with James and my family, that I would never see the love of my life again; not see him until I faced him in Durham Crown Court.

Chapter 2

Five years earlier

It's so hard to describe yourself accurately. It's lovely when someone else gives you a compliment, but when you give yourself one, you often appear vain and rather self-obsessed. I certainly don't want to come across as big-headed and self-absorbed, but on the other hand I don't want to downplay my looks and portray myself as someone who should only be seen with a paper bag over my head.

My name is Coleen Greenwood. In 2014 I was a forty-one-year-old, pleasantly attractive mum of two daughters. I have blonde, shoulder-length, highlighted hair and blue eyes with a decent enough figure. I take pride in my appearance and like to dress youthfully: not too young and inappropriate, but definitely not knee-length skirts and sensible shoes either. I was just an ordinary divorced mum sharing custody of two girls, Laura (17) and Katie (15), with my ex-husband, John. A very ordinary woman living a very ordinary life. Nothing spectacular to see here – but I was happy. Happiness is never something that should be taken for granted.

It was a quiet Sunday afternoon in September. I had just finished tidying the house and doing all the washing – chores I

hated but liked to get done and dusted on a Sunday ahead of the coming week. I worked thirty hours a week in a busy student housing letting company in Durham city centre, and had little time; so I liked to get a proper clean done on a Sunday.

I would get up early, tie my hair back into a messy ponytail, stick on my favourite music – perhaps 'Scouting for Girls' or 'Snow Patrol' – and get busy, happy in the knowledge that once I had finished, I could chill, perhaps read a book or enjoy a boxset. I relaxed on the sofa, satisfied that my home was fit for royalty, and enjoyed a well-deserved mug of coffee and a chocolate biscuit. That afternoon I was scrolling through messages on a dating site app on my mobile, which would occasionally send an alert to incoming messages.

"Firefighter J likes you." A new match pinged up on my screen. His profile said he was divorced with two children. It had his age, height, likes and dislikes, but no accompanying picture. It was disappointing not to have a picture, something visual to go on. In all honesty, I wouldn't normally have picked to date someone so anonymous, but after Firefighter J messaged a couple of times, he seemed nice enough. I asked why there were no photographs on his profile.

He told me his name was James, and because of the nature of his work (being in the fire service) photos weren't allowed online. It seemed plausible enough and we messaged back and forth for the rest of that Sunday afternoon – Firefighter J had struck a match. I had no idea at the time just how far those flames would spread across my life, or how damaging they would be.

My story isn't a cautionary tale of the perils of online dating. I could have just as easily bumped into James Scott in a bar. I'm quite a sociable person and enjoyed a night out and a glass or

two of white wine at local bars in Durham or Chester-le-Street, the town where I lived. However, I didn't meet James in a bar, I met him on a dating site. The photos he sent me were real, that much I know for sure. I can't even say he ever tried to get any money out of me: he didn't, not even a single penny, quite the opposite in fact. However, everything he said or did over the next few years amounted to a web of lies. James wasn't who he said he was.

Maybe I would have understood his motivation better if he'd wanted some fast money or used fake photos to try to scam me, but he didn't; he put himself up front and very quickly inveigled himself into my life. The fact that I never gave him a single penny puts a whole different twist on it. What did James Scott really want? And who was he? This was the start of a truly extraordinary chapter in my life that, as stated by the investigating police officer, was so unbelievable that it would be rejected as too fantastical a storyline by even the most outlandish soap opera!

Chapter 3

First date

James Scott Facebook post 15/09/14:

"3 hours till shift ends. Nightshift begins tomorrow."

I had split from my ex-husband John a couple of years before I received the message from James. I had already dipped my toe back into the dating pool. I'd had a brief relationship with a nice guy from work, but the flame had fizzled out quite quickly. I think it was just too soon for me after the breakdown of my marriage. I still needed time to grieve its ending. I then went on to meet a lovely, genuine guy online who I dated for a few months. This also sadly ended: although he was keen, I really felt we were better suited as friends.

I wouldn't normally have interacted with a faceless, name-less profile. However, James had sent such a lovely message introducing himself that I felt Firefighter J and I had a spark. In all honesty, I'm not too hung up on looks. In my eyes a very

attractive person can become ugly if they've not got a good personality and a kind heart. I understood that in his line of work it might be frowned on to have personal pictures online, and he was more than happy to send me some privately. I thought he had a nice face, quite a big nose, definitely not a looker, but pleasant enough looking: a little thin on top and not the tallest. He was a little paunchy, but I quite like a dad bod. Although I take pride in my appearance, for example getting my highlights done regularly and liking to wear a little make-up, I was still a 41-year-old mum of two teenage girls. I certainly wouldn't have won any beauty contests myself.

What I really liked most was the way he talked about his two daughters. His love for his two girls shone through. This was by far his most attractive feature as, to me, family is everything. My twin sister Karen and her now husband, Ryan, lived a mile away and Karen and I worked together. My mum, Jennifer, lived even closer – across the road. My two girls Laura and Katie were with me half of the time and half with their dad. This worked out well, as he also only lived a mile away and the girls could happily pop between houses. We are still a close, happy family.

It was a few days after my initial message from James, and my mum had popped over for a cup of coffee. She had brought a home-made coffee cake with its gooey icing dripping down the side. She would often bring over goodies, even though I told her not to as her baking was impossible to resist. Not good for the waistline, but so good for the taste buds. Mum was a youthful 66 and great company: slim and attractive with highlighted blonde hair and a smart casual way of dressing. That day she was wearing her normal 'uniform' of smart shirt and tailored jeans with tasteful jewellery. Mum had retired from her job

in banking years before, but liked to keep a busy social life. There was golf and her bridge club to keep her occupied, and she loved nothing more than a night out with Karen and me for a meal and a few cocktails. There was nothing I couldn't talk to my mum about, and we would often while away an afternoon chatting like a pair of girlfriends.

Once I'd made the coffee and Mum had cut two generous slices of her cake, we sat down at the kitchen table for a natter. I pulled out my phone and showed her a couple of the pictures of James.

"Well, what's your opinion?" I asked. Mum took the phone and squinted at the screen. She swiped through the photos, taking in the different shots – James taking a golf swing in one, and staring wistfully into the distance in the other. There were no photos involving the fire service and none of him in uniform.

"Well, he's no Harrison Ford," Mum commented, laughing. Mum had always had a soft spot for Harrison ever since she'd seen him in Witness.

"Harrison Ford's old now, Mum," I laughed. "You need to get a new toy boy actor to fancy. But seriously, what's your opinion of James?"

Mum passed my phone back across the table. "He looks nice enough," she commented, obviously not overwhelmed by him. "As long as he's a good guy, love, that's all that matters." She picked up her fork and continued to eat her cake. That was the end of the James conversation for that afternoon.

Perhaps if she'd said, "Oh no, he looks awful, don't go there," my family and I could have been saved a lot of pain and heartache.

James was becoming very persistent that we should meet

11

up. I was more reticent and felt happy just messaging for a while. However, a couple of weeks after the first message, we did meet for the first time. That afternoon I was at work, busy inputting figures into a spreadsheet, when a message from James pinged up on my phone. He was playing golf at Ramside Golf Club, not far from where I worked. Could I meet him for a quick coffee before he picked his daughters up from school? He had an hour to spare and couldn't think of a better way to spend it than with me. It made sense that he could be free at that time, as he was a Watch Manager at Darlington Fire Station, so working shifts. He suggested the local Starbucks, just across the road from my work.

I worked with my twin sister Karen. We were as close as sisters could be; not just sisters, but best friends too. Technically she was my boss, so I turned my chair round to face her.

"Could I leave an hour early, please?" I asked her, fluttering my eyelashes in a manner that always made her laugh. "James has asked if I'll meet him for a quick coffee across the road."

Karen shrugged her shoulders. "It's fine by me; you haven't had a lunch hour yet, so you could finish a bit early." She shuffled some papers on her desk. "It's only a coffee, where's the harm? You can see if you have the same connection face to face."

I sent James a message agreeing to meet. Ten minutes later and after quickly tidying my desk and applying a sweep of scarlet lipstick for confidence, I nervously headed out of the door. I'd only had a few dates since my 17-year marriage had ended. I still got butterflies in my tummy at the prospect of meeting someone new, but like Karen said, what had I got to lose? If only she knew how those words would come back to

haunt her.

James and I hadn't talked on the phone by this stage, we'd only exchanged messages – of which there had been many. I had no idea what this man even sounded like, but from the few photos he'd sent me, I was sure to recognise him. My first glimpse of James Scott was as he crossed the road, and I have to say that my stomach sank. He was wearing those awful short, checked golf trousers and a garish pink jumper. He was definitely the man from the photos, as I recognised him straight away; and he clearly recognised me as he waved enthusiastically as he crossed the road to greet me. My first impression was still, as I'd thought from his photos, that he was a nice-looking man, if not movie-star looks; but his outfit was horrendous. Could he not have changed before he came to meet me? Putting my reservations aside, I thanked him for holding open the coffee shop door for me, so at least he had good manners.

James ushered me over to a seat at the back of the coffee shop. "What can I get you?" he asked. "It's my treat, have anything you like." His voice sounded confident, not at all nervous; but rather high-pitched, which surprised me as it wasn't what I'd anticipated. You know what it's like: you see a picture of someone and you get an idea what their voice will be like, and James's voice wasn't at all what I'd expected.

"Just a skinny cappuccino for me, please," I said with a smile.

"Your wish is my command." With that, James went bounding over to the counter to order our drinks.

When he returned with my cappuccino and a large filter coffee for himself, the conversation flowed. There were definitely no awkward silences; truthfully it was hard to get a word in edgewise.

"My job is my life," he told me proudly. "Well, that and my two daughters." He talked in detail about his love for his job: how he had always wanted to be a firefighter even as a little boy, just as his father and grandfather before him; it was in his blood. He talked extensively about the intricacies of the job, and his knowledge was so detailed that I felt myself swept up in the many stories.

He talked lovingly about his daughters, Maddison and McKenzie, who were 12 and 7 years old. He showed me many photos of them on his phone but confided that he had an extremely strained relationship with his ex-wife, Jill. She was planning to move to Texas with the girls and their stepfather. His eyes welled up as he said how the prospect of having his daughters so far away in the US was breaking his heart.

We spent a pleasant hour together, and as I said goodbye to cross town to my bus stop, I wondered if I would ever see him again. He was nice, quite easy-going and funny, but the conversation had been rather one-sided. What I did find endearing about him was his old-fashioned attitude to dating. He was clearly a romantic. He said he'd met two other women online, but one of them had only wanted to meet for a physical relationship and that wasn't for him. He said he wanted to 'meet the love of his life' and have a lasting relationship. I thought this was charming. I got the impression that he had his eyes set firmly on me. However, from my side it certainly wasn't love at first sight.

Before I even arrived at the bus stop my phone was ringing. I pulled off my leather glove and fumbled in my bag, desperate to locate the device before the ringing stopped. It was James.

"It was so amazing to meet you today," he gushed. "I had the most fabulous time and can't wait to see you again."

Wow, keen, I thought; wait till I tell Karen.

Chapter 4

The courtship

James Scott Facebook post 22/09/14:

"Cracking lunch with a beautiful lady, hopefully plenty more to follow."

The messages came from James thick and fast. He was very eager to arrange a second date. However, it was well over a week before I agreed to meet him again, during my lunch hour, at a local tapas restaurant.

James was already waiting for me as I approached the restaurant. He was dressed more appropriately this time, in pale blue jeans and a cream jumper, but with a leather baker-boy-type cap on his head. Was this to cover his receding hairline? Yes, his mousy blond hair was thinning – but so what? He would definitely have looked better without the cap. There's nothing wrong with a balding man, and this cap made him look rather camp. It seemed to accentuate his nose and give it a somewhat beaky look. I wondered to myself if I could persuade him to lose the cap. While I was pondering this, he

planted a large sloppy kiss on the side of my cheek.

"You look beautiful," he said. I felt my cheeks flush. I was flattered. He was really very sweet, and what woman doesn't enjoy a compliment?

"Thank you," I replied, "it's lovely to see you. I can't believe how cold it's getting already and it's still only September." Whenever at a loss for words, I always revert to talking about the weather. I needn't have worried though: once we were inside the restaurant and had ordered an array of tapas dishes – seafood for me and meat for James – the conversation was in full flow, if still rather one-sided, with James happy to do most of the talking.

It's only human nature to make initial judgements about people. From James's voice and demeanour, I assumed he was a typical working guy. Nothing at all indicated that he had any sort of wealth; and honestly, I wouldn't have cared either way. The person is all that matters to me. If anything, at this point, I assumed that I was probably better off financially than him. He drove a pretty beaten-up car and didn't give off a 'wealthy vibe'. He was, however, generous: despite my many protests to split the bill, he insisted on paying. I was warming to him, and he was easy company.

The following weeks we often texted and spoke on the phone about our day. But on several occasions when I phoned him, he either didn't answer or else appeared rather flustered and said he couldn't talk. He then quickly texted me with an apology. Often it was due to the fact that he was with his daughters and wanted to give them his full attention. This was fine by me, as kids must come first. It was still early days, and understandably his daughters might not yet know of my existence.

A few weeks later we moved our relationship to the next level. He started visiting me at home in Chester-le-Street. Due to his shift pattern he didn't stay overnight, and often we just met for a quick coffee during the day. We never spent a full day and night together. However, it still felt that he was a constant presence within my life. His 'thing' was that he always had to have the last word at night, so his words would be the last thing in my head as I drifted off to sleep. At first it felt romantic: the long wordy poems and quotes about undying love, but after a while, when you've had a busy day at work and are dealing with two teenage girls, you just want to say "goodnight" and go to sleep. I didn't tell him this, though, as I didn't want to hurt his feelings.

Although we weren't meeting up that regularly, I would often be surprised at work with deliveries of beautiful flowers. Understandably, as a woman who had been in a long marriage previously, to suddenly feel so treasured again was intoxicating. However, the frequency of the gifts and flowers to my workplace began to feel somewhat overwhelming. Truthfully, as someone considered shy, I was beginning to find all the attention a little uncomfortable in front of my workmates.

At this stage we were dating exclusively; or that was my impression, anyway. I was taking it slowly, mindful of my daughters' feelings and just seeing how it might go. By then I really liked James and enjoyed his company. I looked forward to seeing him, and he always had a knack of cheering me up if I'd had a hard day. But I wouldn't say I was in love. James, however, felt it was time to declare his undying love for me, and was pushing me to reciprocate the feelings.

We'd arranged to go out for dinner. It was a Thursday night and we had made a reservation at a local Chester-le-Street

restaurant, DaVinci's. They had a reasonable happy-hour menu and I often went there with my daughters. I had decided to get dressed up a bit and was wearing a black and white bodycon dress and a pair of high-heeled black pumps. James was also looking smart in a fitted pair of indigo jeans and lilac shirt, but again he was sporting a ridiculous hat. It was a bobble one this time, reminiscent of Pootle out of the Flumps. What was it with him and hats? I decided it was time to grasp the nettle.

James gallantly held my chair out so I could sit down. I thanked him before asking the question, "James, what is it with the hats?" I picked up my menu and began to cast my eyes down the list of appetisers.

"What do you mean?" he asked. He seemed genuinely perplexed by my question. "Do you not like them?"

I looked down at the tablecloth, feeling a little embarrassed. "Honestly no," I admitted to him. "I don't think you suit them at all, I prefer you so much better without them."

He grinned broadly. "No problemo," he quipped. "The hats are no more," he said, clicking his fingers. "That's how much I love you."

I laughed nervously. "Well, I'm glad about that." I tried to steer the conversation away from talk of love. "I really thought you should have been auditioning for Right said Fred in the leather number! It definitely wasn't too sexy."

He laughed until he was struggling to catch his breath. I thought this was a little strange, as I really wasn't that funny. "How about you?" he asked. "Do you love me?" He was staring at me, waiting for a reply like an eager puppy.

Fortuitously at that very moment the waiter appeared. "We should order," I declared, picking up my menu again. I had

dodged the bullet that night.

I may not have had to declare my love to James that night in the Italian restaurant, but James was like a dog with a bone. He was always pushing for reassurances about the strength of my feelings. But it took me a little while longer to get to that point.

Then on a mid-week date to the cinema a couple of months later, I realised I had fallen in love with James. I'd nagged him to take me to see the film Legend. I am a huge Tom Hardy fan and will watch anything he's in; James would tease me about my 'other man Tom'. We headed into the cinema that afternoon in high spirits. James was walking ahead carrying two large containers of popcorn, and I followed behind with the drinks. Then suddenly James lost his footing for a second, desperately tried to keep upright, but stumbled unceremoniously to the floor. Seeing him lying there covered in popcorn and grinning sheepishly up at me, I couldn't help but laugh.

"Good job I love you, but you'd make a rubbish juggler." The words just popped out of my mouth and I wanted to cram them back in. Was it too soon? No, it hit me hard, I did love him very much, my feelings were strong and they ran deep. I couldn't imagine my life now without James, and I didn't want to.

Till then I'd had my times with James separate from my time with my daughters. But I now felt the time was right for him to meet my two daughters, Laura and Katie. The girls had been pushing to meet James, and he was also keen to get to know them.

As it turned out, the meeting with James and my girls was taken out of my hands and it happened spontaneously, as many things in life do.

Laura and Katie were spending the weekend at their dad's house, but Laura had forgotten her pyjamas. An hour after they'd initially left the house, Laura burst through the front door with Katie behind her.

"Only us, Mum," Laura announced. "I forgot my pyjamas. I'm just picking them up and then we'll be off again." She was still speaking as she entered the living room, her words dying in her mouth as she spotted James relaxing on the sofa with a cup of coffee. "Oh, sorry," she said, flustered. "I didn't know anyone else was here."

"This is James," I announced as Laura and Katie stood awkwardly by the doorway. "We're just having a cuppa and then we're heading out for some lunch."

"Whatever," exclaimed Katie. She was chewing at her short, painted fingernail, something I was always nagging her to stop doing.

"Do you two fancy a drink and a chat for a few minutes?" I asked eagerly. Laura looked at Katie and they both shrugged. "OK," they said in unison.

James was on fine form that day. As he talked about his daughters with Laura and Katie, they found some common ground. James had a rather boyish quality about him, and I could tell my girls were warming to him. To them he seemed cool for an oldie.

After the girls had met James on a couple of occasions, they told me very enthusiastically how much they liked him: he was really nice and funny. They were happy for him to be in their mum's life.

Our relationship continued – but it wasn't without bumps in the road. On one occasion he was going to watch his girls in a school play. He sent me a picture of the programme and

was really excited and proud to be seeing his girls on stage. He was due to come and see me after the play had finished and he'd returned his girls to their mum. But he never came. I tried ringing and texting, but to no avail. To say I was somewhat miffed was an understatement. How long does it take to fire off a text? This thoughtlessness was so unlike James. He was usually so attentive with his texts that it didn't make sense to me. I took myself off to bed questioning if he really was everything he seemed to be.

The following morning he turned up at my workplace full of apologies. I had just taken off my coat and was busy unwinding my scarf when he came bursting through the office door. It wasn't even 9 a.m.

James looked rather flushed in the face and extremely agitated. "I'm so sorry about the play," he said. "I didn't get a chance to call you, and then the evening just got so complicated."

He went on to explain that he'd received news that his grandfather had passed away suddenly. Understandably, he was devastated. He had to break the news to his daughters and be there to support them. Once he was at his ex-wife's house, his phone had died and he had no way of contacting me. Seeing his grief-stricken face, I felt wretched for having doubted him. Yes, he had left me to worry alone all night, but he simply had no choice. He needed to put his grieving daughters first.

In the early months of the relationship, there were many times when I was left questioning where he was. I would wonder why I had been let down at the last moment. There was always a plausible excuse, often backed up by text messages and emails. This would put my mind at ease. I hated the fact that perhaps I was being unreasonable, as that isn't the kind

of person I am.

Chapter 5

Before James

Karen and I were born in 1973 in a little village in West Yorkshire to our parents Jennifer and Arnold. My mum and dad always wanted two children, so they struck it lucky when they got us both and felt the family was complete. Dad was an inspector in the police force and mum worked part-time in banking. When Karen and I were little, we moved to the Roundhay area of Leeds. We had a happy, comfortable, middle-class family life. Growing up we could always look forward to our family holiday abroad once a year. By the time Karen and I were 15 years old we had travelled throughout the world. Overall, though, we were just an average family.

Being a twin was wonderful. Although we often bickered over clothes and boyfriends, we were the best of friends, and still are. We might have criticised each other, but God forbid that anyone else did. We were so close and looked so alike as twins that growing up it was hard for even our family to tell us apart. We still laugh today about the adventures we got up to when we were children: often swapping classes to see if we could trick the teachers. On one occasion a boyfriend of mine stopped

Karen in the street and had a lengthy conversation with her, all the time thinking it was me. She played along, thinking it was hilarious. More than once we would go out shopping separately but still manage to come home with exactly the same outfit. It has changed a little now, as we are slightly different sizes and Karen has dark shoulder-length hair, while mine is blonde. However, looking back at old family photos, I struggle to tell us apart.

Karen was always the more artistic one and loved writing. I was the more academic one, but never particularly enjoyed school. Much to my parents' disapproval, the day before I was due to start my A-levels, I decided to venture into the world of work. I was 16 when I started my first job. I've always worked hard, initially in the Department of Social Services dealing with benefit claims, then moving to banking, working at Barclays Bank until moving further north in 2005.

I met my ex-husband, John, when I was 23; when I married him two years later, I was already pregnant with Laura. Then Katie came along less than two years later.

Both pregnancies were problematic. Once I had given birth to Katie, I was adamant that two children were quite enough for me, so I settled down to being a mum with my lovely girls and husband.

When Katie was four, John was offered a promotion at work which would mean relocating further north-east. This made me really happy; it was daunting to leave Leeds, but the prospect of being close to my sister Karen again was wonderful. She had moved to Chester-le-Street eleven years earlier, and I was excited at being able to see more of her up there. By then Karen had a 7-year-old daughter, Emily, so Laura and Katie could be closer to their cousin. While John and I looked for

our perfect family home, we actually lived for six months with Karen, her then husband and Emily. Overall we all got on like a house on fire; not to say that at times it wasn't difficult with three adults and three children living together in a modest terraced house, but we made it work. Looking back, these were really happy times when the children were little and there was much to look forward to.

I had several jobs when the girls were small. I always tried to work part-time so that I could be with them at home as much as possible. In my late 30s I started working for a student letting company based in the centre of Durham. I was offered a permanent 30-hour week position, and loved the job.

Eight years later, just before my 40th birthday and after being with John for 17 years, we decided to split up. There was no particular issue: nobody else, no drama. We just drifted apart as can happen, and we became more like friends. I guess the marriage had run its natural course, and although it was sad for us both, I think we both knew it was time for us to go our separate ways. I stayed in the family home; while John, still wanting to be close to the girls, moved to an apartment about a mile away. We still met up for special occasions, like the girls' birthdays and Christmas. Despite not being a couple, we remained close. John married a lovely lady about four years later and we continued to happily co-parent. If ever I had a problem, I knew I could contact him; and I hoped he felt the same.

Chapter 6

Family time

James Scott Facebook post 04/11/14:

"I love Coleen Greenwood and I don't care who knows x".

I was incredibly happy with the fact that my girls were so fond of James. My daughters' opinion of my relationship would have been make or break for us. However, as the girls loved to spend time with James, we had great family days out: going to the cinema or shopping trips, as teenage girls love their retail therapy.

By this stage, James had met my sister Karen and her now husband Ryan. Karen was a little wary of James. "He's not your usual type," she commented. "He's a bit of a live wire, constantly on the go; you normally go for a more laid-back, chilled-out sort of guy." Karen was very protective of me, as twins have such a close bond.

The first time they all met was over a quiet Tuesday evening drink at the Butcher's Arms pub in Chester-le-Street – a nice traditional pub that served good ales and was the perfect place

to have a quiet conversation. Karen and Ryan were already at a table in the corner of the pub. Ryan spotted me as soon as I entered the bar area and started to beckon us over. Here we go, I thought a little nervously as James and I made our way over to the two spare stools at Ryan and Karen's table.

I shouldn't have worried. James introduced himself to Ryan and Karen and started enthusiastically shaking their hands. "So great to meet you both," he enthused with a wide smile. "Can I get you both a drink?"

"We're fine thanks, mate," Ryan replied, gesturing to his barely touched pint and Karen's glass of wine.

James excused himself and strode over to the bar to order the drinks for us: a glass of dry white wine for me and an orange and soda water for himself.

My eyes darted between Ryan and Karen, trying to gauge their opinion. "What do you think of James?"

"Looks canny," Karen replied, munching on a crisp. "He's not your regular type, but he's all right." She started laughing to herself. "He's not going to scare the villagers anyway," she said, making a sweeping gesture towards the other drinkers in the pub. I quickly hushed her as James returned with our drinks.

I remember it being a very pleasant evening. We just chit-chatted amongst ourselves, mostly small talk. No religion or politics, nothing that would cause any divisions at the table.

Looking back, I do remember Ryan saying to me later that he found it quite hard to understand everything James was saying. Ryan had worked in a platinum mine in South Africa as a teen, resulting in hearing loss; he therefore had to lip-read and react to people's facial expressions when in conversation with them. But he found that James talked incredibly quickly

and moved his head around a lot, so he missed quite a lot of his conversation.

Ryan also thought James was a little full of himself, showing off a little too much. Everything Ryan had done, James had gone one better. Perhaps this was nerves: James trying to make a good impression and being a little over the top, I remember thinking. However, even with this, Ryan said he seemed a decent enough chap, perhaps not someone he would want to go out for a pint with on his own, but not terrible; and Karen was happy enough, so I felt the evening was a success overall.

Over time both Karen and Ryan would warm more to James, and we all became very close. James had the gift of being able to win people over in time with his charm, or more likely his manipulation.

There was one occasion when Ryan and James arranged to play squash together. James was keen to organise it and Ryan was happy to play as he had been a keen squash player in his youth. But Ryan had not played in many years and was quite out of shape, so his game would be somewhat below par. James was ribbing him good-naturedly prior to the match, saying he was going to wipe the floor with him, run circles around him, calling Ryan the chubby old man, even though Ryan was barely two years older than him. James was extremely fit, or so he would always tell us: he had to be physically fit in his profession, so he liked to run regularly and play squash as often as he could.

Karen and I were waiting for them to finish their match, while sitting enjoying a glass of wine in a local pub and hoping that James would go easy on Ryan as he was so much fitter. Karen was concerned that if Ryan couldn't keep up with James, it might dent his confidence and stop him wanting to

participate in future. But she need not have worried as Ryan came striding purposefully into the pub with James tailing behind him rather sheepishly.

"Go on then, Ryan, how much did he thrash you by?" Karen asked light-heartedly.

"He didn't," Ryan responded triumphantly. "I beat him 8-0!"

Both Karen and I laughed at this, assuming we were having our legs pulled. How could Ryan have beaten James by this score when James was the fit one of the two? However, Ryan had indeed beaten James, not merely beating him but annihilating him completely. Ryan had literally run rings around James, as James had ended up sitting red-faced in the middle of the squash court unable to catch his breath.

It felt a little odd. Why would James have been so keen to arrange a squash match with Ryan, and boast about how he was going to thrash Ryan, only to end up rather humiliated? The rest of the time in the pub was a little lukewarm: Ryan in good spirits at his win, and James rather quiet and sullen.

We used to make up a foursome at the local pub quiz every Thursday night. Our team was called 'Up the Creek Without a Paddle', a somewhat fitting name as we often came out bottom. James always needed to be contactable because of his work, so he was the only one permitted to keep his mobile phone switched on for the duration. He quickly became known as James the fireman. The regulars would often ask him about his day and he would regale them with anecdotes. He was very well liked, with a way of being the life and soul of any room. He was well and truly embedded into every aspect of my life.

Amusingly, looking back at things now, the only time our team won the quiz was when James and I had to leave early. He

was suffering from back pain. Karen and Ryan then went on to win first place on their own.

Another time James and I had to cut our evening short as James said that he felt uncomfortable.

"What's wrong?" I asked him, as I was keen not to miss any of the quiz questions. It was the music round, my favourite.

James gesticulated to a couple sitting at the next table enjoying a meal. "I can't bear the smell," he said, making a gagging expression.

I cast my eyes over to the couple eating. I couldn't smell anything offensive, quite the opposite: there was a delicious aroma wafting from their plates.

"He's eating pulled pork!" James declared.

I shook my head at James, not understanding. "So what?" I looked at the man who was eating his baguette. It smelled really good to me.

"It smells just like burning flesh," James cried. "I can't bear it, I need to leave."

In that moment I felt bad for him. He was obviously distressed. Hugging Karen and Ryan and wishing them good luck for the remainder of the quiz, we left for the night.

Thinking back, that was such a bizarre thing for James to say, especially for someone who would have to deal with the aroma of burning human flesh during his life. I find it hard now to comprehend the tales he would tell me, the lengths he would go to. However, I know one thing for sure: since that day at the pub quiz, I have never been able to face eating pulled pork again.

Poor James was forever plagued by back pain – but was this just an excuse for him to ensure we left the quiz early as he wasn't the smartest person there? He said he had broken his

back while jumping out of a burning building with a little child in his arms some years before. He had saved the boy's life. I felt so proud of his bravery and had the thank you card from the little boy on my desk at work as James cherished it. James had given a talk at the child's school as he was his 'hero', and there was a letter of thanks from the boy's father. This was another reason that Karen and Ryan warmed to James: he really was a good guy; putting his own life at risk to save another.

James was proud to wear his firefighter's uniform: he said it made him feel like 'someone special'. Personally, I really wasn't into the whole uniform thing. I know some women covet a firefighter, but that wasn't true of me. In fact, growing up with a policeman father, I knew how annoying the shift patterns could be: missing family occasions, such as Christmas Day. I would have been just as happy if James had said he worked in a supermarket or an office. However, James Scott chose to pretend to be a firefighter. That was just the beginning of a string of lies that would smoulder under the surface until it became too difficult to ignore the smoke signals.

My mum Jennifer grew very fond of James, as did my mum's best friend Yvonne. Yvonne lived two doors down from my mum, but was a big part of our family and we are all incredibly close to her. Mum and Yvonne would regularly come over for a cup of coffee after I got home from work. On many occasions James would be there. Sometimes it would be a flying visit and he would be wearing his full firefighter gear, smelling strongly of smoke. Let's be honest, what mum wouldn't take pride in seeing her daughter dating a hero? A hero dressed in a uniform I would discover was bought from E-Bay! It makes my blood run cold now. We all now know how easy it is for the hero to become the villain.

Chapter 7

The smokescreen

James Scott Facebook post 29/10/14:

"What a clumsy sod I am... How do you walk into a fire engine? Looks like I'll be sporting a black eye for my meeting tomorrow."

James was an amazingly talented guy. Unfortunately, his talent was for deception.

My life before James is an open book. I thought his was as well. Now I know that everything about his life was lies. You may wonder how we fell for all his deceit; but believe me, we weren't the only ones.

You must have a certain kind of confidence and self-belief to pull off the magnitude of deception that James did, and absolutely no conscience. To James, my family and I were simply characters in his twisted games. There was no empathy towards any of us.

James didn't have much of a social media presence. He said this was due to the nature of his job. He did, however, have a

Facebook profile, which is still active to this day, with a few friends. I didn't know any of these friends, but they would comment and like his posts. I now know that these 'friends' were all accounts he had, and the people did not exist. He quickly sent Karen a friend request, and then began adding all my friends. I found some of his Facebook posts declaring how wonderful I was to be cringeworthy. I must admit I wondered how he didn't get teased by his 'friends' about his declarations of devotion – but of course he didn't, as they weren't real people.

As we were about four months into our relationship, James clearly thought it was time I learnt more about his family. I've always had this unwritten rule that you should wait a good while into a relationship before meeting children, so I was fine with not having met McKenzie and Maddison. Plus the fact that I knew he'd had an acrimonious relationship with his ex-wife. However, it was starting to irk me that James had infiltrated my life so quickly, and I had not met any of his family or knew much about them.

He hadn't the closest relationship with his mum. She lived in Nice, in the South of France, with his stepdad John. James portrayed his mum, Maureen, to be a rather cold and aloof woman, and he hadn't had the happiest of upbringings. My heart went out to him, imagining this little boy with the austere mother. How all he wanted while growing up was for his mum to give him a hug. Maureen, however, didn't have time to waste on hugs: she was far too busy with her career, her one true love. Maureen was a very successful businesswoman – or so James would tell me. She worked as a sports agent, and he would drip-feed me information about her clients. I think I was supposed to be impressed. However, as I know barely

anything about sport, these names were lost on me.

James started hinting that his mother was wealthy. It came as a bit of a shock, as prior to this he hadn't really mentioned her much. I remember saying. "Good for her; it's always nice to hear about another woman succeeding in business."

I do recall one afternoon walking around Sainsbury's doing grocery shopping while James was talking at length about his mum. He was staring thoughtfully at the items in the shopping trolley: I had no sooner added a reduced-stickered pack of yogurts to the small mountain of groceries than James took it out and put it back in the fridge.

"What are you doing?" I demanded. "They're great for the girls packed lunches."

James was shaking his head. "My mum would never buy anything reduced like that in a supermarket. It's letting people think you're poor and you can't afford to pay full price."

"Don't be so ridiculous," I snorted, adding the yogurts back to my shopping haul. "Everyone loves a bargain, and it's not as if they're out of date. I'm sorry, James, but your mother sounds a little out of touch with reality."

His face darkened somewhat. "It's not about a bargain," he insisted, "it's about perception. Why would you want people to think you need to buy cheap?"

I recall laughing at him. His mum must be a right character caring what strangers in a supermarket would think about the goods in her trolley. Surely everyone was too interested in their own shopping to be checking out other people's.

I now think that conversation was rather telling. It gave a glimpse into the workings of James's mind. Perception was what mattered to him. If he garnered respect and admiration from other people, that was what mattered; not the manner in

which he acquired it.

Maureen living in France would mean that James didn't see her very regularly. He said this suited him, as they weren't particularly close. However, they would text often, we heard him speaking to his mum on the phone.

James also had two sisters. There was Bronwyn, who was about 40 and lived with her husband Mike and three sons in London; she worked for a legal firm. Then there was his sister Jodie, aged 36, who had emigrated to Australia a few years earlier; she worked as a doctor and had an active Facebook profile. Jodie would send me messages via Facebook, so although we hadn't met, I felt I had a connection with her already.

James was much closer to his sisters than his mother. As he was the baby of the family, he would say how protective they were of him. He would joke that being the older sibling, Bronwyn would boss him around. He affectionately referred to her as "Bossy boots Bron". I would often see three-way text conversations between them happening in real time.

All James wanted was to have a family. He was so disappointed that his marriage to his ex-wife had come to an end, although he was glad to be out of the conflict. In many ways she was a difficult and controlling woman, but he felt he had failed his daughters not making their marriage work. His ex-wife Jill had become increasingly manipulative and controlling during their marriage, leading to its inevitable breakdown, he told me. He had to end the marriage. The woman was a nightmare – she even checked the mileage on his car and would question where he'd been and with whom. Poor James had been in a horribly coercive relationship with a narcissist. If I'd only known the truth! I don't know whether I should laugh or cry.

James worshipped his daughters: they were the apple of his eye, he told me constantly. It just saddened him that he couldn't spend more time with them. He was really cut up that Jill was planning to take the girls to Texas to start a new life. The girls were keen to go and were excited about the prospect of a whole new exciting life.

James was torn. He wanted his daughters to be happy, but he couldn't bear the thought of them being so many thousands of miles away. He sought legal advice to explore his options, and he would often have lengthy conversations with his sister Bronwyn about it. She was legally trained – or so I believed.

Jill was angered by his attempts to stop her leaving the country with his daughters, and he would show me some truly horrible text messages she sent him. Other family members and I would hear him having heated telephone conversations with her late into the night.

James had a beautiful picture of his two daughters as a lock screen on his phone. He had many other photos he would show me: Maddison trying to look really grown up with a bit too much make-up and her long blonde hair styled fashionably; and McKenzie waving at the camera with her missing front tooth, wearing her bright pink wellies when they went to the park. Thinking back, James wasn't in any of the photos; but he wouldn't be, would he? After all, he said he was the one taking the photos.

I still hadn't seen James's house, but why would I? I hated driving, and it just made sense for him to come to mine. Anyway, he started talking about selling it – having got his head around the idea that his girls would be moving to Texas, so he really didn't need the spare bedrooms. He wanted to be closer to me. He decided that a nice little riverside flat in

Durham City Centre would be just the ticket. Suddenly, I was being dragged around property viewings in my lunch hour. In all honesty, I would have preferred to spend the time relaxing a bit before returning for the afternoon, but I wanted to support him. He was keen that I should have input into his decision – as he said, "I would be spending a lot of time there."

Luckily, he found his dream digs within a few viewings and was keen to pay the deposit and sign the paperwork. He had quickly accepted an offer on his own property from a couple who were eager to move fast and had no chain. So, time was of the essence.

I helped him pick out a few items for his new flat. He said he wanted my input, as he didn't want it to be too much of a bachelor pad, but more of a love nest.

Just before James was due to take possession of the flat, he had a call from his superior at work. An exciting job opportunity had arisen, and James was the man for the job. It was a Senior Training Officer at the Fire Training Academy in Washington, Tyne and Wear, and it came with its own accommodation. James was in two minds whether he wanted to take this position. He was keen to get my opinion. As this job would involve more training of new recruits and less danger, I was keen for him to take it.

The thought of James being less at the front line appealed to me so much. When James was on shift, we had our own code for him to message me. I wouldn't phone him when he was working. James would send me different emojis when he had callouts at work. There would be the fire emoji when he was called out to a fire, and car emoji when it was a car traffic accident. This meant he could send a message in less than a second and I would understand the significance of what he was

doing.

Looking back, I realise just how cruel and manipulative this was. I would often get a fire emoji in the evening and not hear anything more from him until the next morning. I would be racked with fear, wondering if he had been hurt – or worse, was dead. I wouldn't be able to sleep and would fret all night, tossing and turning until I had to get up in the morning, ready for work. At the time I thought it was our cute way of communicating; now I can see it for what it really was.

So many lies were being told; it was only a matter of time before someone got really burnt.

Chapter 8

Heartbreak and loss

James Scott Facebook message 01/02/15:

"Had a great day and night yesterday with the amazing Coleen Greenwood. Love u princess x. "

His love was so all-consuming. He would at times bombard me with messages. He still sent flowers to work regularly and would drop in unannounced – sometimes several times a day. My workmates would joke he was the "unpaid employee". This made me feel embarrassed. On one occasion a fire engine passed the office. My work colleague commented, "That was James driving, I'm sure of it." I agreed that it could have been, as he was on shift.

James was great with the romantic gestures. I would never have thought you could tire of candle-lit meals in posh restaurants, but you can. James loved to be out and about. I would honestly have enjoyed just to get my pyjamas on and eat a pizza in front of the soaps most evenings after a day at work, but this was often not the case.

James was so charismatic, but he could also be arrogant at times. He sometimes enjoyed belittling waiting staff at restaurants, which made me feel very uncomfortable. Both my daughters have worked in hospitality, and I know how difficult and thankless it can be. On one occasion he was quite rude and dismissive to a waitress about the way his steak had been cooked. We had been enjoying a lovely candle-lit meal on a Saturday night in a smart restaurant in Durham: we'd finished our starters and our main courses were then delivered by an extremely polite young waitress.

"Is that supposed to be medium rare?" James demanded, poking at the piece of meat on his plate with his knife.

The waitress reddened slightly. "I'm sorry, sir," she apologised; "is it not to your liking?"

"I think the chef needs to learn how to cook properly," he barked. "Get me another and get it right this time."

I pulled James up on this angrily. "I think you were really rude and condescending to her. You should apologise."

There was no apology, though he did leave a 30-pound tip. I think he would see apologising as a weakness. As always, he just let his money do the talking.

Christmas came and went. I'm normally happy to receive just a box of chocs and a few token gifts, but not that year. James well and truly spoiled me. I didn't get to see him much though, as he spent most of the festive period with his daughters. I wasn't going to make an issue of this. After all, his girls would be leaving for America in a few weeks. It was so important that he made some memories to treasure. I would so have loved to meet them over Christmas, but his ex was being a nightmare. She didn't want the "new woman" around his girls. Reluctantly, I took a step back. But I did spend time finding

them gifts I thought they would treasure, as I wanted them to appreciate me. I wanted them to know I was thinking of them. I also received gifts from them – toiletries and chocolates.

I still liked to spend some time over Christmas with my daughters and my ex-husband. It was our thing. Laura and Katie really liked us to be together for a meal. James was not impressed at all: he made me feel I was an oddity. I had split from my ex, so in his mind it wasn't appropriate for us to spend time together. He was starting to take more control.

"Why on earth would you want to spend Christmas Day with your ex?" James demanded angrily as I was doing the washing up one evening after I'd made us a meal.

"Why wouldn't I?" I retorted, stacking the dried dinner plates in the cupboard. "It's nice that we can still get on, and it makes the kids happy."

I really couldn't see why it would be such an issue. Yes, John and I had had a lengthy marriage, but it had ended amicably. Neither of us was keen to rekindle it, the idea would be ridiculous to us. It was just amazing that we could still remain friends.

James was having none of it. "It's just not respectful towards me," he insisted. "You're with me now, I'm your partner, you shouldn't need to see John at all."

This wasn't the only conversation James and I had on this matter. He really was like a dog with a bone.

James was not impressed, and this was the last year that I would spend time with my daughters and my ex-husband all together.

Karen and I have always been close, but when we grew older, around our late 30s onwards, we always had this little joke that if we were down or upset about anything, we would always say

to the other, "Could be worse: at least you're not pregnant." It would always make me laugh and thank my blessings that those days were long behind me.

Karen and I were forty-year-old women, and the thought of an unplanned pregnancy was a scary prospect. How was it then that I was staring in disbelief at a positive pregnancy test? I thought that we had been careful, but clearly not careful enough.

James and I had to sit down together and have a difficult conversation about what we should do. We both decided that I should have an abortion. It was an incredibly hard decision for me, and I felt wretched. My children were young adults and James and I had only been together for a little over six months. Although we both agreed, it felt like a cloud had settled over our relationship.

As the pregnancy wasn't very far along, I was given tablets to end it. I wrote a letter to my future self to read when I felt upset, which I still have to this day. The nurse I saw suggested this. I remember thinking it was an odd thing to do, but I'm so glad I did as it still brings me comfort. The night the pregnancy ended, James left me all alone. He claimed he had to work. There was simply nothing he could do.

"Don't you think that if there was any way to stay with you rather than work I would?" he implored. "Work is short-staffed, I have to be there." He looked so concerned and I felt I was being unreasonable. Of course, he desperately wanted to be with me and comfort me, but he had to work; it couldn't be helped.

I felt so frightened and incredibly sad. I just wanted to feel him comforting me and his arms around me supporting me, but I was on my own.

Chapter 9

A gift from God

James Scott Facebook post 19/04/15:

"Coleen Greenwood, you're the love of my life, love you darling."

In the following days after the termination, I was terrified. Would I fall pregnant again? Sex was definitely off the table. I felt sorry for James, but I just couldn't take the risk. I was in my forties but had fallen pregnant so easily. What was to stop it happening again?

"I'm getting a vasectomy!" James announced over the breakfast table. "I'll book an appointment urgently. Our family is complete and I'm not having my princess worrying."

I felt a weight had been lifted off me. I was so grateful and relieved, happy that James had made this decision.

A few days later he attended an appointment at a private clinic – the Woodlands Hospital in Darlington. He was seen by his consultant, a Mr Maddison, and had the procedure within a few days. It was straightforward. Poor James did have a bit of

bruising on his pubic area, which he showed me. He also had a gauze dressing pad and he had been shaved.

I fussed over him that night. "Don't you move a muscle," I insisted, bringing him yet another cup of coffee and a plate of biscuits.

"Thank you, princess." James gratefully accepted the coffee and biscuits with a wince. "I must admit it's sore; feels like I've had a ferret dangling off my family jewels by its teeth!"

I remember laughing at this and giving him an affectionate kiss on the cheek: so happy that he'd gone ahead with the procedure; after all, he was only 35 years old and could have felt he was too young to end his chance of being a father again. But James had selflessly decided to put me and our family first.

In due course he showed me the paperwork from the Woodlands Hospital. It was confirmation that he had a nil sperm count. Normal service was resumed in the bedroom, much to James's delight.

It was a warm Friday evening, several months later, in early July 2015. James and I were meeting Karen and Ryan at a local Italian restaurant. We were going to enjoy a meal and then take in a bit of live music. Chester-le-Street is a lovely friendly place to live, and we often enjoyed a night out there. It was the closer option than travelling into nearby Durham.

The meal had been lovely: we'd all enjoyed three delicious courses and copious amounts of wine to accompany it. The lovely restaurant staff had very kindly given us a complimentary amaretto shot after the meal to accompany our coffee. We all had a lovely time.

The conversation had been entertaining. Once again James was keeping us all enthralled with his many stories about his work and his gang of eccentric workmates. There was always

some drama happening. I remember Ryan saying how dull it was working in IT in comparison, as the only tales he could regale us with over dinner would be about spreadsheets and servers and turning everything on and off again.

I had really enjoyed my meal – my favourite calamari to start and seafood linguine for main – but I had this strange feeling that something wasn't right. I couldn't understand why I was feeling so out of sorts, really uneasy. I was tired and my breasts felt sore, and I was also a little queasy. I knew it was ridiculous, but I was feeling how I did when I was pregnant. I scolded myself. "Don't be so daft! You've seen the nil sperm count."

I remember that James offered to pay the bill that night, generous as always, but Ryan insisted that he paid half. As we all thanked the restaurant staff and walked out into the cold evening air, I quickly bundled Karen to one side. "I need a word," I insisted urgently.

James and Ryan were walking someway ahead, about to cross the road to enter the Lambton Arms pub in time for the live music at 9 p.m.

"I think I might be pregnant," I whispered.

Karen snorted with laughter at my concerns. "I think you're looking for things to worry about! You've obviously just had a dodgy prawn in your linguine."

I laughed too. I knew Karen was right, and started to relax a little, but I still couldn't shake off the feeling of unease.

A few minutes later we were all seated in the pub, a good table not too close to the band but near enough that we could see and hear all the action. Ryan had brought over drinks from the bar: a pint of lager for himself and orange and soda water for James. Karen and I were sharing a bottle of white wine.

I looked at the bottle of Sauvignon Blanc as Ryan poured the

contents into two wine glasses, and again my feeling of unease returned. I blurted my fears out to the table.

Karen turned to James. "For goodness' sake, James, will you just pop to the little Tesco? Just put her mind at rest and get a pregnancy test. Then we can enjoy our evening out with no drama." James nodded and off he went.

Ten minutes later, as I sat in the pub toilet cubicle, the small room began to spin around me. I stared in disbelief at the two blue lines on the small windows on the test stick. How could this be possible? I don't know how long I sat staring at the test. It could have only been a couple of minutes, it could have been half an hour. I have no idea. Eventually, on shaky legs, I returned to the pub table. Everyone was laughing and in high spirits. I felt so disjointed from the scene. It felt surreal.

Without saying a word, I passed the test to Karen. I'll always remember the shock on her face. She laughed nervously and pulled my wine glass towards herself. "You won't be needing that." I really think in that moment she didn't know what else to say.

Everyone sitting at the table was in shock. James put a supportive arm around my shoulders. "The test can't be right," I whispered to him. However, the four more tests I completed that night all bore the same result. I was pregnant!

To say I was in shock would be a serious understatement. I barely slept a wink that night. The next morning James was getting ready for his shift. We hadn't really talked about things. I sat on the edge of the bed and stared out of the window. I couldn't get my head around it. How could I be pregnant? James would think I'd cheated. I have never cheated. Never could.

James was so lovely: he sat on the edge of the bed with me

and wrapped me in a loving embrace. "I know you'd never cheat, princess."

I remember thinking what an incredible man he was. He never doubted my fidelity for a single second. He knew beyond all doubt that I would never cheat on him. I wish at the time I'd questioned just how unrealistic this was. No matter how strong a relationship is, he would have had doubt. After all, the form recorded a nil sperm count. We'd both seen the paper. However, James never doubted me for a single second. Why would he? He alone knew there was no Mr Maddison, no appointment at the Woodlands Hospital. The medical report he'd shown me was fake. He knew the sperm count report was forged and that he'd never had the procedure at the Woodlands.

Later that day, James spoke to my mum, who was as shocked as the rest of us. Her hands flew to her face and a look of bewilderment was evident on her face. "Oh, my goodness," she said, "how is it possible? James had the snip."

"I know, Jennifer," James replied, giving my mum a hug. "It's our little miracle, a gift from God. I know now that our baby desperately wanted to come back."

Mum stared at him open-mouthed; she simply had no words.

It was all about control to James. We know that now. The countless unwarranted visits to my workplace were him marking his territory. His many Facebook profiles were to warn ex-boyfriends away. He was dripping poison behind the scenes to anyone who would listen. Trying to cause problems between Karen and Ryan. Openly he was Ryan's good mate, but I would discover that he was fabricating stories and creating situations to cause issues between them. He was also causing a rift between my girls and their dad. He clearly didn't want any other males in his carefully orchestrated world. It was clever

and insidious. That's why he got away with it for so long.

There were no limits to the depths this man would stoop. It was sick and twisted.

Chapter 10

Our growing family

I t's amazing how the human brain works. You can have an incredible shock, be in a world of disbelief, yet you must just find a way to get on with things. I guess that's the coping mechanism kicking in.

As soon as I saw those two blue lines on the pregnancy test, I knew there would be no termination. I couldn't put myself through that again. Plus, James's words about the baby being a 'gift from God' and having come back to us played heavily on my mind.

James was excited, my girls were excited, and in time I couldn't help but get swept up in it all. Their excitement was infectious.

I had to be realistic though: I'd had two difficult pregnancies and I was so much older now. My pregnancy with Katie had been 13 years earlier. I was no longer the young woman I was then. I worried about all the possible complications of a pregnancy in your 40s. Over time, though, I couldn't help getting excited too.

After I had passed the 12 weeks mark I tentatively began to tell everyone. There were a few shocked faces, but by and large

everyone was incredibly supportive.

I even received lovely baby gifts from Maureen: a beautiful outfit for a new-born in a neutral shade. His sister Jodie also sent a thoughtful gift. It was a care package containing bath goodies, chocolates and a pair of fluffy socks. I'd received lovely messages from Bronwyn: no gift from her but, as James joked, "bossy boots Bron" was a bit tight with her money!

James's daughters were now living in Texas. They were incredibly excited about getting a baby brother or sister. We received lovely messages and cards from them. I was so touched and proudly displayed them on my mantelpiece. I would sit smiling as James spoke at length to the girls on the phone. I heard McKenzie shout "Hi Coleen" on the end of the line, and I remember waving at James as if his daughter could actually see me. James was adamant that as soon as his girls could come back to the UK for a visit, we would all be together.

Now that I was pregnant, it was even more important for me to meet his family. Our families were going to merge, and I really wanted us all to be close. James said we could take a trip to Nice to stay with his mother and stepdad John. It was imperative that we make this trip soon, before my third trimester. James was busy on his computer securing the flight and making all necessary arrangements.

A few days later we received some shocking news. James was sitting on the edge of the bed in tears. I remember thinking it was a scene reminiscent of me from several weeks before, when I sat in the exact same position crying when I had discovered I was pregnant again.

I flew over to James's side. "What's happened, what's wrong?"

James looked up at me with such a raw look of grief on his face

that I remember it really frightened me. "It... it's Mum," he stuttered through deep sobs. "John's just phoned me, Mum's been diagnosed with breast cancer."

I embraced James, his sandy head resting on my shoulder, his tears dampening the sleeve of my shirt. I remember feeling so absolutely useless in that moment and not knowing what to say to make him feel better. James was devastated. I knew he wasn't the closest with his mother, but to see him in that moment, it was clear how much he truly loved her.

Maureen was understandably in a dark place. She was struggling with her diagnosis. She withdrew socially. I understood it was not the right time for a visit. James cancelled all the travel arrangements he had made.

Maureen did ask that when we went for our 20 weeks scan, she would love a recording of the baby's heartbeat. She told James this would make her feel connected to her grandchild. I thought this was a lovely sentiment.

Of course, Maureen had not been diagnosed with breast cancer. I know that now. I know so much now! Maureen was not sitting in her palatial home in the South of France. The real Maureen was actually sitting in her modest property near the town of Bishop Auckland, completely unaware that she had another grandchild on the way.

Who lies about cancer? It really is the lowest of the low. In our lives we have all been touched by cancer in some way. To lie about a cancer diagnosis to facilitate your deception is next level. Karen finds this part of our story the hardest. She has now been diagnosed with cancer twice and has dealt with the fear and misery of it: the Macmillan nurses, the surgeries, the ongoing treatment. It was a wicked lie to tell, but not the only time James would stoop so low.

Chapter 11

The lies

J ames was a very clever man. He invented a whole new world with me; a world that ran parallel alongside his actual life. He knew to keep some details similar, keep the names the same; less chance of tripping up and letting the cat out of the bag. He kept so many plates spinning, it must have been exhausting.

His mother was actually called Maureen. That was the only truth I knew about her. He had no ex-wife. He had a very present wife. He didn't have two daughters, he had three sons. He used his sons' names as his sister Bronwyn's sons. The happy pictures I saw of James smiling proudly with his three nephews I now know were happy family pictures with his sons. How could they have been Bronwyn's sons? He had no sisters – there was no Bronwyn.

I remember getting a telephone call from his sister Jodie once. James and I were shopping in Mothercare, looking at prams etc. As it was early days in the pregnancy, I didn't want to make any big purchases, worried that I would jinx things. It was a constant worry in the back of my mind about my age and the complications that being pregnant when older can bring.

Jodie had called me to reassure me and put my mind at ease.

I found the telephone call with Jodie really comforting. Being a doctor, she was so knowledgeable about the likelihood of me experiencing complications with my pregnancy. She talked me through all the tests I would be likely to have to rule out conditions such as Down's Syndrome and Edward's Syndrome. We talked for about twenty minutes, and when the call ended I felt a weight had been lifted from my shoulders.

"She was so lovely," I commented to James, who was busy looking through the racks of new-born baby clothes.

"Yeah, she's a good one is my sis. Told you she knew her stuff."

James had an incredible memory for details. I suppose you must when you have two lives running simultaneously. I do remember one time he almost slipped up but recovered his composure in the blink of an eye. We were at Lumley Castle, a medieval hotel, having Sunday lunch. James and I had taken Laura and Katie. They loved Lumley Castle: they thought it was cool and spooky.

We were all talking about the baby: what colour we would paint the nursery, the normal stuff you chat about when you're nearing the arrival of a little one.

"I simply can't wait for the little one to come," James announced through a mouthful of his roast dinner. "I thought I would only have my three kids, but to have another one coming is the best feeling."

I remember that Laura, Katie and I just stared at him in confusion. I shook my head, perplexed. "What do you mean, three children? You only have two."

James stopped eating and put down his knife and fork; with barely a second's hesitation, he answered. "Yes, yes, my two

daughters and the baby in the ground." He paused for a second, visibly distressed and tears began to well in his eyes. "You know about my two daughters, but you don't know there was another baby." He went on to explain how his ex-wife Jill had had a late stillborn birth. He told us he still found it traumatic at times to talk about, and that's why we didn't know. His grief seemed so genuine. I remember that Laura looked down at her dinner plate, not knowing what to say. Katie, who is a very sensitive soul, was openly crying.

My heart hurt for James. What a terrible thing for him and Jill to endure. I leant across the table and squeezed his hand to try and comfort him.

Now I realise that he had slipped up. Without thinking, he had talked about his true life and his three children – his three sons. What makes me shiver now is how quickly he could regain his composure. He didn't look the slightest bit unnerved. He just managed to cry instantly on cue and "kill off" one of his children without a second thought.

I remember then feeling such sympathy for him; now I feel none. I reserve my sympathy for his many, many victims.

Chapter 12

Fireworks and fears

It's easy to take things for granted. Life can pass at such an easy pace. It's easy to believe that it will always be like that. It's always calmest before the storm.

Life was good. I was still working 30 hours a week. I enjoyed shopping in Durham in my lunch hour with Karen. We would coo over the tiny Baby-Gros and plush toys. As my tummy grew, so did my excitement. Karen was excited too. It had been such a long time since our family had welcomed a baby, you couldn't help but feel the thrill of anticipation of a little one who would soon be here.

Laura and Katie were so sweet. They made me cups of tea without being asked, and even did the washing up, which would previously have been unheard of! They used their pocket money to buy little gifts for the baby: just little things, a rattle or some teething rings. They were the little things that meant so much.

James was incredibly excited. He really was the doting dad-to-be. He was still working hard, doing regular shifts at the training centre.

He loved to spoil me – mostly with edible treats. There would

always be a large supply of my favourite chocolate bars – and he would encourage me to indulge. "I'm putting on too much weight," I would complain as I scoffed down yet another Twix bar. "I'm eating for two, not twenty." He would just laugh and tell me I was beautiful.

He often brought home Tupperware containers of home-made brownies from his work. They were delicious. A little old lady would come to his workplace selling them, he said. Her husband had died of cancer, and she was trying to raise money for Cancer Research. James felt so sorry for her. He was so generous, he would buy everything she baked, even giving her requests for my favourite flavours.

Of course, there was no grieving widow at his workplace. He had no workplace. The delicious baked goods were actually being made by his wife. She had been making them as a kindly gesture – not a kindly gesture to me, of course. James had told her that the wife of one of his friends had been diagnosed with cancer so she was trying to cheer her up.

I was approaching 20 weeks pregnant and tentatively looking forward to my scan, which would tell us the sex of the baby. I was convinced I was having another girl because I already had two girls, plus the fact that James had two daughters; so I thought another daughter was pretty much a given.

The day of the scan arrived, and James, Laura and I turned up to the appointment. I remember walking into the little examination room with a feeling of trepidation. I think it's the same with all mums to be, you know everything is probably OK, but until you have confirmation you can't help but worry a little.

I was lying on the examination table as the sonographer moved the probe across my tummy. "Any preferences on

whether you want a boy or a girl?" she enquired, concentrating on the screen in front of her.

I smiled at her nervously. "Obviously the most important thing is for the baby to be healthy, but I can't lie: a little boy would be lovely."

As James and I both have girls, it would be icing on the cake to have a little boy, I thought. Laura and Katie had always been extremely vocal that they would love to have a baby brother too.

The sonographer turned the screen around so we could see. "Best start painting the nursery blue then," she commented with a large smile.

I was absolutely over the moon. Laura was too. James kissed me on the forehead and said. "That's amazing, sweetheart." It was a tender moment. However, looking back now, for the normally exuberant James, his reaction was rather tepid. I thought he would have been punching the air and whooping with glee.

Now I realise that he really wished for a girl: he already had three sons, so he and his wife had always dreamt of a little girl. They even had their favourite names picked out. You've guessed it! Maddison and McKenzie.

We went out for a family meal that evening to celebrate. Life felt good, and we had much to look forward to.

A month passed by uneventfully. I was now wearing maternity clothes as my fitted work wardrobe became too tight. It was nice to feel more comfortable, and I still liked to apply my make-up and keep my hair nice. I was feeling good.

It was Bonfire Night 2015: a typical Thursday morning, and I was up early to get ready for work. I'd just showered and dried myself off and was starting to choose my outfit for the day.

Something felt wrong. I felt a strange sensation of something trickling down my inside leg. I sat on the toilet and that's when I saw the blood.

I was panicking and terrified. I was in the house on my own. Pure panic set in. James was at work. The girls were at their dad's. With my hands shaking and tears running down my face, I rang James. No answer. I left messages telling him I was going to hospital. No answer. I don't know how many missed calls or frantic messages I left on his voicemail. I know there were many. Whether he read them and listened to them or not I'll never know. What I do know is that he didn't turn up to the hospital for hours – many, many hours.

Luckily my mum answered her phone when I called. "I'll be over in a minute," she said. "Just let me get my coat on and grab my keys." I could always rely on Mum. We travelled together to the hospital. Mum comforted me and reassured me that everything would be all right. I was scared, as scared as I can ever remember being.

When we got to the hospital, I was whisked into a side room of the antenatal ward. A doctor and nurse came to examine me. I always remember that after the doctor examined me, a look passed between the doctor and nurse. I knew it wasn't going to be good news. I was told my waters had broken at 23 weeks 5 days pregnant.

I was visited by Jane from the Neonatal Department Support Unit. She was so lovely and kind, a pleasant looking woman in her early fifties with a kind smile. Mainly, I just remember feeling terrified. As my waters had broken, the likelihood was that I would go into full labour within the next 12 hours and deliver the baby. They talked me through the likely scenarios I could face. Jane cleared her throat and began speaking in a

soft, clear voice, pausing every few seconds so that the gravity of what she was saying could sink in.

"There are three ways this is likely going to go," she explained, sitting on the side of my bed so we could make eye contact. "As your waters have broken, Coleen, it's likely you'll go into labour. I'm so sorry, but because the pregnancy is so early, the baby would be born dead." Jane stopped speaking for a few moments to let her words sink in.

"Please God, no." I remember saying, feeling such grief rush through me, like a fire burning my entire body. I picked at a thread on the thin blanket covering my legs, willing myself not to cry.

Jane continued, "If your baby is just alive when you deliver, he'll be wrapped in a blanket and given to you, Coleen. You would then be able to hold your baby until he passes away."

I remember staring at her in shock, barely comprehending what she was saying. Jane explained that before 24 weeks, a baby is not legally classed as viable, so they wouldn't try to save his life. However, Jane went on to explain that although this was the law, there was a glimmer of hope. If my little boy was born under the legal viable timeline but showed determination and strength, they would make an exception and try to save him. However, it would be unlikely that he would survive. If he did, in all probability he would have serious developmental issues.

I was utterly petrified. Jane asked if I'd understood everything she'd told me. I nodded at her, unable to speak. I was so scared at what was to come. Jane squeezed my hand kindly and left the hospital room. I was alone again.

It was hours since I'd left the voicemails and messages for James. He still had not arrived. Where was he? What

could be more important than being by my side? I was alone in unfamiliar surroundings, scared to move; scared even to breathe; terrified that my labour would start at any second.

I knew that if I could hold on for another two days and get to the 24-week threshold, then the baby would be classed as viable. Then every effort would be made to save his life if I did go into labour. I stared at the clock above the door, willing the hands to move faster. It felt like time had stopped. I don't think I have ever felt more alone. My mum was still there for me. She was wonderful, but I just wanted my James by my side.

Several hours later, James finally arrived, full of apologies. He swept into my hospital room wearing his firefighter gear. He looked anxious, a film of sweat covering his pale face, his tired eyes webbed with crows' feet under the harsh hospital lighting.

"Forgive me, princess," he implored. "I've only just got all your messages." He took my hand. "It's been the most horrendous shift. You know what Bonfire Night is like? Everyone behaves like an idiot."

Where had he been? He certainly hadn't been having a horrendous shift as a firefighter! Had he been shopping with his wife and sons? Seeing yet another woman? I know now for a fact he wasn't working a shift. He chose at that moment not to be with me. Did he not care whether his son lived or died?

I don't think that a day passes that I don't think about my dad. It had been some four years since Dad had died of cancer. We missed him so much as a family. Growing up, he had always seemed to be such a strong bear of a man, and Karen and I had loved him so much, always vying to get his attention. He had gone to heaven far too soon, aged 65. However, that night as I lay in that narrow hospital bed fearing the worst, I truly believe

that Dad was looking down on me. I had the strongest feeling he was there. Whatever it was that night, Dad protecting his grandson or just plain good luck, I defied the odds. I didn't go into labour that night.

I didn't go into labour the following two days either. On midnight of the Saturday night, the lovely young nurse on duty came and gave me the biggest hug. "You've made it!" she said, beaming. "You're at 24 weeks now."

I knew then that my little boy was a fighter: he may have not been planned, I may have had my doubts, but one thing I knew with complete certainly as I lay on that hospital bed was that I desperately wanted this little boy with all my heart. I couldn't have loved him more.

I was in hospital for a week in total, then discharged under strict instructions. Total bed rest and weekly swabs, blood tests and scans. It was the medical opinion that my waters had not fully broken, as first thought, and I had instead suffered a leak. I had to be very careful with the remainder of the pregnancy, to ensure that the waters did not break completely too early.

It made sense that James should move in with me, as I needed to be looked after. He was still, as I thought at the time, living in accommodation at work. He could surely take fewer shifts and be there to support me. Didn't it make perfect sense?

But while it made perfect sense to me and would make things so much easier for me, for James the opposite would be true. His double life was well and truly in jeopardy.

It was time for him to make a decision. Something had to change. The last night I was in hospital, James left early. He kissed me on the forehead and said that he wanted to go home and tidy the house ready for my return. I was fine with this. I was really exhausted and eager to get home; I knew we would

have all the time in the world in our home together.

In truth he didn't go home to clean the house. He had something far more important to do. He went back to the home he shared with his wife. That night he left his wife a letter in the kitchen informing her that he was leaving. He had met another woman and was having a baby with her. I can only imagine his wife's devastation. Until she received that letter, she had no knowledge whatsoever of my existence. Much later, she confided in me that when she found the letter and realised he had left, she rang him and begged him to return. She told him she needed to talk. So, he came back and they spent the night together.

This was one of the longest nights of my life, another night when I counted down the hours till dawn broke, petrified and alone, while James was in bed with his wife.

Chapter 13

The Downton days

When I tell people my story, I always refer to the following months as The Downton days: the long days I spent on the sofa watching box sets, typically Downton Abbey or Breaking Bad, two excellent series that I can no longer bear to watch. We also watched countless episodes of Don't Tell the Bride. I loved a bit of reality TV: pure escapism. James used to say that I would make a beautiful bride; I laughed and said we had enough excitement in our lives without adding anymore! They were actually happy days: somewhat boring at times, but it was imperative that I took it easy.

James was incredibly attentive, barely leaving my side. He would take the odd shift, but like he said, "I was his priority." I felt safe and protected.

James had moved his clothes into my wardrobe. It felt strange to have men's clothes hanging in the wardrobe again: strange but good.

Once again sex was off the menu. James was very understanding. We would hug, kiss and cuddle in bed, but that was as intimate as it got.

I remember feeling that this period must be difficult for James. He had a high sex drive, and suddenly having no action at all in the bedroom must have been frustrating to him.

That couldn't have been further from the truth. On the occasions that James was still doing the occasional shift, he was actually with his wife. Their intimate relationship continued. I don't understand why his wife still wanted him after he confessed he'd been seeing another woman and had got her pregnant; but want him she did. I can only imagine the tale he spun to her to convince her to keep seeing him while he was living with me.

His wife now knew about me. I still knew nothing of her. It would be well over a year before I would learn of her existence, their children and their whole other life.

I'd had to leave work now, and I wasn't seeing so much of Karen as she was having to pick up the slack in the office. However, when Karen did get a chance to pop around to the house for a coffee, James would take the opportunity to leave for a bit. "Don't want to interrupt the girl talk," he would say with a wink. He liked to catch up with his ex-colleagues at White Watch, he said, as he missed the banter between the guys. I know now these were the times he was with his wife.

Meanwhile the weekly hospital visits were going well: everything was positive and I was feeling incredibly lucky. At a week before Christmas, I was now 31 weeks pregnant. I've always found being pregnant at Christmas a magical time. Obviously not being able to have a tipple of Baileys was a pain, but that was a small price to pay. The house was beautifully decorated, the tree looking amazing. I still liked to display the decorations that Laura and Katie had made many years before, much to their embarrassment.

Laura and Katie were due to spend Christmas Day with their dad. Karen and Ryan were going to spend the big day with James and me, as were mum and Yvonne. I was excited, being allowed to go to the local pub for Christmas lunch. I felt as if I'd been under house arrest for the last few weeks: I was sick to death of my sofa and staring at the same four walls; a slice of dry turkey and Christmas pudding at the local sounded like heaven. It would be lovely to see other people too.

James could barely contain his excitement. His girls were coming back to the UK for Christmas to visit the family. He was a whirl of wrapping paper and bows as he wrapped their many presents. He liked to wrap their gifts in silver and neutral colours, as he told me his girls were at an age when they didn't like anything too girly! I'm sure his boys didn't either, and now I know those presents were for them, it makes complete sense.

James had arranged for me to meet Maddison and McKenzie on 27 December. We were going to meet at our local shopping centre and have lunch. Again, I was excited at the prospect of another day away from the sofa. More than that, I was incredibly excited to meet the girls. I was confident that this meeting would go ahead. The girls were apparently excited about the pregnancy, and James assured me that his ex-wife Jill was happy for us all to meet. James was hopeful that the girls would even be able to spend some nights at our house in the future. Over the previous months he had even enlisted a builder to convert the integral garage into a spare bedroom for his daughters, costing him several thousand pounds. He was keen that they should have their own space and a room that they could feel was a "home from home". He decorated and furnished the room in shades of purple as this was Kenzie's

favourite colour. The new twin beds were made up with matching bed linen and a cute soft toy on top of each that he thought would make his girls smile. It was turning out to be a very good Christmas.

There was still another surprise that I didn't see coming.

Chapter 14

Hard to say no

I s it love, or is it control? I now realise that what can first appear as wonderful romantic gestures can actually be much more sinister.

It was Christmas Eve, and we were having a lovely family evening. The chocolates were being passed around and the Christmas songs were playing. Laura and Katie were sitting on the floor playing a board game, which I thought a bit odd, as my girls were not really into those types of games. But they were giggling a lot and sending furtive looks at James.

"What's going on now?" I thought.

"Col, doesn't that decoration on the tree look odd?" James asked me through a wide grin. I glanced at the tree, which looked perfect.

"Go and have a closer look," he insisted.

Sighing, I heaved my pregnant body off the sofa and waddled over to the tree. There appeared to be a small black book poking out of the branches halfway up. I gingerly pulled it out, avoiding displacing the sparkly tinsel and colourful baubles. It was a small black diary for the following year. Written on the cover was 'Coleen Scott's Wedding Diary'.

Laura and Katie were thrilled by my discovery. "We've been dying to tell you, Mum!" Katie said, all smiles. "James has organised everything! You're getting married next year. How exciting is that?" Exciting was one way of putting it. Blindsided might have been a more apt choice of word, in retrospect.

Katie wasn't kidding. He really had organised everything. As I thumbed through the diary, everything was booked in: the cake tasting, the florist, meeting the wedding planner; the dress fitting was also booked in, as was the date of our wedding, written in as 12 p.m. at Wynyard Hall. Next to the date and venue were the words "Marry Me?"

In stunned amazement, I slowly made my way back to the sofa and lowered myself on to it, the black diary grasped tightly in my hand. What was James thinking? Yes, I enjoyed watching Don't Tell the Bride, but it certainly didn't mean that I wanted to live my life like an episode of it.

Here I was, heavily pregnant, looking at 'my wedding' arranged in minute detail. James was grinning like a Cheshire cat. "It's all sorted," he announced proudly, "my princess doesn't have to do a thing." He went on to tell me that he had already been to see my mum to ask her permission. My girls had known for weeks and had helped him with the arrangements. Karen and Ryan also knew. My girls were happy; his girls were happy. No doubt his wife only twenty miles away would not be so happy; but then again, she wouldn't know.

The whole wedding was arranged. It was a fait accompli. Some may say this was incredibly romantic. Others may argue it was controlling and coercive. All I know is that I had made it clear to James months before that I wasn't looking to get

married. Yet I appeared to be engaged. James pulled a little jewellery box from his jeans pocket and slid an impressive diamond platinum ring onto my finger. All without me actually uttering a single word.

Maybe I should have put my foot down at this point; said it was too soon and I needed more time. I should have cared less about upsetting James and letting people down and cared more about what I actually wanted – but I didn't.

I agreed, and as I gazed at the ring on my finger, I resolved to make the best of the situation. As I gently rubbed my expanding tummy, I pondered on things. I mean, we were having a baby together after all. We loved each other. Wasn't getting married the next natural step, to cement the foundations of our relationship?

James said he told all his family the news and that they were of course all absolutely over the moon for us. The congratulatory texts came in abundance as did the engagement gifts arriving daily in the post.

"Just wait until you meet my girls in the next couple of days," James enthused, glancing at the ring on my finger. "You'll be able to show that rock off." The words that tumbled out of his mouth proved to be just as fake as the gaudy ring twinkling on my finger in the Christmas lights.

What was the need for the big elaborate proposal? Why did James do it? By now we all knew he loved to play the showman with the big gestures, holding court and being the biggest personality in any room. Even though this at times felt overbearing, we all loved him for it. You really felt you could rely on James.

It makes no sense now. He knew there would not, could not be any wedding the following December. So what was

his game? Why do any of this? Why take me for a wedding cake tasting, choosing our favourite flavours for the five-tier cake? The bakery, 'Mrs Boucake' in Chester-le-Street, went out of their way to source a fireman cake topper and a ladder leaning up the side of the cake, at James's insistence. Our colour scheme was to be red and white to fit the feel of the festive season; also red and white was the colour of his football team, Sunderland AFC. Then he wanted a little orange on the cake, to depict flames in keeping with the fireman theme.

James left a hefty deposit and detailed instructions for delivering the cake to Wynyard Hall where we were to be wed. The florist was decided on and the flowers selected – red and white roses. No expense was spared, and James was by now paying out money hand over fist. He must have done so knowing he might as well burn his money in the street, as this wedding could never happen. But no, he splashed out again and again, getting bigger and bolder and more elaborate as time went on. He was enjoying the role he was playing, but it certainly wasn't coming cheap!

I did make my own suggestions for the wedding: little things I thought would inject some of my personality into the big day. I've always been a traditional sort of person and like the more classic style of things. James would smile at me indulgently but say that maybe my taste was a little 'old-fashioned'. I did want to put my own stamp on my wedding, but James insisted that he could manage. I was to relax and leave everything to him; after all, the hospital had told me to take it easy, and I couldn't risk putting our baby's health in danger. Hearing this, I immediately agreed that he should take full control of the arrangements. He was right that if anything should happen to our baby, I would never forgive myself. I couldn't take the risk.

James totally immersed himself in his Don't Tell the Bride pantomime act: even deciding to bring a wedding planner on board to ensure all the plans and preparations for the big day would go without a hitch. "Don't worry, princess," he told me, "come and meet the wedding planner once, and then the strain will be off your shoulders. I'll sort everything with her. You just concentrate on keeping healthy, and you'll be busy enough when Junior arrives."

James's enthusiasm could be exhausting, but with my head full of worries of keeping my baby safe and well, I resigned myself to just letting him get on with it. So once again, like many times before, I just nodded in agreement. That's not to say that at times I felt regret at not having more input into the wedding arrangements. It should be such an exciting time for a bride, but James was like a force of nature that couldn't be stopped. Once he had made his mind up, that was that.

Dates from Coleen Scott's wedding diary from James:

Saturday, 21st May 2016 at 11am – Dress fitting, Poppy Bride, Darlington.

Saturday, 11th June 2016 at 10am – Wedding Planner (Donna) at Ramside Hall.

Monday, 12th September 2016 at 6.30pm – Wynyard Hall.

Friday, 23rd September 2016 – Wedding (update).

Monday, 3rd October 2016 –Dress fitting.

Saturday, 26th November 2016 – Balance for wedding cake due.

Friday, 16th December 2016 – Wynyard Hall room booked for overnight.

Saturday, 17th December 2016 – at 12:00pm – Marry me??

Monday, 19th December 2016 – Honeymoon!! Fly NCL – Heathrow 02:30/ Heathrow – Vegas 10:40 (3 nights MGM Sig-

nature – Las Vegas)

Chapter 15

Donna who?

I only met the wedding planner, the so-called Donna, once. I've wracked my brain over and over to remember the surname that I was given for her, but to no avail. Maybe it was my baby brain at the time, but all I can remember is the name Donna.

Meeting Donna was all I had to do, everything else was being sorted by James. He and I arranged to meet her at Ramside Hall. I was a little nervous as it all seemed so real, but James was his normal exuberant self. "Just wait till you meet Donna, she's a great girl," he said. "She'll make sure you have the wedding of your dreams. Nothing will be too much trouble for Donna."

Ramside Hall is a hotel, spa and golf club on the outskirts of Durham city centre. It is luxurious, with beautiful grounds and breath-taking views. The golf club is extremely well regarded by its clientele, and James was a keen golfer who often availed himself of the facilities. It was a perfect venue to meet a wedding planner. Even though it wasn't James's choice for our wedding, Ramside Hall is a very popular wedding venue itself. The bar where we met Donna had a nice convivial feel

yet was private enough to discuss all the intricacies of wedding planning.

James and I arrived at Ramside Hall a good twenty minutes before we were due to meet Donna. I had dressed smartly for the occasion in my maternity blouse and jeans and my most forgiving winter coat. James was smart in tailored shirt and skinny jeans. He looked pretty good overall. I remember thinking to myself, rather critically, that I wished he would ditch the skinny jeans: they only really suited young boy band members, and made his thin legs look disproportionate and skinny next to his burgeoning gut hanging over the waistband. That's what too many rich calorific meals were doing. I made a mental note that once our baby was here, we were both going on a diet. I never did get James to ditch the skinny jeans, but at least his plethora of hats had been relegated to the depths of the wardrobe.

James and I were sipping on our drinks: a herbal tea for me and the obligatory filter coffee for James, when I noticed a thirty-something lady with dark shoulder-length hair looking anxiously around.

"There she is," James said, striding towards her purposefully. He gave her a swift hug and quickly introduced her to me. "Coleen, meet Donna," he announced.

I smiled broadly at Donna and shook her extended hand. "So pleased to meet you," I said. "James has told me so much about you."

"An absolute pleasure to meet you, Coleen." Donna returned my smile. "I feel like I know you already from all James has told me, and I'm confident I'm going to give you the wedding of your dreams." Donna was extremely well dressed and had a confident, professional manner about her.

James busied himself gaining the attention of a nearby waiter with the click of his fingers. He proceeded to order Donna a coffee and another for himself.

We must have talked for at least an hour, and Donna was extremely chatty and informative. She laid out a large leather binder on the table in front of us. It was a portfolio with detailed wedding information and photographs. Donna and James claimed to have known each other for many years, and it certainly seemed the case. They had that open easiness that friends often do; they even had their own banter with each other, almost like family.

When talk turned to money, James secretively wrote a figure on a slip of paper and pushed it across the table to Donna. It was a rather thrilling moment, rather like a scene from a film. James would never discuss money: to him that was crass and not the done thing. He also quoted his mother: "If you need to ask how much, you definitely can't afford it."

Donna picked up the proffered paper, and after glancing at the figure declared that it was more than enough to cover James's vision. I don't know what was written there. Maybe nothing; maybe an inside joke at my expense. I will never know.

The truth is that the Donna who claimed to work for Wynyard Hall as a wedding and events planner simply did not exist. How did she know James? I would love to know who this woman actually was. Later, the police could not shine any light on the matter. No one knew who the mysterious Donna was. Wynyard Hall had definitely never heard of her either. Was she an old friend pretending to know James Scott? Was she an actor he employed to play a part in his twisted charade?

Chapter 16

Mankini and mince pies

As I embraced my second Christmas with James, this one as his fiancée, I did feel content. Yes, I had some reservations about the speed and direction that my life had so quickly taken, but I did not think of this as control. My friends told me how lucky I was, that he was the absolute dream guy. "Come on, Coleen," friends would say, "he would give you the world to make you happy. You don't realise how lucky you are." I lost count of the number of times I heard this.

Everyone was happy: my family, his family, our friends. Our little baby was growing safe and well and approaching his due date. I was meeting Maddison and McKenzie in a couple of days, and I would be lying if I said I wasn't happy and excited. I felt the future looked bright.

Christmas Day 2015 arrived, and we had a lovely day. I missed my girls, as this year it was their dad's turn to have them for the day. We still exchanged our gifts in the morning before they left, with much joy, hugs and laughter. They were returning on Boxing Day to have a get-together at my house, and we were all really looking forward to it.

Despite being almost the size of a small country at this stage,

I dressed up to the nines (well maybe just the fives) and got ready to enjoy a lovely festive lunch out. It was at my favourite local pub, the Whitehills, and we were due to meet Karen, Ryan, Yvonne and Mum there at midday. Even though it wasn't far to walk, because of my condition James drove. Anyway, James did not drink alcohol often, liking to keep a clear head. Orange and soda water was his drink of choice; plus he was shooting off soon after lunch to go to his ex-mother-in- law's to meet up with his girls for present-giving in the afternoon. Jill had agreed to this, and James intended to spend as much time with his daughters as he could while they were in the UK.

He was bubbling over with excitement: talking non-stop about his girls, telling tales at the dinner table about when they were little, forever playing the doting dad. We let James monopolise the conversation, as it was nice to see him so happy. Who would begrudge him, when his beloved daughters were usually so far away?

Even before we had finished our Christmas pudding, James was hastily kissing me on the cheek. "I love you, princess," he declared before bounding out the door. I laughed as I waved him off, safe in the knowledge that he would be full of tales of his afternoon when he met up with us later for Christmas evening at Karen and Ryan's house.

I spent the next few hours peacefully with my family, enjoy-ing the festive cheer. When James did return, he was bearing gifts from his girls that they had generously bought for Laura and Katie: Hershey bars and Twinkies for them to try. They really wanted to see if my girls loved American chocolate as much as British. Although Kenzie and Maddison were missing many home comforts from England, for example Cadburys chocolate and pease pudding on their ham sandwiches (a local

dish from the north-east of England made with split yellow peas), they were really enjoying their new life in the States.

James relayed stories of their new schools and school chums, and how much Kenzie had got into horse riding – and Texas was certainly the place to do it. She even had her own little pink cowgirl hat. He missed them desperately when they were away, but it warmed his heart how well they were settling into their new life. Even Jill hadn't been as antagonistic as usual, and was still happy for me to meet his girls a few days later. It was a good day for all.

The following morning dawned, the annual family Boxing Day get-together at my house. Mum and Yvonne helped me put on a small buffet, Mum placing her home-made trifle in the middle of the dining table with pride. I can remember that when I was a little girl, Mum's strawberry trifle always made an appearance on high days and holidays. In Mum's words, "It's no party until the trifle arrives." We were all anticipating a fun family day: plenty of sausage rolls, turkey sandwiches, the obligatory trifle, plus fun and laughter as is the norm for so many families across the country during the festive period.

We watched television, played board games and just had a really splendid time. A good few drinks were enjoyed by Karen, Ryan, Mum and Yvonne amidst plenty of laughing and merriment. We have a family tradition of exchanging a novelty gift, an inexpensive, humorous present rather like a secret Santa. Karen got a pink bell to ring whenever she required a Prosecco, and Laura received a stick-on temporary tattoo eyeliner, as we joked she was going through her goth stage.

During the afternoon James disappeared upstairs to put on his 'gift' and reappeared with a flourish. He was dancing around the living room sporting his novelty gift, a lime green

mankini that Karen and Ryan had bought for him. It was very brief and was styled after the Ali G character, Borat. Much hilarity ensued.

"Would you look at that!" Ryan was howling with laughter. "It's the last turkey left in Sainsburys!"

No one wanted to be mean, but as James pranced around the living room, he did look pretty absurd: skinny and plucked like a turkey, because James always shaved off his body hair. He said this was due to his job: that the heat and the heavy gear would cause rashes and itching if he had body hair. He really did like to immerse himself fully in his firefighter character.

But James was not happy. He loved being the centre of attention, but only to be adored, not to be mocked. Without any more hesitation he flew up the stairs to get changed. However, the laughing in the lounge continued; seeing James's pale hairless paunchy body resplendent in the lime green get-up had made everyone else's afternoon.

To add insult to injury for poor James, later in the afternoon Ryan drunkenly appeared in the lime-green mankini. Let's just say that at 6 foot 4 and a former rugby player, he filled the outfit somewhat better. There were whoops and cheers from everyone, especially the older ladies in the group, as he posed like a bodybuilder in the garish ensemble. James was extremely quiet and reserved for once. He was the butt of the joke, and it certainly didn't sit well with him. I kept checking and asking if he was OK, but he insisted he was fine.

It felt like the atmosphere in the room had become rather stale. Half an hour passed, and with the mood already sombre, James received a call which was witnessed by everyone in the room. It was the care home where James's maternal grandmother was living. There was terrible news: she had

suffered a stroke. He had to go, so once again everyone's attention was back on James.

After he had left, the atmosphere in the room remained bleak. Karen and Ryan made their excuses to leave. Karen wrapped me in a huge hug. "You know where we are if you or James need us. Just look after each other and our nephew." I hugged her back, and they made their way out into the frosty December evening.

Mum and Yvonne busied themselves helping me to tidy away the buffet. Mum sighed as she looked at her barely touched trifle: it was normally demolished within minutes, and the dish barely ever needed washing it was so well scraped. However, this time she covered the cream and custard confection with cling film, commenting, "Blimey! James's family don't have much luck, do they? They're dropping like flies." She shook her head and laughed. "You had better hurry up and meet them before one of them pops their clogs."

I smiled and tutted at Mum but couldn't help agreeing with her.

Chapter 17

Families and lies

J ames's mother Maureen was still being distant and withdrawn, he told me. She was trying to come to terms with the reality of her breast cancer diagnosis and the physical changes she was experiencing. Before the mankini drama on Boxing Day and James having to rush off to be at the bedside of his ailing grandmother, he had relayed a story to us all. His mum had told him, I'm assuming in confidence, that she had opted for breast augmentation following her double mastectomy. She was having a lot of difficulties accepting her new body. "Mum feels so self-conscious," James divulged. "She catches John looking at her differently now, like he's leering at her pert new boobs, and it makes her feel objectified. She just wants to be on her own with her own thoughts most of the time."

You could have heard a pin drop after James made this revelation to a room full of people. People that had not even had the pleasure of meeting Maureen now had intimate details of her relationship with her husband. What an odd thing to tell your son, and even weirder for your son to enthusiastically relay the story to other people. We all felt

incredibly uncomfortable, and once we had told James how sorry we were and to send her our best wishes, the topic of conversation was hastily changed.

Now that I know that Maureen never had breast cancer, I find the conversation that James chose to fabricate to be so distasteful and rather odd. The lie itself that she had cancer was unforgivable, but to go even further to embellish the lie like this in such a disrespectful manner felt callous and really showed his aptitude and capability to lie.

James returned from seeing his poorly grandma later that night. "She's stable, thank God," he announced, flopping onto the sofa with a deep sigh. "She's a tough old bird, that one. I can't wait until she's on the mend and can meet you, Col. She's going to love you." I too sighed: yet another relative I would have to bide my time to meet.

The following morning James bounded out of bed at the crack of dawn, full of the joys. It was finally the day when I would get to meet his daughters. I too was excited, but also a little nervous. Would they like me? I hoped they would. It was so important for me for us all to be a big happy family.

I chose my outfit carefully. James was busying himself filling the kettle to make yet another cup of coffee when his phone began to ring. The annoying rap music he had downloaded as his preferred ringtone blasted around the kitchen.

Maddison was on the phone, and I could tell from James's facial expression and the edge to his voice that it was not good news. He was quite clearly upset and agitated, but desperately trying to calm his daughter down. From what I could hear, I felt an intense feeling of foreboding. Surely to God there couldn't be another issue, could there? I was ready and excited to meet them. The gifts I had bought for them – make-up for

Maddison and a soft toy bear for McKenzie, neatly wrapped in penguin-adorned Christmas wrapping paper – were sitting on the chair next to me.

"OK, sweetheart, I'll speak to you later," James said in a voice so heavy with emotion and regret that it touched my heart. He threw his mobile phone onto the table, sank into the leather kitchen chair next to me and reached for my hand, tears welling in his eyes and slowly running rivers down his cheeks. "They're not coming," he sobbed. "My bitch of an ex-wife is playing her tricks again."

I sat silently, full of anger and disappointment, but encouraging him to tell me exactly what had happened.

"Can you believe it?" he fumed. "Maddison was ringing me from her bloody wardrobe."

She'd got into a fight with her mum, the way mothers and teenagers often do. I can't remember knowing who started the fight, just it was something trivial, clothes strewn on her bedroom floor or something similar. Jill had grounded her, forbidden her and Kenzie from seeing her "dad's new fancy woman" and confiscated Maddie's phone. Maddie had sneakily retrieved her mobile phone from Jill's handbag and phoned her dad while hidden in her wardrobe, whispering and sobbing as she told him what happened.

James was devastated, calling his ex-wife the worst names you can imagine, but sorrowful as his girls had been so looking forward to meeting me. I sighed once again, as I often did, and found myself comforting James. What else could I do? I was so disappointed and deflated, but it wasn't James's fault. It didn't feel fair to pile any more stress on him and vent the bubbling anger that I felt. He was at breaking point already. It was Jill who was the callous one. How could she be so vile? What was

her problem with me?

"It is what it is," I told James, rubbing his arm. "She's the one who holds the cards. You're not to blame."

It was just going to be the two of us yet again for the day. I'd have to wait patiently until the time was right to meet James's daughters. It wasn't ideal, but it couldn't be helped.

Chapter 18

The James Scott Show

The last few days of December sped by as they often do. With normal workdays being disrupted and the bank holidays, it's easy to get confused by which day is which. Each one flowed into the next, with too much rich food and never-ending repeats on the television.

I enjoyed this last Christmas, knowing that the following one would be so very different. There would be no long, lazy lie-ins with a little one to contend with, and much more noise and mess to deal with, but more happiness too. I smiled to myself: I really couldn't wait.

January came uneventfully, a particularly cold and icy start to 2016. James treated me like fine bone china as he helped me in and out of the car. I was still attending my twice-weekly blood tests religiously, plus swabs and scans at the hospital, and thankfully Junior seemed to be doing well.

My consultant thought that the safest option for my labour would be to be induced at 36 weeks, as there was still a high risk of infection. Therefore, on 31 January 2016, hand in hand, James and I walked into the University Hospital of North Durham, me clutching my hospital bag. Every step I took

brought an increased feeling of excitement and anticipation.

We made our way through the winding corridors to the maternity ward, where a lovely young nurse led me to my bed in a bay of six other women. She busied herself checking there was water for me and my notes were hanging on the end of my bed. She bid me goodbye and left me for a while to get settled, saying she would return shortly to take all my observations and have a chat about what was to come.

James as always acted the biggest personality in the room. Enthusiastically introducing himself to all the other expectant women on my ward, he regaled them with tales from the hero firefighter, whether they wanted to hear them or not. I had to go to the toilet every five minutes, with Junior tap dancing on my bladder, and as I headed back to my bed there was James sitting at the Nurses' Station, laughing and joking without a care in the world, the staff clearly enjoying his tales and lapping up his many lies.

A few hours passed slowly, until it was time for the nurse to start inducing my labour. This involves gel being used to open the cervix in the hope of starting contractions. It is not a pleasant process, but needs must. The nurse was lovely and tried her best to keep me calm.

James took this opportunity to leave. He gave me a kiss on the cheek: "Be brave, my love; it will all be worth it when our little boy is here." He was already heading out of the door, speaking as he went. "I'll give you some space, check in on everyone and give them an update." His car keys were dangling from his index finger.

Alone that afternoon in that hospital bed, I was again scared. Everything was becoming so real. I just prayed that my little boy would be born safe and well and I would be in labour soon.

Unfortunately, that was not to be. Three times over the next two days the nurses tried to induce me, again with the gel. The second attempt was on the first evening: James was there for the procedure, but had to leave once visiting hours ended. I started to contract strongly and was in a lot of pain, but my cervix would not dilate. It was an extremely long night. I couldn't sleep and sat up in pain, trying to distract myself with the film Meet Joe Black on the small patient TV screen above my bed. Normally Brad Pitt would lift my spirits, but not that night.

When the morning finally arrived, the contractions had thankfully eased off, but I was extremely pale and feeling exhausted.

When James bounded onto the ward once visiting had started, he was in great spirits: full of energy and enthusiasm, and talking ten to the dozen to everyone and anyone he could. It was draining just to watch James in full flow. That afternoon it was time to try and induce me again. Within what seemed like no time at all, I was feeling severe pain. James was happily sitting on the end of my bed giving all the ladies in the ward an episode of the James Scott Show. He was clearly completely oblivious to the pain and distress I was in. I just couldn't stand another moment of him.

In my distressed state I called for one of the nurses. "I'm so sorry," I apologised with a moan, "I'm in such pain I just can't cope." I was holding my tummy protectively. Her gaze darted from me to James and back again, and her lips set in a pursed line. She promptly closed the curtain around my bed. "There you go, my love," she said, "just try and relax a little and I'll be back in a min to examine you again."

James's head popped through the curtain, aware that by

shutting the curtain the nurse was also cutting his chattering short. "Everything OK, Col?" He scurried over to the side of my bed. "What's happening?"

"I'm in so much pain!" I snapped; my anger evident. "Not that you would take the time to notice." I was finding pain and exhaustion did not mix too well with James Scott in full flow.

The nurse returned to examine me and discovered I had only dilated 1 cm, but as I was becoming more distressed, it would be best if I was moved into the delivery suite, where they could in due course attempt to break my waters. I was on the move again. I took James's hand and bid farewell to all the other soon-to-be mothers on the ward.

"Good luck," they enthused, waving me off. Even though I had not had much interaction with any of them, they all still wished me well, probably sad or possibly relieved that the gobby firefighter would now leave them all in peace.

Chapter 19

The birth

I had a delivery room to myself, and I tried to settle into my new surroundings. Karen and Ryan kindly arrived for a visit, at which point James rapidly headed out of the door.

"Where're you off to, mate? I don't think the boss will be too impressed with you making a getaway while she's stuck here," Ryan joked, pulling over a seat for Karen to sit in.

"I'll give her some time with you two guys," James laughed. "To be honest, I think I'm getting on her nerves. Good luck, I think you'll need it."

The delivery room was pleasant enough. I think they try to make it as homely as possible with scatter cushions and pictures adorning the walls. However, as I stared at the pale green walls and the calming wildflower print hanging at a slant on the wall, I honestly felt terrified. Karen, bless her, tried to calm me down as much as she could.

"Col, don't be daft," she spoke in a comforting voice and gave me a big hug. "You're an old hand at this pregnancy stuff, you've got it covered. You've nothing to fear, you're a great mum."

Her voice was reassuring, but I could see the concern in her wide blue eyes. I could see that she too was worried; scared for her twin and what the upcoming hours could bring. I was 42 and being induced with the birth of a little boy that I'd already almost lost once. I had never thought I would be in this situation. So much had changed in my life in the last 18 months since I'd met James. Was I ready to bring another life into the world? Here I was, but where the hell was James? He should have been the one comforting me, and the way Karen kept glancing angrily at the door, I could tell she was also less than impressed.

"I'll go see if I can track him down." Ryan wearily dragged his tall frame out of the small plastic chair. "This is ridiculous," he muttered to himself. "He should be here, so what's he playing at?"

"Too bloody right," Karen fumed. "Tell him to get his arse back here before I tear him a new one!" My sister pulled no punches when she was angry and looking at the expression on her face and her narrowing eyes, I could see she was livid.

I couldn't help but smile to myself. I was lucky to have such a wonderful supportive family. Ryan had only been with Karen and part of our family for a couple of years or so, but he was such a good fit. He was quiet and thoughtful and Karen's rock in life's difficult situations. It warmed my heart to see Karen so in love with such a good man – who time would show would also be a rock for our entire family to cling to.

Ryan eventually returned with a shame-faced James in tow. Ryan had found him outside the ward deep in conversation on his phone. When James had spotted Ryan, he quickly ended the call. As they both returned to my bedside, James was gushing with apologies: he claimed he needed some air and was worried

I had too many people at my bedside crowding me in. On and on the excuses came.

My icy stare soon froze his ramblings. "Seriously, James, you certainly pick your moments to go AWOL," I scolded him tersely. "I need you with me. If it's not too much to ask, can you please stick by my side? This is your baby too."

I fumed away to myself. What was wrong with him? This was the only place he needed to be. What on earth could be more important?

The hours ticked by mercilessly slowly. The nurses couldn't have been more lovely, and as to be expected, James was his chatty exuberant self with all the hospital staff. I was exhausted, not just tired but drowning under that all-encompassing fatigue you feel through your very bones. At this stage I'd not slept for the best part of two nights, and the pain was really starting to take its toll.

It must have been after 1 a.m. on 2 February 2016 that the nurse came to do yet another internal examination. I already had an epidural put in by the on-call anaesthetist to help with the pain, and finally there was some good news. I was still not much more than 1 cm dilated, but it was enough for them to attempt to break my waters.

The best way I can describe what happened next is that absolute bedlam broke out within the ward. My waters broke and there was much more fluid than anticipated, cascading everywhere. As they'd already leaked at 23 weeks, it had not been expected that there would be so much fluid.

Palpable fear and panic overtook the room. An alarm was sounded and I was moved into an all-fours position.

"The cord has prolapsed," I heard a panic-stricken female voice shout, "I'm going to have to push the baby back up inside

with my hand," she explained to me. "We have to rush you down to theatre NOW."

Everything was happening in a blur. I was on all fours being rushed at speed down a long hospital corridor on my bed. The bright lights of the ward made my vision dance as they flashed by. I was petrified. I recall believing I saw my dad inside a lift at the end of the corridor smiling out at me. Maybe it was the drugs confusing my mind? Maybe my exhausted brain conjuring up images that were not real? I know what I believe: I believe I saw my dad there when I needed him, and that knowledge gave me great comfort over the days to come.

I came to a stop and was somehow now lying flat on the bed. A male surgeon in all his paraphernalia leant over me. Everything felt surreal. I felt confused and scared.

"Do you consent to us proceeding with an emergency caesarean?" he asked, or words to that effect. Everything is still hazy to this day. There was no time for written consent. I now know that both my life and that of my baby's hung in the balance. I nodded my consent and was instructed to count back from 10. I maybe got to 8 and the next thing I recall was coming around in a private room hours later with an oxygen mask covering my face.

Karen was sitting by my side. I was so confused and groggy but did my best to take in the words Karen was speaking. She was filling in the blanks for me.

"I'm so glad to see you awake, Coleen," she said with her eyes welling up with tears. "You gave us such a fright." Her voice was thick with emotion.

"Where's my baby?" I demanded to know, wincing in pain as I tried to pull myself into a sitting position on the bed.

Karen gently eased me back onto the bed by my shoulder.

"Easy there, you've just had major surgery, and to be honest you look like death warmed up."

She went on to explain that my little boy was safe. He had been taken to the Special Care Baby Unit as he needed help with his breathing. This was not unusual as he was premature, and the birth had been traumatic. She reassured me that I should be able to see him soon.

Chapter 20

Charlie

I pushed the bedcovers to one side, trying to leave the bed. "I need to see him now," I demanded.

Karen tried to calm me down, and left the room to find a member of staff to speak to me. Shortly afterwards a nurse came in to inform me that my baby and I had been very lucky. If my waters had broken anywhere other than in the hospital, which could easily have happened, especially as they had leaked previously, my baby more than certainly would have died and in all likelihood I would have also.

The urgency of the surgery meant that my son's head had been cut with a scalpel. Not deeply, but enough that he still bears the scar to this day. We say it's his little warrior wound.

This could have been such a different story; in fact, probably not even a story at all. If tragedy had struck and I had died along with my unborn baby, I believe with all my heart that James Scott would have disappeared into the night, never to be seen or heard from again. Without his real name to go on, my family would have had no luck locating him, and he would disappeared from our lives like a puff of smoke.

It chills me to the bone to think of the even darker turn this

story could have taken. James Scott's lies would have left my girls without their mum; our bond is so close that we're like the three musketeers, but it could have been so easily snuffed out. Why had James chosen to fake that vasectomy result, to lie about the doctor and hospital procedure? To control me, maybe? Those are questions only he can answer.

One thing James did know for certain was that after that termination, I would never ever put myself through another one. He chose to play God. He knew I never wanted another baby; he knew the risks, but James Scott chose to ignore all that. To me that is unforgivable.

I love my little boy with all my heart, more than words can ever say, and when I look at him, I feel such overwhelming pride and adoration every day; but I know how differently life could have turned out. My two girls without their mum, my twin Karen without her other half, a family truly devastated. Who does that? Who plays such games with innocent people's lives?

I did get to see my little boy briefly that afternoon. Karen wheeled me down to the Special Care Baby Unit. My eyes filled with tears to see my tiny little boy hooked up to so many machines. He was so very fragile, and my heart felt it would burst with love for him.

"Don't you worry, Charlie," I whispered to him. "Mummy's here now and she's not going anywhere."

Charlie was a name I loved. Early in my pregnancy I had decided, irrespective of whether I had a girl or a boy, that the child would be called Charlie.

James had nodded in agreement. "Yeah, I like it," he agreed. "It's a good name, but how about James for a middle name after his dad? We could even call him CJ for short?"

I shook my head vehemently. "No, I don't think so." I had made up my mind. "Charlie James doesn't feel right to me." I paused thoughtfully. "I like Oliver as a middle name though, I much prefer it."

James nodded and threw his arms up into the air in defeat. "OK, you win, Charlie Oliver it is, but for the record I still much prefer CJ."

Well, he would, wouldn't he? His secret family already had their very own CJ, his eldest son, went by the nickname CJ. He seriously wanted our little boy to have the same nickname as his eldest son. Maybe this was to make it easier for him to keep everything in check if two of his sons bore the same nickname. Fewer names and details to keep straight in his head. Whatever his reason, there's no question that it was a sign of twisted behaviour.

James was flitting around the hospital at this time. He was there sporadically, in and out of my room like a yo-yo, talking constantly on his phone, sometimes in earshot of me, sometimes not. He told me how all his family were sending their best wishes. He was like a blur, while all my energy and thoughts were now on Charlie. He was my first concern.

A kindly older nurse came bustling into my room to speak to me. She told me, with a look of concern on her face, that Charlie was not adequately clearing the carbon dioxide out of his lungs. I felt a wave of fear pulse through my body, but the nurse tried her best to reassure me. She was confident of the care he was getting hooked up to the machines, and this would improve given time. However, when I did get the next update, it wasn't good news.

Charlie had taken a turn for the worse and his condition was deteriorating rapidly. They now believed he would have the

best chance of survival if he were transferred to the James Cook Hospital in Middlesbrough. This hospital boasted a much more sophisticated Neonatal department. Speed was of the essence, but first the hospital staff wheeled Charlie into my room for me to see him before they whisked him away in the Neonatal ambulance to make the journey to Middlesbrough.

I felt like my world was crumbling around me. My tiny precious baby was being taken miles away from me when he was barely a day old. A small cot was wheeled into my hospital room. Through tears I saw the tiny little body wearing a miniscule nappy with a small blue woollen hat on his head. My precious little baby was there in front of me, but all I could do was gently stroke his arm; I wasn't even able to give him a cuddle.

"I love you," I told him tenderly.

The same nurse that had comforted me previously handed me a polaroid photograph of Charlie and I held it close to my chest. I now know they took this photo as a precautionary keep-sake: something to remember my baby by as in all probability I would never see him again.

I still have that photograph, and it is one of the most precious things I possess.

Chapter 21

Little and all alone

J ames was not in the room when they brought Charlie in to say goodbye. When he did turn up from wherever he'd been, I was an emotional wreck.

"You need to go, James," I implored. "you need to go to Middlesbrough and be with our son."

At this stage I was nearing hysteria, thinking about my little boy making the trip in the back of an ambulance to the hospital in Middlesbrough with neither of his parents with him.

"They won't let me go with Charlie," I explained to James. "I'm just out of surgery and it's too dangerous for me; but you must be with him. I can't bear to think of him all alone without his mummy or daddy."

James was zipping up his jacket. "Calm down, princess, of course I'm going. I'm going to be with him all night; he won't be alone, so you don't need to worry."

By this stage Karen and Ryan had arrived, smiling and loaded down with toys and balloons. But their smiles slowly turned to frowns as they heard of Charlie's deteriorating condition.

Ryan placed the assorted blue toys and gifts on the bottom of my bed. "I'll come with you, James," he insisted. "I'll drive,

you've been through enough. You need some support, mate."

James declined Ryan's offer with a forceful shake of his head. James insisted that he wanted to be on his own with Charlie. He explained that his head was in bits and he needed to think things over. He really didn't think he'd be good company.

Ryan told James not to be so ludicrous. He was having none of it. "Stop playing the martyr, James," he scolded. "I'm driving. I'm doing it for Charlie's sake too, he's part of our family and he needs us all."

But no, James was adamant that this was a journey he needed to make on his own, and he would not budge on the issue. He explained that he would be there for our son every moment: Charlie would never be alone, but he needed it to be just father and son.

I truthfully couldn't fathom what James was thinking, and why he wouldn't gratefully accept the help from Ryan. However, I was so exhausted and distraught that I couldn't put up a fight; after all, the longer James was resisting a lift from Ryan, the longer Charlie would be on his own.

I remember that Karen stayed quiet, but the confusion was evident on her face. Ryan threw his arms up in the air, and with a sigh of defeat agreed not to make the journey to Middlesbrough.

James headed off into the chilly February night alone. To make the forty-minute journey to be with Charlie. Or did he?

Why couldn't Ryan take James? It made no sense. What I do know is that Middlesbrough Hospital is not very far at all from where he lived with his wife and sons. Did James have somewhere else he preferred to be that night? Was Charlie left alone? I hope to God not, but my gut tells me otherwise.

I hate to even contemplate that night while I tossed and

turned, fretting about my tiny, vulnerable little boy and whether he was all alone that night. All alone in the world, so little and poorly.

Early the next morning, nobody was stopping me from getting to see my baby. I would drag myself there if I had to. It took me half an hour to get out of my hospital bed and shuffle painfully to the toilet. I was in such pain.

I rang the James Cook Hospital and was informed that there was no change in Charlie's condition. I wished it had improved, but at least he was still fighting. My miracle baby was definitely a fighter.

The nurses tried to stop me discharging myself from hospital. The birth had been incredibly traumatic, and I was still very weak. But I was having none of it: despite their protestations at my leaving, I could see in their faces that they understood why I had to go. I needed to be with my son, and neither hell nor high water was going to keep me away.

James arrived and I was bundled into a wheelchair; off we headed, Middlesbrough bound. I was in so much pain, but if anything that just spurred me on. Arriving at the hospital, my heart was in my mouth; it seemed an eternity for us to find the ward through the maze of corridors. James was practically running, pushing my wheelchair as we zipped along.

When I finally got to Charlie, I was in bits. He was encapsulated in some space-age contraption, and the room was frighteningly quiet apart from the beeping and whirring of the many machines. But there was Charlie, tiny and fragile. The tears rolled down my face as I took in his little form lying still in the incubator. My little boy was putting up the fight of his life.

Shortly afterwards, a doctor came to talk to us. "Don't

look so frightened," he reassured us, "he's doing really well. Honestly, he's a marvel. He's showing true fighting spirit." He gave me a warm smile. "His oxygen levels are improving, and we are constantly monitoring him. I believe we can be quietly confident."

The relief I felt was overwhelming. I can't put into words the feeling of elation that coursed through my body. I could barely believe it: my little boy was hopefully going to be OK.

Exhausted, James took me home to our house, where I duly collapsed on the bed. Days of no sleep, pain, shock and fear had finally taken its toll. I slept.

I ended up staying in bed for the next week, the health visitors and doctor checking on me regularly. Frustrated to be on forced bedrest again, I insisted that James go to the hospital every day and stay at Charlie's side. When James did return to me, I would constantly phone the hospital for updates on Charlie's condition. The hospital must have been sick of me, not that they ever showed it though; they were so kind and patient with me.

Whether James was with Charlie all the times I believed him to be, I don't know. I doubt it very much. I do know that the only photo I recall receiving of Charlie is when my daughter Laura went with James to the hospital. I do hope James made some visits apart from this one.

Charlie was now taking milk orally, only a teaspoon or so at a time, but we were all thrilled. And after a long week it was decided that Charlie was strong enough to make the journey back to Durham Hospital, only a few miles from my home. With me now so much stronger, nothing was going to keep me away from my son.

After maybe another week in Durham, where I had finally

been able to hold Charlie, feed and bathe him, my little baby was allowed home. Our family was finally complete. Charlie was home where he belonged.

It truly felt like we were all in a little bubble of happiness and contentment, with visitors and well-wishers pouring in, bringing gifts and cards welcoming Charlie into the world.

And there were presents from Maureen and John, Bronwyn, Jodie and James's girls too. James's family always seemed to be so thoughtful.

"Wait until you see what the guys from the Academy have got for our Charlie," James beamed excitedly as he came through the door one afternoon weighed down with armfuls of presents: a build-a-bear teddy named Charlie, dressed head to paw in firefighter attire, and a large toy box big enough to sit on that was a fire engine.

I laughed. "They certainly like to stick to a theme: good job you're not an undertaker," I joked. I was really touched though by his colleagues' thoughtful presents. They must all hold James in such high regard, as he hadn't been in his new position that long. I hadn't yet had the chance to meet any of them.

"I'll send them a thank you card," I announced; "it's the least we can do."

James hushed me. "Don't you bother yourself, Col. I'll get bacon butties in for them to say thank you next time I'm in." With that James took back control.

Chapter 22

So far away

L ife was good. I was healing well, and all Charlie's checks were looking good. For the first time in as long as I could remember, I felt I could breathe a sigh of relief and relax.

But the tranquillity I felt then did not last for long. Only a couple of nights later, while Charlie was sleeping peacefully in his Moses basket in our bedroom, James's phone began ringing persistently in the darkness. I jolted awake and quickly nudged James to answer it before the shrill ringing caused Charlie to waken.

My stomach churned, as it was still the early hours of the morning. Who could possibly be ringing at this time? My first instincts were that it surely couldn't be anything good, and I was right. James took the call out onto the landing and pulled the door to, to muffle the sound and let Charlie continue to sleep peacefully. Even through the slit in the door, I could hear the anguish evident in James's voice.

Something terrible must have happened. I climbed out of my side of the bed, quickly grabbed my dressing gown and wrapped myself into it, pausing to gaze down at Charlie to

check on him. Luckily he was still fast asleep, looking like an angel without a single care in the world.

I joined James on the landing. He was sitting on the top step with his head in his hands.

"Whatever has happened?" My panicked voice rang out in the night. "It's not your mum, is it?"

James lifted his head, his sandy hair sticking out in tufts in all directions from him running his fingers through it agitatedly. "No, it's not Mum," he confirmed, his voice wavering, "it's my little Kenzie." James's face was etched with anxiety and concern. "That was the doctor from the hospital in Texas. She's had an accident while out horse-riding. She's been kicked," he stuttered, "it's her head, they're not sure how serious it is but they're running tests." He was sobbing uncontrollably now, his shoulders heaving. "She may need surgery. What was she even doing? She knows better than to run around the back of a horse."

I was at a loss for words, my breath caught in my throat. This was every parent's worst nightmare! Your child being hurt and you not being with them to comfort them.

I sank down on the top step, took his hand and rubbed it, trying to comfort him. "Was that Jill on the phone?" I asked as I continued to rub his hand between mine.

"No," James spat out angrily, "I've already said, that was the doctor. Miss High and Mighty hasn't even bothered to text me." His face was colouring red with anger. "It's evening there and Kenzie's not long been admitted." James began nervously tugging the sleeve of his pyjama top. "What do I do, Col?" He sighed heavily. "I want to be with my little girl, but you're not long out of hospital and Charlie is so very little." His face creased as he continued to sob and I held him tightly.

"You need to go, James," I insisted in a soft but stern voice. "I've got support here, I'll be fine, go and be with your little girl; she needs you."

I headed downstairs to put the kettle on. The chance of any further sleep that night was long gone. James eagerly pulled out his laptop and sat at the kitchen table to fire it up, keen to get onto websites and book a flight and accommodation in Texas, as close to the hospital as he could find.

The next morning my opinion of the situation was mirrored by everyone in the family. Of course I needed to let James go to be with his daughter, it would be selfish not to. What if the worst happened? He would never forgive himself if he hadn't got to her in time. The outpouring of support from my family towards James and his predicament warmed my heart. James too was touched, and with his mum on board to help with the associated medical costs that would be incurred, James was soon off on the long journey, alone and fearful of what he might find once he arrived in America.

James stayed in touch all the way. Posting pictures from the airport, he sent a photo of a cuddly toy monkey from one of the airport shops he had bought for Kenzie; it was very cute and had Velcro hands that could be attached together – perfect for Kenzie, as it could always give her a hug when he couldn't be there for her. How lovely, I thought: such a sweet gift for a loving dad to buy his daughter.

I continued to receive many pictures and texts on James's journey, as did Karen and my daughters. However, once he arrived in the States he went very quiet. I understood totally that he needed to focus 100 percent on his daughter, and I gave him the space he needed. After all, I was doing well at home; and even though I kept constant watch on Charlie, my family

were all around for support. In fact when Laura and Katie were with me, I hardly got a look in as they doted so much on their baby brother.

James returned within a few days, exhausted but reassured and much happier. Kenzie had suffered superficial bruising, facial swelling from a damaged cheek bone and a black eye but would be fine. She was a very lucky girl, as it could have been so much worse. James was incredibly glad he had been there with his little girl and found quality time with Maddie too.

"My girls are getting grown up so quickly," he commented in a sad reflective tone. "I do miss them so very much."

"What about Jill?" I asked. I couldn't help it: as a woman I was curious to know what his ex was like, and how she had been when he saw her, as they hadn't had any contact in many months.

He let out a lengthy sigh. "As civil as I think one could ever manage." He gave a cynical laugh. "She's certainly not someone I miss: she's all the way in Texas, and it's still not far away enough; pity she's not on the moon."

James took his phone from his pocket and began to scroll through the many saved pictures, stopping on one that he wanted me to see. It was a headshot of a young girl with a bruised swollen face sporting a bandage on her head. She looked so different from the previous pictures I had seen of Kenzie, I was shocked; though of course she would look different with the injuries she had sustained.

"Poor little thing," I exclaimed, "I wouldn't have recognised her under the dressings, but I'm sure she'll be back to her old self soon." I gave James a reassuring smile.

He returned my smile with a thankful one of his own. "You're right, I know you are, it's just hard to see my little girl looking

so hurt." He slapped his palms on the legs of his dark blue jeans as a sign of ending that particular conversation.

"Anyway," he said, taking a deep breath with a mischievous look in his eyes, "I didn't come straight here from the airport; I made a little detour instead."

I turned to look at James in surprise as I leaned down to pick Charlie up from his Moses basket and gently rocked him in my arms.

"Really?" I was confused, convinced he would have been exhausted from his journey and desperate to get home to Charlie and me. What was so important to make him decide to take a detour?

A wide smile spread across his face as he carefully pulled back the left sleeve of his jumper to reveal his wrist. I stared at his arm, covered in a layer of clingfilm. Realisation began to dawn.

"Is that a tattoo?" I asked in a shocked voice, as he had always said he would never have a tattoo; it just wasn't his thing.

He didn't answer, just continued to smile as he slowly unwrapped the clingfilm from his wrist to reveal the artwork.

"I wanted to get something permanent on me to show the world you mean everything to me." He looked deeply into my eyes. "You're my soulmate and nothing will ever break us apart."

The soggy clingfilm was now discarded next to him on the arm of the sofa. I stared at the swollen markings on his wrist. They were tinged in red, and I was totally confused as to what I was actually looking at.

"I don't understand," I admitted, confused, staring at what appeared to be three circles coloured like they were

representing the earth with a flattened ring above them in black ink. "What does it mean?"

He took in my confused expression and laughed. "Oh, princess, isn't it obvious?" He took my hand in his. "The circles represent the world: there're three of them, for my two girls and Charlie, as my children mean the absolute world to me." His misty eyes held my gaze meaningfully. "The halo above is for you: you're the glue that holds us all together, the halo is for you, my princess."

I stared hard at the tattoo, back to his face and then back to the tattoo again, genuinely perplexed. "Wouldn't a crown have made more sense for a princess? A halo is for an angel, surely?"

He laughed again dismissively. "No, Col, to me it represents a princess," he replied. "It's for you from my heart, to show my total love and devotion to you."

For a moment I was speechless; the room fell silent apart from the slow ticking of the clock and the happy gurgling from Charlie sitting on my lap.

James's face crumpled. "Don't you like it, Col?"

Truthfully, I really didn't. It made no sense to me, but looking at his deflated face I couldn't bring myself to say the words. "I do love it, James," I reassured him in a soothing voice. "I was just a bit taken back for a moment, as I really wasn't expecting it, but it truly is a lovely gesture."

I reached over to James and kissed him on the cheek. "As long as you don't expect me to get a matching one, I really don't think that's for me."

James smiled indulgently to himself.

The tattoo may have made no sense to me, but it made perfect sense to James, and in time I would understand the significance

of the inking.

James had just spent a lovely three days, not in America as I believed, seeing his injured daughter, but with his wife and three sons in Darlington. Walking past a tattoo parlour with his wife, they had decided to get a permanent reminder of their love. The three worlds on the tattoo were, as he had told me, to represent his three children: but not his two daughters and Charlie, but actually his three sons. The halo that he told me was to signify his love for me – his princess – was actually for his wife. I was right when I had suggested that the halo represented an angel, as his angel was his wife. The tattoo was a testament to his love for her, not for me as he led me to believe.

Chapter 23

Missing in action

My little life continued as before: safe and predictable, which is how I liked it. James was working and we both doted on Charlie, enjoying our cosy family life together. However, I was beginning to feel torn: I had agreed to return to work by the middle of March 2016, as I had been absent for many months. I knew I was sorely missed at the office, especially by Karen. My return date was approaching at breakneck speed, and although the thought of returning to work left me a little anxious, I was also excited about being a working woman again. James was going to cut back on his number of shifts so that he could be the main caregiver for Charlie, with Yvonne and Mum champing at the bit to take up the slack.

I knew that little Charlie would be in safe hands, and Karen kindly let me tweak my hours at work so I could leave by 3 p.m. every day to have quality time in the evening with my little boy.

About a week before I was due to return to work, I was enjoying a lovely relaxing evening, curled up under a blanket on the sofa, watching a film I'd been keen to see for a while.

Charlie slept peacefully in his Moses basket next to me. James had picked up a last-minute shift at work, as they were short-staffed, and my girls were in their rooms listening to music or the like.

I went to take Charlie out of his basket and check on his nappy, when in horror I witnessed his head roll backwards and his tiny body become limp in my arms. He wasn't breathing – and pure panic hit me like a sledgehammer. I started to rock him in my arms as I ran to the foot of the stairs and shouted to Laura and Katie, "I need you both now! Charlie isn't breathing."

The girls came tearing down the stairs, anxiously taking them two at a time. My terrified brain was racing out of control. I didn't know what to do. I couldn't lose my precious little boy, especially after everything we had already been through. I was visibly shaking from head to toe.

Laura has always been the calmer and more level-headed of my two daughters, and while Katie was panicking and sobbing just as much as I was, Laura took her baby brother gently from my arms. She reassured me that he would be OK and tenderly laid him on his teddy bear changing mat. Charlie's pallor was looking chalky grey. Frightening images were flashing through my brain, nightmare pictures of tiny coffins and a life without Charlie, scaring me to my core.

I started to sob uncontrollably while Katie was on the phone, desperately talking to the emergency services. Laura massaged Charlie's tiny chest and I looked on despairingly. Finally Charlie took a little breath; one breath and then another and another. Laura thankfully picked him up and he began to gurgle happily in her arms. I breathed a silent prayer of thanks, so relieved but terrified it might happen again and he might

once again stop breathing.

Katie passed her phone over to me and I was told that the ambulance would be with us very shortly. As I gave my address to the lady on the phone, the front door of the house flew open and Mum came hurtling through it, her long black winter coat over her pink flowery nightdress, her face etched with concern for her grandson. Katie had texted her and she had woken from her sleep with a start, ready to assist in any way she could.

I hugged Mum distractedly, watching out of the lounge window along the dark street to see the ambulance finally approaching. I rushed to the door to welcome the paramedics. They checked Charlie over thoroughly, and although they said he seemed all right, his history suggested we should take him to the hospital for a more extensive check-up.

So once again, we set off for Durham hospital, this time in the back of an ambulance. I kept glancing at my phone screen, desperate for any message from James. Katie, in a panicked state, had left a frantic message on James's voicemail, but we'd had no response from him.

In the hospital we had to wait many hours to be seen. Still there was no contact from James. Mercifully Karen and Ryan arrived as they were so worried about Charlie, and I was incredibly happy to see them and have their support.

"Where's James?" Karen demanded. Her face was livid. "Please tell me he's coming?"

"Of course he's coming," I retorted defensively, "give him a chance."

Karen apologised for her abrupt comment, but truthfully I was worried and annoyed he was not there. I hadn't received a fire or vehicle emoji, so I knew he wasn't out on a shout, so why was there no contact from him at all?

James did eventually call, his voice anxious and rather muffled. He was in an agitated state and apologising. His senior officer wouldn't allow him to leave work. He had ended up having an argument with him, but his boss wouldn't budge. I couldn't believe this, and when I relayed the message to Karen and Ryan, they also shook their heads in disbelief. How could James's boss not allow him to leave? Did he not realise how serious a situation this was? I sent a message back to James telling him to get here now, and no excuses.

Eventually Charlie was seen by a doctor and given the all-clear. They believed he had suffered a febrile convulsion - incredibly terrifying when it happens, but actually quite common in young children, and not serious. With immense relief we left the hospital, and Ryan and Karen gave me a lift home.

James did not make an appearance until the following morning, over twelve hours after Charlie had first stopped breathing. He was full of tales of woe about his boss and his job: how he had tried so hard to get to the hospital, but it had been impossible. I found it hard to understand how his boss could be so hard and callous in this situation, but seeing James's pale and exhausted sorrowful face, I let it go. It was clear to see how upset he was.

Anyway, what was the point of staying upset? Charlie was home and safe, and that was all that mattered. Yes, it was bad that James had not been there with us when I needed him, but he had tried his best, so it really wasn't his fault. I was just so happy to be out of the hospital. I had really had my fill of them.

However, hospitals continued to feature in our life. Once I had returned to work, on two separate occasions I had to make frantic dashes to Durham hospital. One time James had

a car accident with Charlie on board, skidding on leaves in wet weather; and another time someone stepped out directly in his path and he had to slam on the brakes. Both times James was fearful that Charlie might have sustained injuries; but the hospital never found evidence that Charlie had been hurt in any way, and James's car never seemed to show any signs of damage.

Chapter 24

Goodbye social life

I knew that James was not happy with my going back to work. He had enjoyed many months with me at home, exactly where he liked me, but now I was out and about again in the wider world and was beginning to socialise again. Would he seriously invent car accidents just to scare me and make me feel guilty about being parted from my son? I hate to admit it, but I really think that was the case.

He never made my life easy; although I loved to be back working again, I had the guilty feeling of so many working mums that perhaps I was neglecting my child, and James used to like to exploit this emotion. I realise that this was his insecurity: he hated not knowing where I was all the time, and who I might be interacting with.

Once again James started making unannounced visits to the office. Although the bouquets of flowers still arrived sporadically, thankfully they were not as abundant as they'd once been. However, I still felt uneasy about him 'popping in for a minute'. Although I loved seeing Charlie, I felt uncomfortable as it looked so unprofessional.

Once back at work, I was excited to start reconnecting with

my friends socially after having been off the social scene for so long when I was pregnant. I'm not talking about going out every night, but a couple of times a month to catch up with my girlfriends for cocktails and chat.

One evening in early April 2016, I was excitedly getting ready for a girly night out. There would be drinks first at Karen's house, followed by a few more at various pubs, culminating in live music from a band in a local pub. I was dressed in a figure-forming knee-length black dress with high heels and subtle jewellery. Although I'd only just had my baby, I was feeling pleased with my new shape. James cast a long look over me, taking in my outfit and make-up.

"You really don't need to go, you look tired and drawn to me. Why don't you cancel and we'll have a lovely quiet night in?" James suggested with an eager expression on his face.

I laughed good-naturedly but was having none of it. "Charlie and you can have a bit of boys' time, plus the girls are back from their dad's tonight, so you won't have a chance to miss me."

As if on cue, the taxi arrived outside the house. I quickly checked my appearance in the hall mirror and kissed James on the cheek, telling him I wouldn't be too late. Then I was out the door, excited to rejoin my friends.

There were seven of us women going out: our ages varying from 30s to 50s, but all great company. I was really looking forward to some good conversation and putting the world to rights over a few glasses of wine. The prosecco was flowing as was the conversation, and we were all having a whale of a time. Karen was being a great hostess, making sure everyone's glass was topped up and they had plenty of nibbles.

Then a text message pinged in from James, and I juggled

my bruschetta and wineglass to be able to read it. The text message read, "My back's playing up terribly, princess. I'm in so much pain and I really miss you."

I sighed heavily, put down my glass and proceeded to message him back. I told him to take it easy; it wouldn't be a late night, so I would be home pretty soon. I felt bad and a little guilty that James was in discomfort while I was out enjoying myself, but honestly there wasn't much I could do to help him, and I hadn't seen my friends in such a very long time.

The messages from James just kept coming, each one ramping up the guilt. Before long I started to receive them from my daughters too.

Katie said. "Mum why won't you come home? James does so much for all of us, and you're out enjoying yourself when he really needs you. I think you're selfish!"

I was feeling really annoyed now. Why were Laura and Katie getting involved in this? What was James playing at?

I tried to not let it upset me too much, and plastered a smile on my face as I listened to the ongoing conversation between my friends. Everyone was laughing and enjoying themselves, and I endeavoured to give the impression that I was too, but in truth I was feeling torn.

We left Karen's and had not even got to the first pub, a mere five-minute walk from the house, when my mobile phone started shrilly ringing. My Katie was on the line imploring me, through tears, to come home at once.

"James is in a bad way! He's only like this because he hurt his back saving that kid's life." She was really upset.

I felt awful. James was such a decent man, and I supposed the least I could do was curtail my plans and get home to be with him. So, guiltily, I told Katie I would get a taxi and head

home as soon as I could.

I disconnected the call and looked around the dark street, hoping for a taxi with its lights on, but as it was still relatively early there was not one to be had. I gently tapped Karen on the shoulder. "I'm going to call myself a taxi. James isn't too good, and I need to be with him."

This was met with a resounding boo from the girls, and much encouragement for me to stay out, but my mind was made up. I waved them all off as they disappeared into the brightly lit noisy pub, and I sat on the wall scrolling through my phone contacts, trying to find a local taxi firm to call.

Only a few minutes had passed when I was startled to see James pulling up alongside the pub. I walked over to the car. What was he doing here? I'd been led to believe he was in agony with his back, but here he was driving the car. I opened the passenger side door and stared in at James in bewilderment.

James gave me a wide smile. "I thought I'd come and pick you up, save you the hassle of trying to get a taxi. Come on, in you get," he encouraged me, patting the passenger seat.

I climbed in, still staring at him in confusion. He didn't appear to be a man in pain; his movements were easy and unencumbered.

"What the hell are you doing here?" I demanded to know. "I thought you could hardly move, so what are you doing driving?"

James shrugged sheepishly. "Maybe I exaggerated a little, princess." He gave me an indulgent smile. "No harm done, eh? Now I have you all to myself."

That was that. My first night out on my own and I was heading home, the night finished before it had barely started.

Chapter 25

Dripping poison

This then became a pattern of behaviour. I did attempt another night out a few weeks later, with just Karen, myself and a work colleague, Denise. We were all having a lovely time in a pub in Durham when I received a jokey text from Ryan on my phone. As Karen was out with me, Ryan was staying in with James for a pizza and beer night. Laura and Katie were there too.

The joke Ryan sent was of an adult nature, a little risqué perhaps but no harm done; Karen had received the message too as we were in a group chat. I therefore thought nothing of the message, and after laughing at the content I sent Ryan a laughing emoji as a response and slipped my phone back into my jacket pocket.

In no time at all my phone was buzzing again. This time it was Katie, telling me James was very upset. He had taken her into the kitchen and confided that Ryan was being really inappropriate with her mum, overstepping the mark, and it was making James feel really uncomfortable.

I was completely confused. Ryan was like a brother to me, so what on earth was James thinking, implying stuff like that to

my girls? It was only a joke, and for goodness sake it was sent in a group chat which included Karen – his partner.

This wasn't all that James chose to tell the girls. He would fabricate stories and tell them tales about any men who got close to me in my life, ensuring that my daughters got to dislike them. He would drip poison in my girls' ears, quite subtly to start with but in such an insidious way that it caused division and doubts. He even tried to distance me from my ex-husband, making up lies and dropping hints.

This turned into another night cut short by James. This time he came to collect me with Katie alongside him in the passenger seat. However, this time I was waiting for him with Karen. When James arrived, I angrily climbed into the back seat of the car and with Karen watching us I passed my phone to Katie.

"Look," I snapped, "it's a totally innocent joke." I turned my head angrily towards James, "I haven't a clue what's going on in your mind, but I can tell you that this is completely out of order."

Katie took in the text message from Ryan, looking baffled. Shaking her head, she passed the phone back to me. "I'm so sorry, Mum," she said. "I must have got the wrong end of the stick."

I smiled back at her through tight lips. "I don't think you're the problem, love."

James at least had the decency to look shamefaced. He explained it away as him being over-protective and worrying about me, the excuses coming thick and fast. Whatever the reason, he had managed to get me home early again: away from the nightlife in Durham to where he could keep his eyes on me.

Looking back at it now, it was so obvious to everyone that

James felt he had to exert control over me. He was not happy if I was out without him and was irked that I had such a good relationship with my girls and with Ryan. Therefore, James felt the need to meddle and ruin it all. He felt he was no longer my primary focus, and he was losing his all-encompassing control over me. James felt he needed to find an angle to distance me and the girls from Ryan, and to ensure his place as top dog again. He must have felt he needed an angle to pull my attention fully back to him.

Chapter 26

Cocktails and dreams

Then suddenly business ventures came into play. James's mother, Maureen, had decided to take a step back from all her business interests, recuperating after her breast cancer ordeal. She was taking some time for herself and trying to enjoy a more leisurely pace of life. However, this didn't work as she became bored with her quieter pace of life.

"Mum's looking for a new project," James announced on one of his many impromptu visits to my office, laden down with takeaway coffees and bags of goodies from the artisan bakery across the road. "She needs to get her teeth into something," he exclaimed, dropping a bag containing a gooey Danish pastry onto my pile of files precariously heaped on the corner of my desk, "something to make use of her business expertise. But she can take a back seat when she needs to, so something not too stressful and demanding."

James took a long swig of his latte and then proceeded to fill Karen and myself in on all the details of the exciting proposed venture.

Maureen had decided that she wanted to have a "dabble",

as she called it, into the hospitality business: maybe a small hotel, bar or nightclub – something along those lines. She had her sports agency work, which was pretty much running itself these days, with her just overseeing it. The portfolio of rental properties she had in the north-east of England was currently under a management company, so required very little time and input from her. A new venture with her family is what she coveted, and Maureen felt that now was the perfect time to do it. She hoped to build a solid legacy in the Scott name.

James's sisters, Jodie and Bronwyn, had been approached first to gauge their interest. Both of them thought it was a fantastic idea: just what the doctor had ordered for their mum, something new and fresh for her to focus on. Therefore, they were behind her one hundred percent, though neither of them wanted to get involved practically. Bronwyn had enough on her plate with her three boys and busy career; she could not consider taking on any more responsibility. Jodie, while loving the prospect of having a restaurant or bar in the family, felt it would be too problematic for her, as she was overseas with a busy career too.

But both agreed that their little brother James should definitely be on board. He was doing fewer shifts at the fire service, to be with Charlie; so with the right staff and management, this could work to everyone's advantage. Maureen would be the major investor, but James would also invest some of the funds that he had accrued from the sale of his home. As he explained to me and Karen, this would ensure that his money was working for him for the future, rather than it just languishing in the bank.

James and Maureen had both agreed that I should also be involved in a practical sense, but I was not expected to make

any monetary investment as Maureen's business manager, Andrew Roberts, was also extremely keen to invest. Karen listened attentively to James's plans, as he was so excited and animated, his enthusiasm evident all over his face. Maureen had emailed a list of potentially appropriate venues from various estate agents, for James to arrange viewings as soon as possible. A business plan and proposal were already winging their way to James's inbox. James was so enthusiastic that it was impossible not to get swept along with it too.

Karen was by no means a wealthy woman, but she did have a good job with a good salary; she also ran a separate business with her ex-husband of rental properties around the Durham area. Also, when our dad had passed away, Karen and I had both come into an inheritance of about £60,000. I had used mine to pay off much of my mortgage, keen to own my own home, something to leave to my children one day. Karen had kept hers and was keen to invest it somewhere that would leave a legacy for her daughter for the future and provide ongoing income for herself. Could this be the opportunity she had been waiting for? Especially as it was something Karen and I had always dreamed of: we'd always imagined ourselves owning our own little café or bistro. We were both extremely passionate about food and loved to cook. All the family knew of our little dream that had never come to fruition, but maybe the time was right now.

It seemed a dream come true: a chance for Karen to invest in a long-held fantasy. And if Maureen's own business adviser was keen to invest as well, it seemed a no-brainer. Karen had been feeling she was at a crossroads professionally, having just turned 42. This seemed the ideal chance for a change and to take a leap of faith. So rather than James having to pressurise

and cajole Karen into investing in the business, Karen was immediately keen to come on board.

Karen would ultimately invest £30,000 into this business endeavour, the aptly named @Scotts restaurant and bar in the heart of the Newcastle Quayside. Maureen was adamant about the name: it was to be a family affair, so therefore she insisted it should have the Scott name. I laugh at the audacity of this now, as in fact the only family member who had the name Scott was poor baby Charlie, the fake name registered on Charlie's birth certificate, registered by his fake father.

James had truly played a blinder now. He had wanted all my attention to be on him, and now this business venture ensured that was the case. Between Charlie, working, wedding plans and @Scotts to plan, there was definitely no time for friends and socialising. There was hardly time to catch my breath, life was happening at such breakneck speed. In fact the ruined night out in Durham, jealously cut short by James only a few weeks earlier, would turn out to be my last time out socially without James by my side.

Emails, contracts and all other manner of documentation were now circulating between myself, James, Karen, Maureen and Andrew Roberts. It was such an exciting time, with a whirlwind of opportunities and exciting possibilities. Viewings commenced of potential properties around the centre of Newcastle that looked suitable for @Scotts.

One property was head and shoulders above the rest, and all parties were in agreement that it was the one we should definitely go for. It was a former Russian-themed nightclub, right on the quayside of Newcastle, called Pravda. Although it had been on the market for five years and needed quite considerable renovation, it was an ideal spot for a bar and

restaurant. The quayside was a very trendy and popular area for Newcastle nightlife, and this was a really good development opportunity.

I went to view the Pravda building on four different occasions with James. Karen and Ryan also came to two of these viewings. On two occasions I actually met the owner of the property, as did Karen and Ryan. He was a distinguished affable Asian gentleman in his mid-sixties, who regaled us with humorous anecdotes of his thirty years in the club and bar business. He really took a shine to James too, and the pair were keen to organise a round of golf together while they chatted amiably like old friends.

James was adamant that Pravda fitted the bill perfectly for everything we were looking for, and I couldn't help but agree. Karen was excited too as we took measurements and made plans. Andrew Roberts turned up at one of the viewings, extremely keen to see the venue himself as he was investing a lot of money and wanted to be able to report back to his boss, Maureen. He too was impressed, and therefore it was all systems go. An offer was made by Maureen, and Pravda was ours.

We now know from the police that the owner of Pravda never met us at any of these meetings. In fact, when shown a photograph of James and myself, he claimed that he had never laid eyes on James or me in his life. No viewings had ever been made on the property; the estate agents had arranged nothing. The agents did not even hold the keys to the Pravda property, the owner had the keys and had given one set to British Gas who were doing essential maintenance repair work in and around the empty property.

The fake owner had let us into the building with his own set

of keys, and on one visit James had the keys himself, which he said he had collected from the agents prior to the viewing. God only knows who the friendly Asian gentleman was, certainly not the owner. He had got on so very well with James. Who was Andrew Roberts, Maureen's business adviser, with his smart suit and well-polished expensive leather shoes? Who the hell were any of these people?

We couldn't have been in the Pravda property, the police later insisted. It wasn't possible, they would tell us. None of it made any sense. I described the interior of the Pravda building in great detail to the police, even down to the dusty discarded bottle of wine on the first-floor bar and the cracked upstairs window that was not visible from the street. Most importantly, we had an interior shot of the building with Charlie sitting in his car seat on the dusty bar, gurgling away happily. The police would concur that we had indeed been in the property, but they could not find an explanation for how this was possible. The only possibility that anyone could come up with was that James had somehow got the keys from someone working for British Gas, and then got other people to act out roles in his fantasy life.

Had be bribed people? Where these fake people actually friends of his from his real life in Darlington? I don't know. I'll never know the answer. Only James does, and to this day he's still not talking.

Chapter 27

House of his dreams

Back then, however, everything was so shiny and exciting – new opportunities and so much to look forward to. We had so many meetings to attend as James brought on board an excellent PR company, The Works, to help oversee all our advertising requirements. James and Maureen would emphatically exclaim that if you're going to do a job, then make sure you do it right. No expense was spared. They were going to move heaven and earth to ensure that this business was a success.

James really seemed to be thriving in his new role of hotel manager. He was also busy sorting out the wedding arrangements, and still picked up the occasional shift for the fire service; but his main focus had definitely shifted to being a business entrepreneur. Even the way he dressed was changing. Long gone were the bobble hats and jaunty jumpers and jeans, replaced with smart tailoring and an air of refined authority. He was completely absorbed in his new position.

One afternoon I returned home from work after a busy day, kicked off my high-heeled shoes, dumped my bag on the floor and slumped down on the sofa with an exhausted sigh. Fanned

out on the coffee table in front of me were a selection of listings from estate agents, details of impressive properties that were for sale in the Durham area. Not business this time, but residential properties. I leaned over and started rifling through them: large lavish properties all costing a pretty penny. I was aghast. What were these, and exactly who were they for? Surely not for us? I had made no secret of the fact that I loved my home, I was very happy here and my girls were settled and content. The house held a lot of extremely happy memories, and logistically couldn't be better placed: for wonderful local amenities, the girls' school, close to all my family and the girls' dad, plus it was an easy commute for me to work and back.

I made myself a strong cup of tea and sat back on the sofa to study the house details more closely. James came bustling through the front door with Charlie cradled in his arms. He strolled over to where I was sitting, and with a quick kiss on my cheek nodded his head towards the pile of estate agents' details strewn on the coffee table.

"I see you've found them," he beamed. "What do you think? What could be more perfect? A new home to start our new married life."

I stared at him incredulously. Surely he was joking? We had a new baby, had just embarked on a brand-new business venture and were getting married. Did he seriously want to lump the prospect of a new house purchase into the mix too? Talk about piling on one of the most stressful things you could undertake in life.

"You've got to be kidding, James. Why would I want to move now?" I stood up and took myself into the kitchen to prepare a bottle for Charlie. "We've got a lovely home here; it's everything we need, and have you even seen these places?

They're extortionate and way too big for us."

James sighed heavily and pulled me away from the sink to face him, but I was still talking. "Have you won the lottery and I don't know?" I quipped, my eyes darting over his face in confusion.

James laughed. He hadn't won the lottery – well, not in the traditional sense anyway – but he had received a rather nice windfall. His mum had apparently been doing a lot of soul-searching recently (a cancer diagnosis will do that to you). She had her regrets about not always being there for her children when they were growing up and needed her. Having always put her business needs first, she now really wanted to make amends. She wanted to see her son and daughters enjoy some of the wealth that she had accrued while she still could. This was with the proviso that James used his early inheritance to get a foothold on the property ladder again, since he had sold his home and moved in with me. She thought he should invest it all in property, where he would make the biggest financial return in the long run; and it would be for her grandchildren too: Charlie, Maddie and Kenzie.

I could understand the sentiment, and realistically property investment was a sound proposal, but I just didn't want to move house. I was incredibly happy where I was in my comfortable well-loved home. James was having none of it though, and opened up to me, expressing how hard he found it to live in a home where I had once lived so happily with my ex-husband. It made him incredibly uncomfortable, he admitted.

I had seen hints of his unease at my ex-husband's ghost in our property. Once I had returned from work to find my bed dismantled in the driveway and a new bed installed in the main bedroom. James had not spoken to me before ordering the new

bed, but he said it was out of necessity. He had no choice but to purchase a new one, as the mattress was aggravating his broken back and he needed a firmer orthopaedic mattress; but now in hindsight I realise it was more likely that he found the idea of lying in a bed I had shared with my ex-husband to be completely repugnant.

I could understand and sympathise to an extent that he would want us to have our own home together, one where we could make our own memories, not be imprinted with memories from my past life. However, my home was my safe place, my sanctuary and my legacy for my children. It was important to me: I had worked so hard, often gone without, to keep its roof over our heads. I had fought to keep it and wasn't prepared to let it go now. As always though, James had the solution. We could rent it out and make a tidy income, but still keep it in the family and keep it safe for the kids' future. He wouldn't let this idea lie, and after days of cajoling and wearing me down, reluctantly I agreed and James once again had his way.

He wasted no time in getting plenty of viewings booked into the diary with various estate agents. We ended up viewing four properties in total, each one larger and more palatial than the one before. The final house that we saw James was absolutely in love with, and I've got to admit it was mind-blowing: very spacious and modern, with all the mod cons you could ever dream of having. It was located in a prestigious setting on the Ramside Park development on the outskirts of Durham. The views from the property were breath-taking, overlooking Ramside Park and the golf course. The purchasers of the property would also receive four lifetime passes to the fabulous spa and leisure suite at Ramside Hall.

I would be lying if I said I wasn't swept along with all the grandeur and opulence of the property. I really did feel like a princess for once. Even the next-door neighbours were celebrities – a Newcastle United football player one side, and a famous cricketer the other. However, I did have a nagging, churning feeling of doubt deep in the pit of my stomach. For starters there was the price: it had an asking price of a staggering £1.6 million. James had not told me how much money his mother was planning to bequeath to him exactly – believe me, I'd asked, but James preferred not to discuss money, telling me not to worry and that everything was in hand.

However, as someone who has never had any sort of money myself, I did worry. I've never had the luxury of not having to. Also, the property was further away from my mum and Karen and was going to be inconvenient for my girls to go to and from school and to their dad's house. I didn't drive and was concerned that I would find myself rather isolated, rattling around in such a big house.

I voiced my fears to James, but he just brushed them away. He shook his head in disbelief. "Are you seriously trying to tell me that Laura and Katie are not going to be over the moon to live somewhere like this?" He gestured his hand with a sweeping motion around the grand entrance hall with its central circular staircase. I sighed: of course he was right. What teenager wouldn't want their own spacious bedroom with a large en-suite and a balcony? They would be the envy of all their friends.

Before I could question James any further, his mobile phone blared out, echoing around the spacious empty property, magnified by the sheer space and marble trappings.

It was his mum calling, keen to hear how the viewings were

progressing and eager to know if we had viewed any that we really liked. James filled her in on the properties we'd seen, and how the property we were standing in at that moment was most definitely the hot favourite. He continued to tell her which estate agent it was listed with, and the name of the agent.

James was nodding to something his mother was saying on the other end of the line. Turning away from the phone, he spoke to the agent directly. "My mum remembers you well," he announced with a laugh, "you sold her property a few years back: The Gables in Wolsingham. She says to make sure you do a good deal for us now too."

The estate agent smiled back at James, nodding his head in agreement. He announced that he remembered Maureen very well, and the sale of the property, and to pass on his very best wishes to her.

This further reassured me that all was well. However, I now know that clearly the agent did not know and had never met Maureen Simms. We now know that she never had a property called The Gables to sell, or indeed any other property. But the agent obviously didn't want to lose face when dealing with such a lucrative potential sale, and so just blagged it.

James really did have the luck of the devil. People are often too scared to lose face or look foolish, so just played along with his agenda. This, however, only proved to strengthen everyone's belief in him. It was like the emperor's new clothes. If you tell a lie but tell it with absolute conviction, people will find it hard to doubt the integrity of what they are being told.

At James's insistence we came back to view the property on two further occasions. Once with Laura and Katie in tow – who totally fell in love with it and were arguing about which

bedroom they would each have. Then the final time with Mum, Karen and Ryan who were eager to see the "Palace for his Princess" that James was boasting about.

Mum adored the property at first sight, but was mindful about it being too far from her for her to be able to see me as often as she would like. She was worried she wouldn't get to see Charlie as much as she wanted and that I would feel isolated. Karen and Ryan were not so keen: Karen preferring a much more period, traditional property than a modern mansion – it was just a little too showy and soulless for her. However, Karen was very impressed with the lifetime gym and spa membership passes that came with the property.

"I'll happily relieve you of one of those bad boys," she joked; "a bit of pampering would be just the ticket."

We all laughed, and James winked at Karen before grandly announcing that Ryan and Karen would both be receiving one of the passes. They were absolutely thrilled.

As we walked around the periphery of the property for one last time, me pushing Charlie as he snoozed contentedly in his pram, I was surveying the many windows of the property and losing count of how many there were.

I nudged Karen, walking along beside me: "Would you take a look at all those windows? Imagine having to clean them; you'd only get finished and you'd have to start all over again," I said.

Karen laughed. "I'm in the wrong profession: I reckon window cleaners must make a fortune around here; maybe I should invest in a new bucket."

Karen turned her head away from me to watch as James and the estate agent were taking a leisurely walk along the extensive back garden together, deep in conversation. James

had passed his phone over to the agent, who appraised the screen for a few seconds before returning it to James. They were now shaking hands and smiling widely, both looking very pleased with themselves.

"What are Tweedle Dee and Tweedle Dum up to over there?" Karen asked me in a low whisper.

Laughing, I shook my head at her. "Looks like we're about to find out," I said with a shrug as I watched the two head back up the garden towards us.

James had a grin on his face as wide as a Cheshire cat's. "It's ours now, princess," he announced emphatically. "I've bought it for us: new home, new life, here we come!"

I just stared at him aghast. What was he going on about now? How could he have just bought it like that? We hadn't even discussed it properly. How much had he paid? Where was all the money coming from? Surely not all from his mother? There was generosity, but this was an absolute fortune.

I was quickly ushered into the vast open-plan kitchen by James, where a bottle of Veuve Clicquot champagne had suddenly appeared in an ice bucket with champagne flutes next to it for everyone.

What the hell? I thought, looking around the kitchen. Did everyone know this was happening, apart from me? As I looked at the faces of my mum, Karen and Ryan, I could clearly tell that they had also been in the dark.

Chapter 28

In his element

So just like that, James had bought our 'so-called dream house'. Half an hour later in the car, before we headed home, he brought his banking app up on his mobile phone for me to view. You could clearly see his current account with the £2 million early inheritance from his mum that she had transferred to him a couple of days earlier.

I had never seen a bank balance with as many zeros in it, and I'd worked in banking for years. It was indeed proof enough of James's new inherited wealth, so the house was marked as sold and James's solicitors were promptly instructed to deal with all the conveyancing required. James wanted it done and dusted quickly, so our dream house would be ready for us to move into as soon as we'd had our dream wedding. So many dreams that could shatter and instead become living nightmares.

Within the week, we duly received our Ramside lifetime membership cards for the gym and spa facilities, and true to his word James ensured that both Karen and Ryan received theirs – boasting of his generosity all over social media. These membership passes for the spa and gym must have cost hundreds of pounds a month each, but here we were with them

in our possession scarcely after the offer was accepted on the property. Everyone was so incredibly confident that things would go without a hitch. Why wouldn't they? James was a solid, upstanding salt-of-the-earth sort of guy, a man from money; I lost count of how many times and from how many people I heard that.

No one ever doubted James, hardly anyone ever questioned him, and on the occasions that someone did, they would be reassured that everything was absolutely fine. He was so believable and trustworthy, hiding all his lies in plain sight.

The next couple of months passed in a bit of a blur. We were all so very busy, the house sale coming along nicely. Even though it was James solely purchasing the property at Ramside, he had requested that I get copied into all the relevant emails. They were flying between his solicitors, James and also to DNA Limited, an interior design company that James had enlisted to oversee the new house's interior design, and also the @Scotts business at the Quayside.

I met the representative from DNA on several occasions, and he was an extremely professional, friendly man. We would meet mainly at the house, but once at the Pravda property. He had many great ideas for the décor of both, spending many hours of his time on designs, plans, layouts etc. He was an extremely talented designer with a wonderful artistic flair and vision. Time would prove that all the effort he spent working for @Scotts and the Ramside property would not bear fruit. He was working for a mirage, developing a vision for properties that had not been secured by James Scott. The poor man had his valuable time and resources squandered.

Everyone said that @Scotts was progressing well, all contracts signed by all the parties involved, so this business and

the property sale were apparently going ahead without a hitch.

While Karen and I continued working our day jobs, James was now busying himself with the exciting activities of purchasing and developing @Scotts. He was often engaged in lengthy telephone conversations with his mother and the PR company – The Works, that he had brought on board to help with marketing and such like.

In time, Karen and I met with the team from The Works at an impressive two-hour long presentation, where they showcased how they would be able to help @Scotts with all our PR and marketing needs. They were a very professional outfit, and James was firing demands and questions at them left, right and centre. The meeting, we all agreed, was a tremendous success, and we all collectively felt we could achieve the @Scotts dream with this PR company working for us. James was clearly in his element during this meeting: he was always at his most self-assured and animated when he felt he was in charge and centre stage, being the big man and calling all the shots.

Life was a busy whirl of activity; however, it was important to me that we still had good, old-fashioned family time together. I was concerned that James was taking on too much, always dashing around from one place to another. Mum and Yvonne had stepped up and were watching Charlie much more frequently during the day while I worked, but James still had so much on his plate.

The wedding was fast approaching, and although I had been for more dress fittings and was overseeing arrangements with Donna, James was still doing the lion's share. He really seemed to be thriving on it all, and he excelled when he was busy; but I still couldn't help worrying about him.

Chapter 29

Barbecue and bust up

I figured that a little down-time was what we all needed, and as the weather forecast for that weekend in early May 2016 was for it to be warm and pleasant, I figured a nice barbecue on a Saturday afternoon would be perfect. I invited my mum and Yvonne, Karen and Ryan around to the house. Laura and Katie were with me that weekend anyway, so it would be a full house. I smiled to myself: I loved our quality family time, and as a social life definitely seemed out of the question at the minute, this would certainly perk everyone up.

Karen and Ryan arrived with some of Ryan's home-made potato salad and some steaks. Ryan was in good spirits as he loved nothing more than a good barbecue, so that sunny Saturday afternoon he busied himself sorting out the copious amounts of meat, marinating them and then cooking them on the sizzling hot coals. As a South African man who loved nothing more than a good braai, the barbecue was certainly his domain; no one else could get a look-in, which was fine by everyone else, as that meant we could chat and have a nice relaxing drink enjoying the fine weather.

Karen and I laid a makeshift trestle table in the back garden,

laden down with the home-made potato salad, coleslaw and salads. I stared happily around the garden at my girls good-naturedly teasing their grandma and Yvonne happily laughing along too, bouncing little Charlie up and down on her knee.

Earlier that day I had asked Yvonne if she would like to be Charlie's godmother. I hadn't yet got around to sorting out the finer formalities, but it was firmly on my to-do list. I had spoken to Karen too and had asked her to be Charlie's second godparent. I had briefly considered James's sisters, but then disregarded them just as quickly: they lived too far away, and anyway they still hadn't met Charlie and the dynamics of James's family couldn't match the closeness of mine. I wanted Charlie to have the best role models he could, not just the more successful, wealthiest ones.

Yvonne's eyes had filled with tears when I broached the question with her. She had lost her darling husband Ken some years earlier and had never had children of her own. She was incredibly touched. "I'd absolutely love that," she exclaimed through sniffles as she sobbed into a tissue. "Our Charlie means the world to me."

I hugged Yvonne to me tightly: she was such a wonderful person and had such a lovely bond with Charlie, it really warmed everyone's heart that she agreed to be godmother. Yvonne wasn't related to us, just Mum's best friend, but she was just as big a part of our family as any of us were.

Karen too got a little choked when I asked her, even more so when I declared we were hoping to have the christening on 24 July if possible, which was our dad's birthday, so even though he couldn't be with us, it would mean he would feel close to us and make the day that little bit more special.

I made a mental note to get on with the organising as soon

as I could. I think the news of Charlie's upcoming christening made the afternoon even more pleasant. James was not there for the beginning of the afternoon's events as he was at a pre-arranged golf tournament at Rockcliffe Hall, but he did arrive about an hour into the afternoon's festivities. He had of course won, he gleefully announced, proudly brandishing his prize of a magnum of Moet. James being James made a show of shaking the bottle vigorously and exploding the cork for maximum effect, spraying champagne over everyone.

We all laughed at his antics, though Karen was tutting impatiently. "Bloody hell, James," she scolded, "stop pratting around wasting it and get the bugger poured." To which everyone laughed.

Glasses of champagne were happily imbibed by all the adults as they relaxed and enjoyed the warmth of the afternoon sun. The soft rock music was blaring out from Katie's music system. Mum, still very youthful and spritely for her 67 years, was dancing and twisting to the music, accompanied by clapping from everyone.

"Grandma, you're shaking your booty there like a bad ass!" Katie squealed with laughter. "You'd give us a run for our money with those moves."

Mum laughed. "I'm not doing bad for an old codger," she exclaimed, twisting down to the grass and back up again in one fluid movement.

Ryan turned the meat on the barbecue before leaving it sizzling for a minute to run over and start dancing along with Mum to 'A-Ha's Take on Me', one of Mum's favourites. Everyone was merrily clapping along to the beat of the music – well, everyone that is apart from James. I glanced over in his direction with concern. What was the matter? He was normally

the life and soul of the party. He had a dark look of foreboding on his face; he really did not look happy at all. Was this because all eyes were on Mum and Ryan? Looking at him, I felt a little uneasy. I'd organised this afternoon to be fun, to relieve some of the stress for James, but it looked as if he was now having anything but fun.

James turned away from my stare and busied himself lighting a wood burner that was on the patio next to him, but to no avail: as he fiddled with the kindling and firelighter, it simply would not light. Ryan commented jokingly that although he might be adept at putting out fires, he couldn't start one to save his life. It was a harmless enough joke, but it was evident to everyone that the atmosphere of the afternoon was changing, and not for the better.

Soon the food was ready and everyone tucked in, enjoying the juicy steak and marinated chicken, congratulating Ryan on how well everything had turned out. Ryan was delighted, lapping up all the compliments; he took his braaiing very seriously.

It was clear to everyone that James was not in the least bit impressed. Was Ryan hogging too much of the limelight for his liking? It wasn't long before Laura and Katie had excused themselves with some lame reason to escape to the sanctuary of their bedrooms.

I took Charlie off to the living room and deposited his squirming little body on his changing mat to check on his nappy. I had no sooner laid him down when James was standing over me, looming down at me. He was not happy, and clearly was spoiling for an argument. It really wasn't like James at all.

"Do you think you should be looking after Charlie in that

state?" he spat out at me, his face contorted in rage.

I looked at him in confusion, not understanding what he meant. "What do you mean, that state?" I asked indignantly.

He rolled his eyes in an exaggerated manner. "When you've been drinking so much. Here, pass Charlie to me, you clearly can't be trusted." He didn't give me a chance to answer before he lifted Charlie up from the changing mat and set off around the lounge carrying him in his arms.

I leant back on my heels and stared at him in disbelief. I'd never been much of a drinker, but since abstaining throughout my pregnancy, if I could manage two glasses of wine now I was lucky; and on this occasion, with all the hosting, I had barely managed more than one glass of champagne. He wasn't listening though as I told him this, instead striding around the lounge with Charlie, ranting like a madman. He told me that he would not stay somewhere where his opinion was not valued, somewhere where he felt he was being laughed at and disrespected by 'my' family.

With those words ringing in my ears, he passed Charlie back to me, grabbed his car keys off the coffee table and stormed out of the front door, slamming it behind him.

I watched his car speeding away up the street, barely com-prehending what had just happened. What the hell had all that been about? He had said I was drunk when I clearly wasn't, and he claimed that I was not in a fit state to look after Charlie; he had taken Charlie off me, only to then hand him back to me, the one who could not be trusted with a child, and leg it off out of the house. What was he thinking and where was he going?

I returned to the back garden, where everyone was sitting in hushed silence, looking very uncomfortable. It was clear they had overheard everything said between myself and James.

The fun family barbecue had fizzled out and come to an early finish. It was somewhat reminiscent of the Boxing Day debacle when James had once again felt outdone by Ryan and been the butt of the joke. That time he had allegedly sped off to be at the bedside of his ailing grandmother, but this time I had no idea where he had gone.

Embarrassed, I apologised to everyone, so confused as to why James had suddenly become so angry.

"Don't worry about it," Karen reassured me. "It's no big deal; it was still a nice afternoon." She smiled at me, but the smile didn't quite reach her eyes.

Mum was busying herself filling Tupperware boxes with left-over meat and salads for everyone to take home. I remember she was quiet, but had a rather worried expression etched on her face.

Yvonne gave me a brief hug and reassured me that it was fine and not to be too concerned, as no doubt James would be back soon with his tail between his legs. It was clear, though, that they were just as stunned as I was by his behaviour. With that, everyone bid me goodbye: Mum and Yvonne to cross the road to their respective homes, and Karen and Ryan to walk the mile or so home.

Chapter 30

Bratty behaviour

James did return a few hours later, full of apologies. He was so sorry, he knew he had really over-reacted, but it was all coming from a good place, a place of genuine concern. He explained in that moment that he had just been worried for Charlie's welfare as I had been drinking. He explained to me that Jill, his ex-wife, had been a bit of a drinker, and it had always brought out the worst of her personality. He was used to her controlling behaviour anyway, but when she'd had a few drinks, she could be antagonistic and angry, sometimes even violent to him. It had left him with deep emotional scars, and it made him so very wary when he was around people drinking.

He took my hand and looked deeply into my eyes. He knew I wasn't a drinker, and he was so sorry he had behaved in such a way, but Jill had left her legacy; he knew how she could turn so nasty at the drop of a hat. I listened and nodded and even returned his hugs when they were offered, but the unease did not fully dissipate. Surely he knew what I was like? I would never do anything that would endanger Charlie or any of my children. Why was this the first time I was hearing about Jill's problem with drinking? And more importantly, why on earth

bring a magnum of champagne to a family barbecue if you were so anti-drinking? Or storm out of the house for hours, but leave behind your son whose safety you were so worried about?

He was so very sorry that eventually I relented. Didn't we all have our own demons in some way or another? Past relationships always leave their scars. Maybe this was James's demon? I should support him. After all, he was always saying he loved me so very much – the tattoo on his wrist was a testament to those words.

On the whole, James continued to be the happy-go-lucky, charming character that I had fallen in love with; but this darker side that I had encountered would rear its ugly head again on occasions.

Only a few weeks after the disastrous family barbecue, we were due to go out again for another family celebration. Emily, Karen's daughter and only child, had just turned 18 years old. Emily had been busy celebrating with her friends on her actual birthday, but the following Saturday Karen had arranged a convivial family meal out as a belated family birthday celebration. It was to be Karen and Ryan's treat, and no expense was to be spared. A lovely restaurant called Rosa 12 in nearby Gateshead had been booked for 7 p.m. All our family were going to be there, including one of Emily's closest friends.

The evening started well, a fun night with plenty of laughs and chatter, us all reminiscing about Emily as a child and many family anecdotes being shared around the table. James, I noticed, was once again in a sombre mood: he was sitting next to me at the very end of the table and not in the centre of the action, which is where he ideally liked to be.

I kept asking him if everything was all right and encouraging

him to tell me if there was a problem. He kept reassuring me that everything was absolutely fine. I remember thinking that maybe he just felt a little left out: after all, a lot of the reminiscences were before he was part of the family, so maybe he felt he could not contribute. But it was not like James: he was not one to fade into the background; he was much happier taking centre stage.

As the starter plates were being cleared from the table by the young waiter, everyone told him how lovely the food was. Emily was at this stage already fairly tiddly, and was chatting enthusiastically to the handsome young waiter; he blushed somewhat, to everyone's amusement.

The main courses arrived promptly, and they too were very good. Everyone had plumped for the steak apart from Laura and Katie, who had decided on the Margarita pizza. After several minutes I noticed that James had no steak on his plate. Surely he hadn't finished eating it already? Karen had noticed too.

"Where's your steak gone, James?" Karen's voice was tinged with confusion. "You can't have wolfed it down already."

James did at least have the decency to look a little shame-faced as he admitted that he had thrown it on the floor under the dining table. He said it was inedible, like old boot leather, and he couldn't bring himself to eat it.

Karen stared at James aghast, clearly stunned by his behaviour, both by how ignorant and childish he was and also by his total lack of respect for the family celebration. It was beyond belief that he had thrown his perfectly good steak onto the floor. To add insult to injury, he wasn't even the one paying for the meal: Karen and Ryan were picking up the tab.

I was mortified beyond belief by James's behaviour, even

if his steak had been inedible, but I severely doubted it as everyone else at the table was commenting on how lovely their steaks had been. Why would he behave in such a horrible, disrespectful, ungrateful way?

I could tell that Karen had made the decision to play down James's behaviour and try to keep up the lovely celebratory atmosphere for Emily's birthday; especially as it appeared that nobody further down the table had realised what had occurred. Karen was also clearly conscious of how embarrassed I must have felt, as his behaviour was totally inexcusable.

Was this purely brought on again because he felt left out? Not the centre of attention? Did he feel that by throwing his food on the floor he was somehow asserting some control? Did he think this warranted him behaving like a spoiled, truculent child? Last time he had blamed me for drinking too much; this time it was the standard of the food.

I tried to shake off the feelings of uncertainty that gripped me. James was just stressed, acting up, he had such a lot to deal with, and maybe all the family talk had reminded him how much he was missing his daughters in the States; but deep down I knew this was no excuse for his appalling behaviour. It's hard, though, when you are in the middle of a situation to see things clearly; you make excuses for things and want to see the best in people.

It would be a few more weeks until we would go out again socially, of course with James always, as I now never went out socially without him.

The Works, who were heavily involved in setting up @Scotts, were the next venue where we socialised. The company was hosting a black-tie celebratory charity event at Ramside Hall on 17 June 2016 to celebrate the company's anniversary. James

had been invited with me and Karen. I asked James why there was no ticket for Ryan: it was strange that they would give Karen a ticket but with no plus one when they knew she had a partner. James shrugged and told me he had no idea: only three tickets had been sent, so only the three of us would be going.

"Could you not have wangled a ticket for Ryan too?" I asked James one evening over dinner. "It would be so much better if he could be there; it's a bit odd just being the three of us."

James shook his head firmly. "No, if they had wanted to send another ticket, they would have. I'm certainly not going to go begging for one." With that the conversation was over.

More likely is that James had just binned Ryan's ticket when he received it or told The Works that Karen would be attending on her own for whatever reason.

The evening turned out to be a lovely event. James was absolutely in his element, schmoozing with everyone, and he really was a big hit. He was entertaining the table with the fascinating tales of his career in the fire service and details about encounters his mum had had. As Maureen Simms was an extremely successful sports agent, she had come into contact with various celebrities, and James was keeping the table enthralled with little snippets of gossip and funny stories.

At one point James received a telephone call in front of the whole table from his mum. As this was a charity event, she was kindly transferring £2,000 into James's bank account that very moment, and she was adamant that he should bid on one of the lots. I felt touched and incredibly proud; what a kind thing for her to do.

We enjoyed a lovely four-course meal, a guest speaker and a disco with a live band playing hits from various decades. The

atmosphere around our table was relaxed and convivial. Karen was enjoying herself, but I could tell she missed Ryan, wishing he could be there as she was the only person on the circular table who was not in a couple.

Everyone was laughing and making the most of the evening, enjoying the complimentary wine and getting to know each other better. Once the dessert plates, cheese and port had been cleared from the table, the charity auction kicked off. I soon got carried along in the excitement, and with Karen's agreement we were encouraging James to bid on all sorts of gifts and events. James, however, kept shaking his head, seeming reluctant to actually get involved. It was surprising, as there were so many lots that I thought would appeal to him: golfing events and spa days, even a clay pigeon shooting afternoon, but he seemed not to fancy any of them.

"Come on, James," I cajoled, giving him a nudge. "Your mum's given you the money to spend, she wants to support the charity."

James smiled briefly but kept his head down, the quietest anyone had seen him all evening. I kept pushing him, encouraging him to lift his arm to bid, but he was adamant that he was waiting for the perfect lot to come up; when it did, he would make certain that he was the one to win it.

I felt really disappointed, and I'm sure that Karen did too. When the auction came to a close without James making a single bid, I turned to him in annoyance.

"Come on, James, that money was for charity; you should have bid on something." I shook my head in disbelief. "I just don't understand you sometimes."

Karen felt the same as me: for someone who loved to be the centre of attention and had this money so benevolently given

by his mother, why had he failed to make a bid?

James turned to me huffily, claiming that nothing had taken his fancy; there were plenty more charity endeavours he could give his money to if and when he wanted to.

He stood up, abruptly pushing his chair away from the table, and stormed off. So that was the end of that. It all felt a bit flat: he had put on such a big show, but it had all ended up feeling a little empty.

With the event drawing to a close, we thanked The Works team for their hospitality and made our way home. James was rather quiet and sulky in the car, I was annoyed and very tired and really just wanted to collapse into my bed, keen to relieve Mum from her babysitting duties. If James wanted to act like a petulant child he could please himself.

Chapter 31

Celebrity chef

There appeared to be much happening and everything moving along well with @Scotts. The Works were doing a fantastic job with the advertising, and the buzz of a new wine bar restaurant soon to open at the Quayside was beginning to gain momentum.

Andrew Roberts, Maureen's business manager, had emailed everyone involved, wanting their ideas and input. He felt that the business, even though ideally situated in Newcastle, was still only a fledgling business and needed a bit of a boost. He felt that while working alongside The Works, we should all try to come up with suggestions about how and what would attract more interest and, as he put it, "create a buzz that couldn't be ignored".

Maureen, he said, had plenty of contacts; and if James, Karen and I could put our heads together too and really brainstorm, we should be able to come up with something.

It was a couple of days later, in the middle of June 2016, that James asked if Karen and I could meet him for a quick impromptu lunch at a pub not too far from the office. He had big news and wanted us all to be together to discuss it.

Karen was not too happy to have to find someone to cover the office at such short notice, but curiosity got the better of her, so she managed to arrange somebody to watch over the office for an hour.

So, on that sunny Wednesday lunchtime, Karen and I headed off together to meet James. We were barely through the sturdy door of the Dun Cow pub in Durham when James saw us approaching and quickly jumped out of his seat, obviously fizzing with excitement. He was all but doing a little jig on the spot.

"Have I got something to tell you two," he enthused, with a secretive little tap of his nose. "You're going to be totally blown away."

He was so giddy that it was difficult to work out what he was saying. He was acting in an almost manic way, his words tumbling over themselves.

Karen quickly headed off to the bar to get a couple of menus and order some drinks. She gave a backwards glance over her shoulder, laughing as she went. "Try and get some sense out of him, Col. I'll be back in a minute."

Eventually James did calm down enough to impart his news, and he was right that it did indeed blow our minds.

His mother, through her numerous business contacts, had managed to secure none other than Gordon Ramsay to put his name to our restaurant menu at @Scotts. Ramsay himself would not actually have any dealing with the business side of the venture, apart from endorsing the menu and having his logo on it.

Karen told James to stop being so ridiculous, and God help him if he was joking. Karen has always been a big fan of Gordon Ramsay, forever happily telling everyone who would listen that

the best meal she ever had was at Gordon Ramsay's Chelsea restaurant where she celebrated her 30th birthday.

However, James was true to his word, and he had emails between Andrew Roberts and the Ramsay group detailing everything, proving that everything James had told us was indeed true.

Apparently, the north-east of England was where Gordon Ramsay really wanted to break into, as he had no presence there yet. Many up-scale eateries were opening in that neck of the woods and making a name for themselves. His nemesis, Marco Pierre White, had a restaurant franchise that was doing very well in the popular Indigo hotel in the centre of Newcastle. Gordon Ramsay and Marco Pierre White were supposedly very competitive, James explained to us, running a well-publicised feud. So this had spurred the Ramsay group to spring into action and establish a standing in the city too.

Karen was beside herself with excitement: it was like a dream come true.

"Can you just imagine us getting to meet him?" she asked me with her blue eyes shining. "It would be amazing." She was clearly incredibly excited, as was I. This was a real coup that would put our little restaurant firmly on the map.

James was basking in the glow of our enthusiasm, loving that he was the man of the hour again and making our dreams come true.

This interest from the Ramsay group, and all the other jobs to undertake when setting up a new business, kept James very busy. Representatives from the Ramsay group came to meet with James and Andrew Roberts in the Pravda building on Saturday 2 July 2016. Karen and I were absolutely gutted that this was the only date they could make; given our work

with Durham University in student letting, this was one of the busiest times of the year for us, when new students arrived and old ones left. There were numerous check-outs of properties and inspections to be done, so it was impossible for us to be free that weekend. However, we were on tenterhooks all day, keen to know how the meeting went.

Not to worry, we were copied into an email from the Ramsay representatives later that day. They were delighted with the Pravda venue, and the professional attitude of James and Andrew, even commenting how little Charlie was the star of the meeting. Everything had gone so well that it was full steam ahead!

As well as the Ramsay emails, I was still being copied into all the relevant emails about the house purchase; and despite there being some issues with the Council's adoption of a road running alongside the property, it all seemed to be ticking along nicely. James was very optimistic that the purchase would complete in plenty of time for the wedding.

Karen and I were making the most of our Ramside spa and leisure centre passes, enjoying, or should I say enduring, early morning gym sessions before work, and I would often have a swim with Charlie at the end of the working day.

I was trying hard to lose the 'mum tum' that was still hanging around since my c-section, and not being much of a gym enthusiast, it was proving a lot harder to shift than I had hoped.

Chapter 32

Promises

The wedding was fast approaching: it wouldn't be long before I went for my final wedding dress fitting; but the thought of struggling to zip up the ivory dress was filling me with dread.

Despite my concerns over my waistline, I was starting to feel a bubbling of excitement. I was nervous too, but a wedding is such a happy occasion, a time when families can really join together. By then, I had resigned myself to waiting until my wedding day before finally meeting all James's family in one fell swoop. It was daunting, but so be it. At least I would feel good about myself, and let's face it, everyone must be nice to the bride on her wedding day.

One afternoon after work, I had to forgo my swimming session with Charlie as James had arranged a meeting with The Works at their office in Durham. James said it was incredibly important that Karen and I attended too. I was happy to go, even though James did most of the meetings and business arrangements. But Karen and I felt it important that we keep an active interest too, to support James so that it didn't all fall on his shoulders. Also, as Karen would often remind us, there

was £30,000 of her money tied up in this, and we all really wanted it to be the success we knew it could be.

At the meeting, while we chatted amiably about the business and the direction it should take, James's phone rang: once again it was his mother, Maureen. You couldn't help but notice how much of a hands-on approach she appeared to be taking with @Scotts, and I was really pleased.

James seemed to be getting much closer to his mum, and she obviously had invested heavily in the business, believing that James was up to the job. I knew that their relationship had been strained in the past, but surely this validation from his mum could only be a good thing.

James took the call outside while Karen and I made small talk with The Works team, waiting patiently for James to return. We were curious to hear what had been so urgent. When James did return, it was with a big smile spread across his face. He agilely jumped onto a chair and declared that he had an announcement to make. His behaviour was certainly unorthodox and raised a few eyebrows, but everyone around the table waited in hushed anticipation to hear what he was about to say.

His mother had made some calls, spoken to the singer Sam Smith's management team, and had been able to secure the singer to perform at the opening night of @Scotts.

James enthused, as Sam Smith was a local star-done-good, hailing from the north-east of England; it was a coup to secure Sam for our opening. The Works team were buzzing over the news. James was very stern though, as he reiterated to everyone in the room that although this information was very exciting, it was completely confidential and should not be made public knowledge. He was very much relying on everyone's discretion; so collectively everyone nodded their

agreement.

Later we had a good old laugh back at my house when Karen laughingly told us that we could rely on her discretion as she had no idea who Sam Smith was!

While The Works busied themselves with the exciting PR arrangements to be made for @Scotts, James told us that the renovation work on the Pravda building was now well underway. He had shown us the quotes he had received from James Richardson, the interior designer and architect, who was going to oversee all the work. It wasn't a small undertaking by any stretch of the imagination, but everyone was optimistic that it could be completed within a reasonable timescale; this would give The Works plenty of time to do their research and make the launch a resounding success.

This suited Karen and me, as we rarely travelled into Newcastle anyway; what with living in Chester-le-Street and working in the centre of Durham, it just wasn't feasible, plus the fact that we would probably just get in everybody's way. So Karen and I were quite happy to take a back seat.

Chapter 33

Christening charade

I was now busy sorting out the arrangements for Charlie's christening. The date fixed was 24 July 2016, on Dad's birthday. Our dad was so missed by everyone, and he would have dearly loved to have a grandson. I felt this was the very least we could do to make the day even more special.

It was going to be a small family affair: the service held at a local church and then back to my house for the afternoon. I had my fingers crossed for the weather to be nice, as I had splashed out on a bouncy castle for the back garden for the children.

Of course I had invited James's family, although understandably his daughters and sister Jodie couldn't make it as they were overseas, but I'd made sure that they knew how much we'd have loved them to be there.

Bronwyn had been non-committal, as James had put it; but if I'm honest about his sister, and from what James had told me and the messages I'd seen from her, she seemed a little too cold and forthright for my liking. Secretly I breathed a sigh of relief that Bronwyn would not be able to come.

James's mum had not confirmed yet, but James was quietly

optimistic that she would make it. After all, it wasn't too long a flight from France, and with her new business interest in @Scotts, we hoped she was feeling in a much brighter place.

Imagine how magical Charlie's christening would be if it was also the first time he met his other grandparents! I smiled to myself at how this would really make the day one to remember.

However, it wasn't to be, as on 14 July 2016, only a week or so before the christening, we awoke to hear some very alarming and frightening news. There had been a terrorist attack in Nice, where Maureen and John lived, on the Promenade des Anglais. James knew that his mum could have been in the vicinity of the attack, so he was in a terrible state of panic – we both were.

Maureen did not answer or return any of the calls or messages that James frantically left for her; there was no reply from John either. Bronwyn and Jodie could not throw any light on their mum's plight. They were all trying desperately to contact their mum, but were having no luck.

It wasn't until much later in the day that Maureen finally made contact, to say that they were both safe, but the shock and fear inflicted on them had taken its toll. They couldn't even contemplate travel at the moment. I was so disappointed, but of course relieved that they were both safe; it could have been so very much worse.

It had been devastating for so many families, but thankfully not Maureen and John – but then again Maureen and John were not actually in Nice, never having been there, even on their holidays as far as I am aware. The horror of the terrorist attack had played right into James's hands, a perfect excuse for his mum's absence from Charlie's christening.

The fact that James had us all worried unnecessarily about his mum was just another sick ploy to achieve what he wanted.

While families really feared for their loved ones' safety in Nice, his 'fear' was purely a lie, another one in his ever-increasing catalogue of reprehensible vile actions.

The day of Charlie's christening finally arrived, and as I had hoped, it was a lovely bright, sunny July day with hardly a cloud in the sky. Mum came round early to help me set out what we could of the buffet, before we headed off to the church in the neighbouring village of Sacriston.

"Here's the star of the show," Mum announced brightly as she came in through the front door, her arms laden with a gigantic home-made strawberry trifle she'd been up at the crack of dawn that morning to prepare. I smiled at her as I hurriedly set down the platters on the table.

"Isn't the star of the show supposed to be Charlie?" I asked, laughing. "Anyway, I think this beauty outdoes even your trifle." I gestured to the centre of the dining table where in pride of place sat Charlie's christening cake.

Mum carefully placed the large crystal bowl down on the left corner of the laden table and surveyed the cake in all its glory. "Well, it sure is different, love, I'll give you that," she admitted. "James's idea, I take it?"

I grinned. "Whatever gave you that idea, Mum?"

Yes, James had been adamant about the cake: we were to have no traditional ivory sponge cake. Charlie's cake was a bright red fire engine, resplendent with flames, and with a little firefighter in situ. It was very impressive, if not a little unusual.

I turned my head to glance out of the patio doors, where the huge bouncy castle had been erected.

"It's more like a kids' birthday party than a traditional christening," Mum commented huffily.

I laughed off her comment. The whole day had James's stamp all over it: a fun and flamboyant circus, with James the ringmaster at the centre of the entertainment as usual.

It was going to be a lovely fun afternoon. The christening service was beautiful, and then the afternoon celebrations back at my home were indeed a resounding success. The bouncy castle proved almost as much of a hit with the adults as it was with the children.

Ryan's nephews and niece had come to join in with the fun and were having the time of their lives. The only slight shadow darkening the afternoon was an atmosphere I picked up on between my two girls and Ryan. While in the past they had always got on incredibly well with Ryan, laughing and joking, now it all seemed a little curt and stand-offish. The girls spent most of their time huddled with James, whispering between themselves. When I broached this subject later with them, they shrugged it off, seemingly not wanting to talk.

Had James been implying things again? Twisting the facts? Making it seem that Ryan was after me? Which was absolutely ridiculous. Surely not, they were teenagers after all and prone to moodiness. No, I decided, shaking my head it had been a lovely day and James wouldn't try to spoil that.

Charlie was now a fully-fledged member of the Scott family, his birth and christening certificate displayed proudly in the living room, alongside the many cards and gifts he had received.

He was such a happy little boy and absolutely thriving, his precarious start to life now well behind us. He was a contented and healthy little boy, his future now looking so bright. He was now named and official, with his proud godparents around him. If only we'd known at the time what a complete farce that

whole day was: celebrating little Charlie Scott with his brave firefighter father holding him up proudly in his arms for the many photos, when it was all just a web of lies.

The father's fake name on poor Charlie's birth certificate, the fake profession, the fake signature making Charlie's very existence fake. Barely six months old and saddled with lies that would prove near impossible to rectify. I look back at the photos of James beaming proudly at the camera, flinging himself around on the bouncy castle, acting like the biggest kid there, clearly giving little consideration to his injured back, while I tried to usher him off it, scared he might hurt himself further. But he just laughed and bounced twice as high.

Did he feel no remorse? Pulling all our strings, like we were puppets in his twisted show. I like to think that on some level he must have felt some remorse, but I know deep down in my heart that no, he was loving every minute of it. And his show was far from over.

Chapter 34

Gemini

Autumn arrived, the leaves changing colour, and you could almost smell the change in the air. Time was flying past so quickly. The house sale was ticking along fine and contracts should be exchanged well in time for the upcoming nuptials. I was still reluctantly heading to the gym before work, conscious of the wedding dress I would have to fit into in a mere couple of months.

This was still turning out to be quite a struggle. James was forever popping into work with goody bags of cakes and pastries, and along with the flowers he still liked to surprise me with, there was often a box of chocolates too. Chocolate is my one big weakness, as if there's chocolate in the house, I have to eat it; it's as if it's calling my name from the pantry, and I can't ignore it.

James knew this, but still the temptations would keep coming. I teased him gently, asking him if he wanted me bursting out of my wedding dress. It's hard enough to lose the baby weight as it is, but he was making it so much harder. He would just laugh and tell me how beautiful I was.

I didn't want to hurt his feelings; after all, he was only being

kind and thoughtful, wasn't he? Like suggesting how I should dress, buying clothes he felt would "suit my shape better". Maybe I didn't dress conservatively enough? I always looked nice, or so I thought, but maybe he was right and there was room for improvement. I should perhaps dress more formally to suit the new business enterprise we were undertaking. He was only thinking of me and what would be best for me. It was always about me, and that couldn't be wrong, could it?

On one occasion James surprised me with a shopping trip. We arrived at an upscale boutique and he made a big show of flashing the cash and buying me a load of new 'more appropriate clothes'. He had the sales staff running around like headless chickens and it would have felt so romantic, rather like the scene out of Pretty Woman, if it hadn't been for the fact that the clothes he was choosing would have been better suited to my elderly aunt. They were beautiful clothes just absolutely not my taste. I tried to tell him this but he just laughed it off and said they were his gift to me and how beautiful I would look in them. Unfortunately, these garments never saw the light of day as they remained in their bags in the bottom of my wardrobe collecting dust. I had been back working in the office thirty hours a week for over six months at this point, and while really enjoying my job, the guilt and sadness I felt being separated from Charlie during the day was a heavy burden and it was taking its toll. I voiced my regrets to James about having returned to work too quickly, and how maybe I could reduce my hours at work. I just had too much to contend with and was beginning to feel I was really struggling. James appeared to be so supportive and would sympathise, knowing that I'd like nothing more than to have more time with Charlie.

One cold September afternoon in 2016, when James turned

up at work with Charlie, this time to give me a lift home, I sighed heavily as I clambered into the car, but was happy to be on my way home for the day, to spend the evening with my husband-to-be and my son.

"I've had quite the conversation with Mum today," James said as he studied the traffic in front of him.

I had sunk back further in my seat, waiting for whatever revelation I was about to hear. "Go on then," I prompted quietly. I did a silent prayer, as apart from the recent exciting business proposition, anything else relating to his mother seemed to be a worry. That poor woman had had so much to contend with.

"Don't look so worried, princess," he reassured me with a smile, "it's all good." He squeezed my knee affectionately. "You're going to like this news, I promise." And I really did.

I already knew that James's mum had many properties that she rented out around the north-east. I assumed that this was lucrative for her, and was told previously that she had enlisted a property management company to look after these. But I still wasn't aware how significant her portfolio of properties actually was.

James went on to tell me that she had some small, two-bedroomed properties in the Sunderland area, but also she owned numerous large impressive homes in the Darras Hall area. Through her sports agent connections, these were let out on temporary or fixed tenancy agreements to Sunderland United football players. Two of these tenants were Vito Mannone and Jack Rodwell. I nodded along, sounding impressed, even though I did not know who either of these footballers were.

James proceeded to tell me that his mum sympathised with

my plight. As a working mother she understood how I was feeling, as she too had put her career first and now bitterly regretted not making her family her priority. Honestly, as James was telling me this, waxing lyrical about how sorry his mum felt, I started to feel quite affronted. My job wasn't my life, it was simply my job, something I had always done to pay the bills and put food on the table. I had gone back to work through necessity, and hated being parted from Charlie. Yes, I loved my job, but I loved my kids more.

Maureen had had choices, and let's face it, even though she was supposed to feel so much regret for not being able to visit us, she wasn't running to the airport to jump on a flight to meet her new grandson. However, I bit my lip and allowed James to finish his story.

"Mum was just saying that it's daft paying good money to a letting agent when we have someone in the family who is fully equipped to do the job instead." James turned and grinned at me. "Just think, Col, you could work from home, spend so much more time with Charlie and still be earning, so you wouldn't lose your independence. Come on, it's a win-win situation surely?"

I mulled this over while James was humming to himself, his enthusiasm evident. Yes, it sounded great in principle, but it would be a lot of work to get a new letting agency off the ground, much too much for just one person. James quickly batted my doubts away with his hands.

"Nonsense, you'd have me to help and support you," he insisted confidently, "and I've been thinking a lot about it since speaking to Mum. What do you think about Karen coming on board too?"

"What, to come and work with Maureen's properties too? I

don't know, James. Karen runs that office, she loves her job and it's a steady and reliable income." I shook my head. "I can't see her just walking away from that at the drop of a hat."

James disagreed; he argued that Karen was even better placed to make the switch than I was. She already had her own portfolio of rental properties she could bring on board, and with managing those, his mum's houses and opening up our services to new tenants and landlords, how could it not be a success? Yes, it sounded good on paper, and the thought of having more time with Charlie had me won over already; but Karen, I really wasn't so sure about.

James was having none of it though, and took no time at all in filling Karen in on all his mum's and his plans. It was the chance for Karen to take complete control over her life and career for the first time ever. She had always worked for an employer, but now she could actually be her own boss.

Karen felt torn: she had the existing security of the office manager position she held at the Durham student letting company, and had enjoyed working there for many years. But she wasn't getting any younger, and this might be her only chance to invest in an opportunity like this. Although she had already invested £30,000 in @Scotts, she still had savings left. James was planning on investing £25,000 from the money he had been bequeathed by his mother, and if Karen decided to invest, she knew she would be able to raise this amount too.

Karen really wasn't sure what to do for the best, and Ryan also had his doubts. If she did decide to go ahead with James's proposed property business, it would use up all her remaining savings, and the inheritance from our dad would be gone.

After much soul-searching and agonising, Karen decided that it was too good an opportunity to miss out on; she

reassured Ryan that she felt positive about the investment and had a good feeling about the future.

Let's face it, James was after all a member of our family and had been for over two years. He was the father of her nephew, plus he was constantly assuring everyone that his mum had never failed in any business endeavour that she had undertaken. She most certainly would not allow her only son to do so. If anything ever did go wrong, she would bail James out. After all, James said it was the least she could do after being so distant in his life for so long.

James had already put plenty of work into his vision. He had cleverly come up with the business name, Gemini Property Services: Gemini because Karen and I were twins. Karen and I would be the two directors of the business, and our closeness as twins and ability to work together so well would be our unique selling point.

James would in effect be an unpaid pair of hands, helping to set the business up and be there when needed, but spending the majority of his time concentrating with his mum and Andrew on overseeing the running of @Scotts.

James was still doing the odd shift here and there at the fire station when he was needed, really just to keep his hand in and for the social interaction with the lads. He really did have everything worked out: he'd already employed a guy who owned Media Savvy to set up a website and email addresses for the business. He ordered 'To let' boards, brochures, flyers, a property management computer package, computers, phones, in fact everything you could possibly think of to run a business. There was also office space rented at a business park on the outskirts of Durham where we could hold meetings.

There was a social media campaign in full swing to get

Gemini Property Services noticed fast. James really wasn't hanging around.

He was so enthusiastic about the new property business that I remember him telling me we were beginning to build our family empire, something to be really proud of. He was so animated and alive when he talked about this business. He would hold my hand between his and describe how perfect our future together would be.

"As soon as we get Gemini up and running, Col, you'll be back where you should be with Charlie." James enthused, "No more stuck in a dreary office day after day with people you don't care about; you'll be back home where you really belong." He honestly didn't need to convince me: to me it was the perfect solution, and I couldn't be happier.

Ultimately it turned out to be the perfect solution for James too. Unlike me though, he wasn't thinking so much of Charlie's welfare: more that this would have me exactly where he wanted me; no more meeting people, especially men. I knew that James had an issue with me interacting with other men at work. I thought it was sweet that he could get a bit jealous; this only showed how much he loved me. At the time I didn't see it as being sinister at all. Yes, I was happy to have the chance to work on my own terms and be with my son, and James was very happy indeed.

Karen and I decided to not leave our existing jobs straight away. It was a busy time of year at the office, but it would tail off as the end of year approached and the students began to return home to celebrate Christmas. We didn't want to leave anyone in the lurch, so we decided to let James get on with setting up Gemini and we would both come on board fully at the end of December 2016.

Once Karen and I did start working full time for Gemini, mine and James's input in the business would be a little hands off for a while, with the wedding and our honeymoon on the horizon. Karen would cope well though, as Christmas time is always very slow in the world of property. James was not too pleased that I wouldn't be resigning from my current job with immediate effect, but I was adamant that it was the right thing to do and eventually he backed down.

He was getting what he wanted, he always did; he would just have to wait a few more weeks for it.

Chapter 35

Benevolent James

James was working incredibly hard to set up Gemini. He was so determined that it would be perfect and a resounding success. Social media and advertising, he believed, were the way to success in the current climate and could make or break a new business. We already had a Facebook page, Twitter account etc, but he had also come up with a perfect way to get positive advertising, our name out in the public domain and help worthy people at the same time.

James always prided himself on his benevolent nature, and it was indeed evident for everyone to see: from sacrificing his own safety when saving the life of a little boy in a burning building, to donating to charity by buying all the cakes at the training centre. He had such a big heart.

During our relationship, James had formed a friendship with a lovely couple, David and Angela, who lived in a village near us. James had met David one day while he was buying a sandwich, and they had started chatting. With James's winning personality and David's good humour, they had soon become firm friends. David and Angela had really warmed to James's big, infectious personality. They also liked his

cheeky chappy persona, which had won so many people over previously.

One day when chatting to James, David had mentioned in passing a friend of theirs called Lindsay. She had a Go Fund Me page for her young son Charlee, called 'Charlee Smiles'. Charlee was three years old at this time, had been born completely healthy, but had suffered a devastating childhood seizure that had left him heartbreakingly with life-limiting disabilities. Charlee therefore needed constant care, and his doting parents were finding it a struggle to afford all the equipment that was needed to sustain Charlee's quality of life. Hence why the Go Fund Me page was of such importance.

James had been moved by Charlee's plight, and since they were a local family, he had decided that it would be beneficial for everyone to get behind Lindsay's fundraising endeavours and help where we could. Karen and I were in total agreement with James: we could raise awareness for Charlee's charity and also Gemini Property Services at the same time; it was win-win.

James approached Lindsay and explained how he was setting up a new property business and would like to sponsor Charlee and support him financially. Lindsay was so happy and touched to receive the phone call from James, grateful for any support that would help Charlee. A meeting was quickly arranged for a couple of days later: Karen, James and I would meet Charlee in Lindsay's home to discuss how Gemini Property Services could raise funds and help support Charlee and the family.

When we met Lindsay, it was clear what a wonderfully warm lady she was: her love for her son so evident that it touched us all. I myself was especially moved by meeting the family: it made me think about my own son, Charlie. There but for the

grace of God; my Charlie was healthy, but he could so easily have been born with disabilities. It is cruel how fate can be.

We sat in Lindsay's living room as the adorable Charlee sat in his specially adapted chair: a gorgeous little boy with a shock of beautiful blond hair. James was striding around the room full of exciting plans for how we could help and raise awareness for Charlee. He promised to arrange a charity event solely in support of 'Charlee Smiles'. He would approach local businesses and get them involved too. He assured us that he would get his mum to donate her Aston Martin car for the day, as one of the lots to be bid for in a charity auction, and she would also use her contacts to ensure that the whole evening would be a resounding success and plenty of money would be raised.

Lindsay was so touched; it was clear she thought that James could be the answer to her prayers. What an amazing man to have just landed into her life. She was so grateful and hugged us all, telling us how incredibly happy she was to have met us.

It took no time at all for James to throw himself fully into his newly acquired role of benevolent business owner. His next move was to approach the radio channel Metro Radio, based in Newcastle, with the story of Charlee Smiles, and also to ask them to undertake advertising for Gemini Property Services. James was keen to have radio adverts aimed at both landlords and tenants running regularly on the station at peak hours.

James dealt mostly with a manager at the radio station who was a charming young woman called Ruth. She informed James that Metro Radio were also running their own charity event, called Cash for Kids, in the run-up to Christmas. James was very eager for Gemini to donate, and therefore pledged a £500 donation.

The adverts needed someone to voice them, and James decided that Ryan would be perfect for this. Ryan had a deep, soothing accent that James was adamant would be perfect to portray our message over the radio. Ryan was rather reticent at first when asked, but after much cajoling from James, he agreed that he would indeed voice the adverts. I remember thinking that maybe James knew his own rather high-pitched voice might not sound best over the radio waves, and that's why he didn't record his own adverts. However, I now realise it is more likely that he didn't want his voice being broadcast in case certain people recognised it.

Once Ryan had recorded the messages and was happy with the way they sounded, we all sat round to listen to Ryan's dulcet tones.

"It's a perfect combination!" James stated clapping his hands together enthusiastically. "Money for charity, and advertising for the new business."

Except that the charity Cash for Kids never received the money promised by the flamboyant, kindly business owner that was James Scott. Neither did another local and very worthy charity, the Joseph George Fucile Fund. James had learned about this charity and had met with the founder, Darren Fucile, on several occasions. Darren's son Joseph had sadly passed away as a little baby from a rare medical condition, and Darren was active in raising money for other families coping with sick children. It was his legacy to his son Joseph.

James similarly promised Darren the world, telling Darren that Gemini Property Services would be supporting the charity financially. James even took it upon himself to commit to run the Great North Run the following September alongside Darren in aid of the charity. James joked that he might suffer from

a serious back injury, but that wouldn't stop him running or limping the whole run for such a good cause. Darren was very touched by James's promises, and when James went on to tell Darren about Lindsay and Charlee, the Joseph George Fucile Fund kindly donated £500 to Lindsay for sensory equipment desperately needed by Charlee.

Ruth, the contact that James was dealing with from Metro Radio, also visited Lindsay and Charlee at their home with James in tow, keen to offer Metro Radio's support to such a worthy cause.

James was now in full swing with his fund-raising endeavours. He realised that this would not only maintain his presence as centre of attention, but also garner the adoration he craved so much. However, James Scott personally donated not one single penny to any of the charities from his own wallet. His huge, generous promises were just cruel lies once again. He never had any intention of helping anyone apart from himself, the only person he ever really helped. As a family, we also donated as much as we could to these charities. Laura and Katie even donated the entirety of their pocket money, but not a penny was ever attributed to James.

At the starting line-up for the Great North Run the following September, there would be no sign of James Scott. He never had any intention to run; this had always been just another empty promise.

Chapter 36

Health woes

We all believed that James was a wonderful, kind charitable man, an individual who would always try to help his fellow friends, a truly good person. But as is so often the case in life, don't the worst things seem to happen to the best people? I was therefore horrified when a couple of weeks later, towards the end of November, James sat me down to talk to me, fear etched all over his pale face. I noticed how tired he was looking, and how there were now deep crow's feet etched at the corners of his eyes, where before there had been none.

"I'm so scared, Col," he told me, his words thick with tears. "I've found a lump and I don't know what to do." His head dropped down and he held his sides as he sobbed deeply, a heart-breaking sound to my ears.

James gently told me through his tears that he had discovered a lump in one of his testicles when he had been having a shower that morning. He was understandably very worried. I told him he must make an appointment with a doctor as a matter of priority, and at my insistence he booked an urgent appointment at the Spire Private Hospital in Washington.

He told me that he wanted to attend the appointment alone, but I was adamant that I was going. I wanted to be with him to give him my full support and love. So after a couple of days' wait, we were sitting anxiously together holding hands in the bland waiting room. I was squeezing James's hand every few minutes and assuring him that everything would be all right. After what seemed like an eternity, but in all likelihood was only a minute or so, a young, attractive nurse strode into the waiting room with a clipboard held tightly in her hands. James was called in for his appointment. He gave my hand a soft squeeze and then let it go.

"I'll be OK on my own, princess," he assured me with a brave smile; and with that he scurried off behind the nurse down the corridor, both of them disappearing into a room together.

I respected the fact that he wanted to go into the appointment on his own, but I would have liked to have been there to give him my full support. He was such a brave man, though, and I understood that he wanted to have some privacy with it being of rather a sensitive nature.

James came out after fifteen minutes with fear still evident on his face. We headed back through the automatic doors of the hospital and made the short journey home.

Once we had returned home, James told me that the doctor couldn't confirm that it was cancer, but neither could he rule it out; further tests were needed. He looked me straight in the eye and confided that he was sure it was cancer, just from the doctor's demeanour and the urgency with which the doctor had arranged the scans. He admitted to me that he was very fearful.

James decided that his best course of action was to go privately again, back to his hospital of choice, the Woodlands

in Darlington. I witnessed several times when James claimed he was on the telephone to the receptionist. I remember Mum being there on one occasion and telling me with concern that she hoped James would be OK.

A few days after James's initial hospital appointment, on a crisp, dry November day, I decided we should have a nice trip out. James definitely needed cheering up, and I hoped we could do something to take his mind off things, at least for a couple of hours. We decided to take Charlie to a children's animal farm, Tweddle Farm in Hartlepool, where Ryan had previously lived before moving in with Karen. Ryan had suggested it would be somewhere nice to take Charlie: a few rides and various animals at the petting zoo, and Charlie could have the opportunity of feeding some of the animals.

Karen and Ryan, along with Ryan's nephews, decided to come along to add to the fun of the afternoon. The farm was quite busy, but not excessively so as it was rather late in the year and chilly for a farm visit, but we all made the best of it. We stood around chatting while we waited for one of the attractions.

Suddenly James's mobile phone started ringing. "Sorry, everyone," he apologised, motioning at his phone, "I really need to take this, it's my doctor."

Everyone nodded at James to answer the phone, and he walked a few feet away from us to do so. We all witnessed James on a lengthy conversation with his doctor, discussing possible treatments for his potential cancer. We could hear talk of surgery and chemotherapy from the distinctive male voice on the other end of the call.

I shivered, partly from the cold and partly with worry about James. Karen rubbed my arm in support.

"He'll be OK, you know, Coleen," she said. "We're all here for you, and he'll get through this, we all will as a family."

I smiled back at my sister, grateful for my lovely supportive family, but I realised what now had to be done. Our wedding was fast approaching, the following month, but it could not possibly go ahead now. I was so sad about this thought, but accepted it was reality. Everyone was so very worried about James and his health with his probable cancer diagnosis looming over us. How could we even think of getting married? The fear and cloud of worry would surely ruin the day.

Therefore, with much sorrow, James and I made the decision to postpone our wedding. Thank God we had Donna the oh-so-helpful wedding planner at hand to rearrange everything for us. She really was proving to be a star; nothing was too much effort for her. James showed me an email from here where she confirmed she would deal with the rearranging of the wedding, as James was in no state mentally to deal with it. He needed to concentrate on his health and whatever the future had in store for us.

While James waited for his follow-up appointments at the Woodlands Hospital, he threw himself heart and soul into the businesses. He said he had to keep his mind busy, or he would just fall into an abyss of fear. He was like a whirlwind, determined not to sit around worrying, but to keep himself as busy and productive as he could.

Chapter 37

End of The Works

J ust before the end of November, one afternoon whilst Karen and I were busy working at the office dealing with student emails, James burst through the glass entrance doors. He was in an extremely agitated state, about as far from his normal happy disposition as you could imagine. He informed us angrily that he had had enough of dealing with our PR company, The Works: they were unprofessional and didn't deserve our business.

"Who do they think they are?" he ranted, striding around the office with his face like thunder and his fists clenched.

Karen and I tried unsuccessfully to talk him round. As far as we were concerned from our dealings with The Works, they had always been very professional, and we had both been incredibly impressed. But James was simply not interested in listening to anything that Karen or I had to say on the matter. He stated that they were terrible, flaky and fobbing him off constantly, and they never returned his telephone calls. He had been left with no option but to sack them.

Karen and I stared at James in stunned disbelief: surely not, we had already invested so much time in the company, they

had done so much work for @Scotts, and we had even been invited to their anniversary charity event which we had all enjoyed.

But no, James told us it was done and dusted, they were sacked, and the matter was not up for discussion. He was the person who had spent most of the time dealing with The Works, and in his opinion, they were simply not up to par. The decision had been made and James was adamant; he could not be swayed on the issue.

Karen and I quickly realised it was fruitless to try to change his mind; there was absolutely no talking him down. I felt, and I'm sure Karen did too, that it would at the very least have been nice to have been consulted about this, especially as Karen's money, not just James and his family, was financing the business.

What had really happened with The Works though? How had they fallen out of James's favour so quickly? James had never mentioned any reservations about their professionalism previously, in fact quite the opposite. He would always gush about how impressed he was with them and their work ethic. Had something else happened? Had questions been asked that James would prefer to avoid answering? Had suspicions been aroused?

This sat very uneasily with Karen; she hated to admit it to herself, but she too was starting to have her own niggling suspicions about James. As time passed, not as much appeared to be happening with either business as she would have liked. Yes, there were many meetings to attend and loads of communication flying between all parties involved, but nothing tangible seemed to be happening; she couldn't help but feel anxious. Little doubts were creeping into her mind, especially

in the middle of the night, those endless hours when it is hard not to fret and sleep evades you. Karen had invested all of her money in the businesses, and so far had nothing to show for it.

Initially Karen went to speak to Mum about her worries, hoping for reassurance. Mum did indeed try to reassure her that all was good. James was family after all, so she shouldn't be concerned. Didn't business plans always take longer to come to fruition than first imagined? Whilst Mum managed to allay most of Karen's worries, she was still concerned and feeling vulnerable. With that at the forefront of her mind, Karen came to speak to me too.

A few days after Karen first started to feel doubts, she decided to speak to me. It was early one Saturday morning, and I was up as normal with Charlie preparing breakfast. I remember feeling shaken and hurt to the core with what Karen said to me in our telephone call. Where was this coming from? Why was she doubting James after all he had done for us? It felt like a betrayal that she did not trust James completely. He was one of the family and I loved him.

On some level, though, I understood her fears. Who wouldn't be uneasy to some degree when you had invested your life savings, whether it was with a family member or not? So with that in mind, I arranged a breakfast meeting the same morning at 10 a.m. in a coffee shop in town, to nip it all in the bud. I had no doubt that James would reassure Karen and all would be well.

I spoke to James, told him about the phone call from Karen and that we had arranged to meet. He was flabbergasted and quite affronted, but said that if this was how Karen felt, then it was best out in the open so it could be sorted. Katie and Laura were in the house that morning, and James shouted up the

stairs to tell them to get ready quickly as we were all off for a family breakfast, and it was his treat.

When we all arrived, Karen was already in the café, a cup of half-drunk tea cooling in its cup in front of her and a nervous look on her face. James strode confidently to the booth where she was seated, with myself and the girls following in his wake.

"Why have you brought the girls?" Karen asked in confusion. I quickly apologised, saying it was my weekend to have them, and James had thought it would be nice for them to come along so we could all get breakfast together.

Karen nodded with a grim expression on her face as she took a mouthful of cold tea. I could tell from her expression that this was far from all right: she couldn't understand why James had brought her nieces along to this meeting, which was about the financial doubts she was feeling. She loved her nieces, but she wanted to air all her worries with James, and she felt constricted having Laura and Katie there, as she knew how much they adored James.

From the outset, it was clear that James was extremely upset and disappointed that Karen could ever mistrust him. He wrung his hands pitifully as he voiced how hurt he was. He was soon to be her brother-in-law and was the father of her baby nephew. James loved our family so much and could never do anything to hurt any of us. The very thought was abhorrent to him. Any delays in the businesses were completely out of his control - like British Gas still working on the Pravda business.

His reasons were plentiful and seemed completely genuine. He was working so very hard. He reassured Karen that there was absolutely nothing for her to be worried about, and that he was distraught that there could even be the tiniest amount of mistrust towards him, especially with everything he was going

through with his health. He really didn't need any additional stress, and neither did I.

At this point James took my hand in his and looked meaningfully at Karen. She lowered her head, clearly feeling embarrassed, and as she looked up she surveyed the family eating breakfast and felt wretched. We were such a lovely family and she could see the hurt in her nieces' eyes. They loved James so very much and were fiercely loyal to him. They looked disappointed that Karen had even doubted him and it made her feel incredibly guilty.

Karen later told me that she had felt ghastly. She was sorry for being unfair and demanding, especially at this time when James and I were so worried about his health. She hugged me close and apologised and told me to forget everything she had said.

"I'm so sorry, Col. When you walked in with James, I was shocked by how tired and pale you looked," Karen told me with obvious concern. "You're not looking like yourself these days." She looked me over again and took in my flat brown boots and tan-coloured cardigan with a sigh. "You just don't look like you: you always joked that you wouldn't even go and put the bins out without your lipstick on."

I smiled, but make-up and clothes seemed low on my priorities now. Caring for my children and worrying about James were about as much as I could cope with. Anyway, hadn't James told me how beautiful I looked as we walked out the door to come to this meeting? He was always reassuring me that I didn't need make-up and it was just gilding the lily. He told me that natural beauty was what he preferred, not the tarty look. I wanted to keep him happy, and surely his opinion was the one that mattered most.

Chapter 38

Pursuing the rugby

November soon turned into December, and James, ever keen for opportunities to advertise the new businesses, decided to approach the rugby team Newcastle Falcons. He already had an association with the club, as previously, when realising what an avid rugby fan Ryan was, James had purchased four hospitality passes for the club. This meant we had VIP status at all the home games with complimentary dinner and drinks. Ryan had been overwhelmed by this generosity, as he loved nothing more than watching rugby, it was his passion. James basked in the praise from Ryan: he really did love to be appreciated, and would always manage to find ways to make sure he was in everyone's good favour. James would often take business contacts out too, using the passes, so he felt it was a good sound investment.

Whilst Karen and I couldn't have cared less about watching the rugby, we were keen on the social aspect and the delicious food and wines. It was always a good afternoon out, often with Karen and I sitting alone with Charlie in the function room whilst everyone else was outside on the terraces enjoying the game. We would be happy just chatting to each other in the

warmth.

Ryan loved his trips to the rugby. He supported the Falcons, but his real passion was for the South African team, the Springboks. A South African born ex-England player, Mouritz Botha, was now playing as part of the Newcastle Falcons team, and this just added to Ryan's enjoyment. He was really impressed when James gleefully informed him that through Gemini Property Services we were going to sponsor Mouritz Botha to the tune of £1,500. Ryan was incredibly touched by this gesture, as it gave Ryan the chance to meet Mouritz in person.

There was a Sportsman's Dinner held at the Kingston Park stadium, and Ryan did indeed meet his idol and enjoy dinner with him. It was a really lovely evening. James spent the time basking in the attention he received. Karen and I were sitting at another table to Ryan and James. We could still hear James's voice ringing out and peals of laughter from his table as he kept everyone entertained. The evening even had a sports-themed quiz to compete in. Though Karen and I were not unexpectedly appalling in our contribution to the answers, we thoroughly enjoyed it and had a really good laugh.

At one point, James jumped up on stage alongside the quiz master. His motto was always why sit quietly when you can make any situation another episode of the James Scott Show?

When the evening came to a close, we bid farewell to everyone, collected our coats and all agreed what a wonderful night it had been. James's smile was the widest, and he gave Ryan, Karen and me a wink.

"The evening went even better than you know," he informed us. "I got talking to a couple of the lads about Gemini; they've got property, and I've put the feelers out." His smile widened

even further before he continued speaking. "I've only gone and got myself a meeting with Dean Richards next week about the businesses."

I hadn't got a clue who Dean Richards was, but Ryan was clearly impressed. Dean was the Director of Rugby, and James had secured a meeting with him at Kingston Park. You couldn't deny that James had the gift of the gab and a real way with people. The meeting with Dean Richards went ahead a few days later. James took Yvonne and Charlie along for the ride and to meet Dean.

Mum's best friend Yvonne often looked after Charlie during the day whilst I was at work. I believed Charlie to be in the care of his dad, but that would often not be the case as James would drop Charlie off with Yvonne when he had 'business to attend to'. Yvonne thought I was fully aware that she had Charlie. James occasionally took Yvonne out for a coffee or lunch to say thank you for being such a hands-on godmother and babysitter. She didn't mind as she loved her godson, but unknown to me others were beginning to think that James was taking advantage of Yvonne's good nature.

At the meeting at Kingston Park, Yvonne was very impressed with how James conducted himself and how confidently he spoke to everyone. He possessed such a natural affinity with people; a way of charming everyone. The meeting was a huge success: Dean Richards even giving Charlie a novelty rugby ball as a keepsake to take home.

Yvonne told us that James had been in his element all afternoon. On the journey home from Kingston Park, he asked Yvonne if she would accompany him to the Woodlands Hospital for his upcoming follow-up appointment. It was only a matter of days away, but James was understandably nervous and

would really appreciate Yvonne's support. Yvonne and James were close, so of course Yvonne readily agreed to go to the appointment with James. He was like a son to her.

The day of James's appointment came, and I was sick with worry: anxiously watching the office clock slowly tick by, wearing the carpet out as I paced up and down it numerous times. Karen tried her best to calm me down, but my mood was low and dark, matched by the ominous clouds and persistent rain running down the office windows. I squinted out as I spotted a car slowing down outside the office.

"I think that's James's car pulling up." I turned to Karen with surprise. "He's back from his appointment already; do you think that's a good or bad sign?"

Karen shrugged and I watched as James left the car and came sprinting through the rain and into the office. He stood in the entrance shaking the rainwater from his dark blond hair, a big smile plastered across his face.

"It's fantastic news, Col, I'm so relieved," he told us.

James filled us in on all the details. There was indeed a lump in his testicle, but it wasn't a tumour. It was, he explained, a condition called Hydrocele: a type of swelling of the scrotum, but nothing sinister. The position of the lump had made it hard for the diagnosis to be made sooner.

Tears rolled down my face, I was so relieved. James was going to be OK. I gave him the biggest hug, holding him close as I sobbed into his shoulder. We stood like that for a minute or so before I regained my composure and grabbed my coat and umbrella. I headed out to where the car was parked up, keen to see Yvonne and Charlie who'd remained in the car to avoid getting caught in the downpour.

I pulled the passenger door open and greeted Yvonne enthu-

siastically. "Isn't it fabulous news? I honestly expected the worst." I reached over and gave her a big hug.

I honestly had expected the worst news, as it seemed from what James had told us that he would be told he had cancer.

Yvonne smiled back at me. "I know, Col", she told me quietly, "it's such a relief for us all."

However, I didn't know why, but something just seemed a little off with her. Yvonne is the warmest, kindest person you could ever wish to meet and I would have genuinely believed her to have been doing cartwheels at this good news. However, she seemed a little reserved. She was not her normal self: a little quiet, her face troubled. Maybe she's just overwhelmed, I thought to myself. Yvonne often takes people's troubles on her shoulders, and this news of James being in the clear for cancer had probably just overwhelmed her.

In fact Yvonne was not overwhelmed at all. She would later tell me that she had been worried and torn. Something was not sitting right with her, and she wasn't sure what to do for the best. When James had parked up in the Woodlands Hospital car park prior to his appointment, Charlie had been a little fractious. James had suggested that the hospital was not a place for a cranky baby and, rather than Yvonne waiting in the waiting room with him for however long his appointment took, they could go for a little walk and maybe pop into a café. James had said he would ring Yvonne once his appointment was over.

Yvonne had readily agreed and had gone for a stroll with Charlie in his pushchair, hoping that James was right and a walk and some fresh air would calm Charlie down a bit. However, as they walked along, Yvonne did not like the quickly darkening sky and the rainclouds looming in the sky above them. She was right, as within ten minutes into their stroll the

heavens opened and it began to rain torrentially.

Yvonne was not sure what to do for the best, so decided to head back to the hospital to seek cover indoors. Imagine Yvonne's surprise when she arrived back at the car park to discover James sitting on the low brick wall in the car park, seemingly oblivious to the rain and was busy scrutinising his phone. His attention quickly turned to Yvonne when she gently touched his shoulder.

"What about your appointment, James?" she asked him. "It surely can't have been that quick?"

She remembers that James looked shocked to see her return to the car park so soon, clearly expecting her to be away for at least another half hour or so, getting a cup of tea in the nearby café.

He quickly regained his composure. "I was straight in and out this time, with no messing about," he confirmed with a wide smile.

James went on to tell Yvonne the wonderful news. It wasn't cancer at all and he was in the clear. She was so happy to hear what James told her that she embraced and hugged him, but she couldn't shake off the nagging feeling that something didn't add up. How had his appointment been so quick? And the look that had flashed across James's face when she had arrived back with Charlie had unnerved her. Had he even been in the hospital at all? Yvonne didn't know what to do for the best. Should she question him? But no, she thought, I'm being paranoid; this is James and this is good news. She pushed her misgivings aside.

But Yvonne was indeed spot-on with her worries that something just didn't sit right. It was incredibly unlikely that James even set foot in the Woodlands Hospital that day. He

had indeed found a lump in his testicle some time earlier, and had been frightened by it, so all those emotions we had witnessed had been true. However, in all likelihood his initial GP appointment would have quickly silenced his fears. Hydrocele is very easy to diagnose. But James was never one to fail to grasp an opportunity if it fell into his swollen lap. The appointment that I attended and witnessed him being called in was a bogus appointment for a fake bladder infection and his follow up appointment the Police discovered he never showed up for. It was just another ruse to back up his lies.

Cancer was by far a better story than a simple diagnosis of Hydrocele: plenty of attention for him and a perfect reason he could use to ensure that the wedding be postponed. It all played perfectly into his hands.

The approaching wedding must have been playing on his mind, as we now know it could never have gone ahead. His existing wife might well have had something to say about that!

What is confusing to me, though, is why only a couple of days later James would show me an email from Donna, the wedding planner. Donna had been in touch with Wynyard Hall, and if we were in agreement she could secure the date of 25 February 2017 as our new rescheduled wedding day. I suggested that we waited a while, got our heads straight after all we had been through the last year, maybe take a little time and concentrate on the new businesses; but James was adamant that we should take the new date. He was so keen that as of 25 February 2017 I would be Mrs James Scott.

Why did he do this? What was he thinking? He'd just earned himself some breathing space with his cancer scare, taken the heat off himself for a bit, so why put himself through the stress all over again? He knew that come 25 February there

could be no wedding and another excuse would have to be made. Why didn't he leave it? But no, for whatever reason in his twisted mind, the pantomime wedding was back on and all the arrangements recommenced.

The new invitations were written with the revised date in February 2017. James took it upon himself to visit the post office to ensure that all the invitations were sent off correctly. Many had to go airmail, with so many of his family living overseas. Wouldn't you think these invites to these non-existent relatives in their non-existent addresses would have found their way into the nearest waste bin via James? Bizarrely James paid the money to send all these invitations. Why did he do this? He might as well have ripped his money up in the street. He was on his own on this trip to the post office, no one with him to witness what he was doing. Had he got so caught up in his own lies that he was starting to forget what was real and what was fiction any more?

Chapter 39

Christmas and New Year

Christmas Day 2016 was fast approaching, and everyone was so very busy: James concentrating on @Scotts; Karen and I now having left our previous employment and working between my home and the office space James had let for Gemini Property Services.

I loved this time of year, as I was a big kid about Christmas. But this year was even more exciting than usual for everyone, with the new businesses and our new home on the horizon. Of course there had been a few bumps on the way, but we had just been to the property and completed the snagging list; everyone was confident that completion was only a matter of weeks away. Christmas Day was a magical one: our wedding might have been temporarily postponed, but we had another one to look forward to.

On Christmas morning, after Ryan and Karen had drunk their bucks fizz and exchanged Christmas gifts, Ryan had surprised Karen with the best gift of all: he had gone down on one knee and asked Karen to marry him. Of course Karen had said yes immediately, and as a family we were all over the moon for them. Rather than have an elaborate engagement party, Karen

and Ryan decided they would prefer a rather more intimate affair. New Year's Eve was only a week away, and it made perfect sense for them to celebrate their engagement on such a magical day of the year.

James and I were invited, and an overnight stay was booked for the four of us at the beautiful Rockcliffe Hall in Darlington for a New Year's Eve party night. It would be a lovely occasion with a delicious five-course evening meal and disco. James loved Rockcliffe Hall, and it was often his venue of choice for playing golf and socialising, so he was delighted to attend. It was to be a very glamorous event, all the ladies in full evening attire and the gentleman in black tie.

Earlier that day James surprised me with another gift, a pair of expensive Louboutin high heels for me to wear. They were very beautiful, but in all honesty not to my taste, very glitzy and sparkly. I shook my head to myself: it was an extremely generous gift, in fact too generous. James was so often encouraging me to wear more sensible shoes, to dress in a more demure fashion, so what had made him buy these? He really was so confusing at times.

Not wanting to appear ungrateful in any way, I wore the sparkly black shoes for the evening. They really weren't my style at all, extremely high and covered in sparkly sequins, plus they were really rubbing my heels and I was trying not to limp too obviously. I remember that as we sat at the dining table, I slipped them off so I could be more comfortable.

The meal was lovely: seafood risotto to start and then a delicious beef dish. The assembled company was lovely too, sitting around a large circular table for twelve people and the drinks flowing. James, as expected, was enchanting the entire table and everyone was fully engrossed in his many stories.

Plus everyone was enjoying the copious rounds of drinks that would suddenly appear at the table for everyone, all courtesy of the charming, generous James Scott. He really was so free with his money, but then again was it ever really his money?

Unfortunately, I cannot say that the remainder of the night was quite as lovely. After all the dinner was consumed, my night quickly deteriorated. Karen and I decided to hit the dance floor and have some fun, burning off some of the calories from dinner. We were enjoying ourselves immensely on the crammed dance floor, laughing and strutting our stuff to the cheesy pop hits. A rather handsome, elegant man, looking splendidly decked out in evening attire, was dancing just behind Karen and kept glancing over at me and smiling. He was in his mid-thirties with twinkly eyes and a close-cropped dark beard. I returned his smile, but not wanting to give him any encouragement, I turned my back to him and continued dancing. It was nice, though, to feel I was still attractive enough to receive attention from a good-looking stranger. I didn't get to go out socially very often anymore, and certainly never on my own, so admittedly it boosted my confidence somewhat.

I just wish that nothing more had happened, just an appreciative smile from a handsome stranger, and that would be it. But the man approached me and tapped me gently on the shoulder. When I turned to give him my attention, he grabbed my arm and started to dance with me, twirling me around the dance floor. Rather than wanting to hurt his feelings, I danced with him for a few seconds before turning away and continuing to dance with Karen. No harm done, I thought, but James had witnessed this encounter and was livid. His face was contorted and purple with rage. That someone had dared to dance with

me and I had reciprocated had made him see red.

Standing on the edge of the dance floor, James was waving his arms around and screaming at me; it was absolutely mortifying. I just longed for the dance floor to open and for it to swallow me whole. James angrily turned on his heel and stormed off while I hurried after him, wobbling on my new high heels and cringing with embarrassment. I was shocked and honestly rather scared by such an extreme reaction from him.

I followed a furious James back to our hotel room, and once we were both inside and the door locked, he commenced pacing up and down the room raging like a madman. His lips curled in disdain and he called me the most horrible names.

"You were out there encouraging other men, acting like a cheap slut in your short dress and tarty shoes!" He spat the words at me, his fists clenched and his eyes menacing.

"James, please stop," I implored, tears flowing down my cheeks. "I've done nothing wrong, I was only dancing." I didn't understand where he was coming from. After all he had approved of my red dress and had bought me the shoes.

I tried desperately to take his arm and encourage him to calm down, telling him he was scaring me, but he shook me away and headed out onto the hotel room balcony. Without even a backward glance, he jumped from the brick one-storey balcony and disappeared into the cold, winter night.

I called after him desperately into the night, but my words echoed back to no avail. He did not return and I was left in floods of tears. I sank distraught onto one of the plush sofas in the sitting area of the hotel suite.

What the hell had just happened? I knew that I had done nothing to warrant this extreme behaviour. I was so very hurt

and upset. How had such a lovely evening turned into this hideous situation in just a matter of minutes? I knew that James could let his emotions take control of him at times. I'd witnessed that on many occasions before, as my family had also, but this was on another level: so very out of character for James. We all knew that he could be possessive, and now I realised he was getting controlling too.

Was all this because he'd been drinking heavily, I wondered to myself. I had thought at the time that his letting off some steam and having a drink to be a good thing. He could relax a little and enjoy the night, celebrate Karen and Ryan's wonderful news; but it wasn't usual for James to ever drink alcohol.

A knock on the hotel room door signalled Karen and Ryan's arrival. They too were in shock, alarmed by James's behaviour. They had both witnessed the exchange on the dance floor and knew I must be embarrassed. I tried to calm myself down and curb my tears enough to tell Karen how James had jumped off the balcony and legged it into the night.

Karen's eyebrows rose quizzically. "He's certainly athletic for someone with a broken back!"

I remember at the time I was very annoyed by Karen's cynical comment, but I couldn't disagree with her.

Ryan reassured me that he would go and locate James, and he did eventually find him after an hour or so of looking. James claimed to Ryan that he had been at the nearby Darlington fire station with his old colleagues, and they had talked some sense into him. Ryan thankfully managed to usher a still drunk and belligerent James back to the hotel room, where he duly passed out on the bed. We collectively stared down at the snoring figure on the bed.

Ryan shook his head slowly. "He needs to sleep that off," he announced, running a hand through his hair. "I've never seen behaviour like that: he was a disgrace." Ryan went on to tell us that James had been incredibly rude and aggressive to the hotel staff and Ryan himself, when he had been trying to get him back to the hotel room. It felt like we had all seen another side to James that night, one that we would all definitely have preferred not to.

The next morning, I awoke early; James was already sitting on the side of the bed nursing a cup of black coffee and swallowing down paracetamols. He turned to look at me with a sorrowful expression. He was so remorseful and full of apologies. He claimed not to be able to remember most of the previous night's events, but of the parts he could recall, he was completely horrified by his actions. It must have been the alcohol, he concluded, and vowed never to drink again. He just couldn't forgive himself for ruining what should have been such a lovely night. It should have been Karen and Ryan's dream occasion.

He apologised repeatedly to me: how his jealousy had overwhelmed him when he had witnessed me dancing with that other man. I shook my head at him, really worried this wasn't normal behaviour. I hadn't even spoken to the other man, and this had been James's reaction. I also thought that James being so attentive was endearing, showing just how much he cared for me, but this felt far from that. It wasn't the James I thought I knew; it had unnerved me.

Chapter 40

Meeting the grandparents

The following couple of weeks of January passed and James was nothing less than the model fiancé: supporting Karen and me whilst we worked hard getting Gemini Property Services established. He was so attentive to me, kind and thoughtful, he was once again the James I had fallen in love with.

Had New Year's Eve just been a bad reaction to the alcohol? A one off? I really hoped so, but if I was truthful to myself, I was not convinced.

Taking a step back and looking at my life with honesty, I knew I had changed. Not just in the way I dressed, but in my confidence too. James so often spoke for the two of us, always saying he knew best and that he was looking out for me. Social activities only happened when James arranged them. I'd felt safe, looked after, but was it safety or was I being controlled? I really didn't want to believe that we would be anything but fine.

We were to be married in a matter of weeks, but I couldn't deny that the cracks were starting to show. James must have picked up on some level that I was feeling unsettled. Maybe I

was quieter than usual, a little distracted. Whatever the reason, I believe that James felt I needed a little reassurance about him and our life together.

As yet I had still not met any of James's family. They were actively in our lives with text messages, Facebook posts, cards, presents etc, but not meeting them in the flesh was a real source of contention for me, and James knew it only too well. On a few occasions James's mother Maureen would Facetime James whilst Karen and I were busy working in the same room, and he would turn his phone towards us. We would always have a brief exchange of greetings with Maureen, and a quick chat about how we were, but James was always keen to shut the call down. He would tell his mum we were busy, and we needed to 'crack on'. It was nice to see his mum on screen, but nothing like meeting in person with the opportunity to get to know her. I really didn't want to wait until our wedding day to get a chance to talk properly to his mum.

Much to my delight, James announced that Maureen and John were now back in the UK for a while. They had come back for New Year and were staying at John's home. The following Saturday we were to be invited to visit them for lunch. I was absolutely over the moon: finally I was getting to meet my soon to be mother- and father-in-law.

On that Saturday morning I was so nervous but fizzing with excitement too. I carefully picked out what clothes I should wear: a nice soft lamb's wool jumper in a muted cream shade with black trousers and flat ankle boots. James had smiled and nodded his approval when I came downstairs in the outfit. We soon headed out in the car to make the journey to meet his mum and stepdad.

It took less than thirty minutes to get to Bishop Auckland,

where we pulled up outside John's property. For the entire car journey I kept quizzing James about Maureen and John, asking him question after question, making James laugh at how obviously nervous I was.

"Honestly, Col, calm down and stop grilling me so much. There's nothing to worry about, they're going to love you," he reassured me with a broad smile. "How could they not?" I smiled gratefully at him, but my stomach was still knotted up in apprehension.

I surveyed John's house from the car window for a few moments before we locked the car and made our way up the path to the front door. It was a nice, modest four-bedroomed detached house with a double garage. A lovely property, but maybe not one you would automatically imagine a millionaire couple owning. However, James had said that his mum had sold her own house, and as they spent the majority of their time in France, they just kept John's house on as their base in the UK.

As I studied the immaculately kept front lawn and flower borders, I commented to James that they must pay someone to keep the garden so well maintained if they were rarely here. Of course, though, it was Maureen and John who tended the garden so well, John being quite green-fingered. They both had so much free time, both being retired, never in the South of France. They were actually living just a short car journey away from my house for the whole time that James and I had been together.

James knocked on the door, a sharp rap, and it was hurriedly answered by a smiling blonde lady. I recognised Maureen immediately from the many photos and speaking to her on Facetime, albeit very briefly. She leant forward and hugged me

with affection.

"It's so lovely to finally meet you, Coleen," she gushed, her voice so welcoming; "we've been so looking forward to it."

I hugged her back, agreeing how good it was to finally meet her too. She was so warm and welcoming, not at all like the cold, hard businesswoman described by James to me on so many occasions. Nor did she look like that. I know you shouldn't make initial judgements on a person's appearance, but the lady standing in front of me wearing fluffy pink slippers, comfy navy-blue jumper and velour tracksuit bottoms wasn't what I would naturally expect a successful, wealthy sports agent to look like. I silently scolded myself, telling myself not to be so daft. It was a Saturday afternoon, so of course she would be casually dressed; this was her 'down time'.

Maureen ushered us into the house, swiftly taking Charlie out of James's arms for a hug. She fussed and cooed over Charlie, very much the doting grandmother. At this point John emerged from the kitchen, a lovely aroma of cooking food wafting behind him. He was putting the final touches to the lunch he had been preparing, and wiping his hands on the bright floral apron he was wearing.

"Welcome, welcome," he declared with a big smile on his face. "No standing on ceremony here. The kettle's on, do you fancy tea or coffee?"

I smiled thankfully and told him that a cup of tea would be really lovely. I remember thinking what a shame it was that it had taken so long for us all to finally meet in person, as they were clearly a delightful couple.

As I settled into their comfy, furnished living room, taking in the floral curtains and copious amounts of scatter cushions on the three-piece suite, I gratefully accepted my mug of tea

from John. The four of us were enjoying our drinks for a few moments before James's phone began to ring out with its annoying pop music ringtone.

James grabbed his phone and was out of his chair, excusing himself while he went out into the hallway to answer the call in private. None of us could hear what the conversation on James's phone was about, but we couldn't mistake the annoyed tone of James's voice. After a minute or so he returned, a pained look on his face.

"I don't bloody believe this," he announced angrily, ramming the phone back into the front pocket of his indigo jeans. "There's been a break-in at one of the rental properties in North Shields."

Thinking it might be one of Maureen's rental properties, I was keen to know which house had been broken into. "Oh no," I declared, "is it one of your..."

James abruptly stopped me mid-sentence. He went on to tell us that the police were already at the property, but they needed a keyholder there. He failed to say which property it actually was, but confirmed that the tenant wasn't answering their phone so there was nothing for it: we would have to get our key and go to the property ourselves immediately. My heart sank; I was just settled nicely on the sofa with my tea, looking forward to getting to know Maureen better while James was saying we would have to leave already.

I suggested staying there, telling James that he could return and pick me up later when it had all been dealt with. But no, James said it would take ages and he was adamant I must go with him. The police needed to see us, plus whatever damage there was to the property would be a nightmare to get fixed as it was the weekend. It would be best if we both left now

and rearranged another catch-up with Maureen and John very soon.

I sighed heavily as I rose from my seat, my tea barely touched on the little coffee table beside me. We had hardly passed through Maureen and John's front door before we were leaving, heading back out of it. We bid our farewells to them, apologising for not being able to enjoy the lunch that John had prepared, and headed off to Chester-le-Street to retrieve the key before going to the property in North Shields.

As James and I began our car journey, it was clear that James was in high spirits: he was jubilant, his face animated. "That went so well, princess", he beamed. "They really loved you. Did you like them too?"

I looked at him in dismay: they had hardly had time to gauge any sort of impression of me, it had been such a flying visit. Such a build-up, but we had barely been there twenty minutes.

I couldn't understand why James was so happy that our trip to his folks had been cut short by a burglary. Surely he should be a bit pissed off? However, James continued to smile happily to himself. What I didn't realise at the time was just how precarious that meeting could have been. James had successfully managed to pull off a first meeting without any devastating revelations. Now that I had briefly met his mum and stepdad in person, he hoped the heat would be off him. It couldn't have gone better for James: he must have been on tenterhooks for those minutes we were there. So easily his mum could have called him by his real name, asking about his real children, his real estranged wife. I might have realised that this was not the first time she had met her grandson, Charlie, as unbeknown to me, Charlie had met his grandparents many times before; but of course Charlie couldn't speak and tell

me this. No, once again James Scott had the luck of the devil, everything seemed to fall just right for him. Before we made it to North Shields James received a phone call from the police as the tenant had now returned to the property. Our attendance was no longer required and they gave James a crime reference number and would call him after the weekend. As we no longer had to go to the property I was keen to return to Maureen and John's house to continue our afternoon but unfortunately James began to suffer from his back injury and insisted we went home so he could rest. All the puppets in his show were still none the wiser about the performance unfolding.

Chapter 41

The successful networker

As time passed, James, Karen and I we were all working hard on the Gemini business, and it was flourishing. The radio adverts running on Metro Radio were a huge success, drumming up a lot of new business. Karen would arrive at my house before 9 a.m. Monday to Friday, and it would often be after 8 p.m. before she made her way back home, exhausted but happy in the knowledge that our new business venture was thriving. It was indeed hard work, but we both felt it was worthwhile as we trusted we were building a great future for ourselves. We would reap great rewards in the long run.

Any meetings now were held at the office space James had rented in Durham. Gemini Property Services was looking like a very professional set-up. To establish our business further, James felt we should make new business contacts, so we joined various business network events. There were B2B networking meetings at 7.30 a.m. every Friday at Chester-le-Street Golf Club. Karen accompanied James to these meetings, whilst I stayed at home with Charlie. The meetings were friendly events, involving networking and discovering each

other's businesses over a light breakfast. There would be approximately 15 businessmen and women attending, from many different fields. The chair was a very successful barrister, and there were also other landlords, IT specialists, tradesmen etc. present.

James was of course a huge hit at these meetings, and everyone absolutely loved him. He got on extremely well with the chair, and James enjoyed talking to him at length about his mother's firm of lawyers, Clifford Chance, based in London; the chair was enthralled, obviously not realising that every word from James's mouth was a lie.

Every attendee at these early Friday mornings would give a twenty-minute presentation to all the other members on their business: a brief showcase of their profession. A different person contributed each week, though the presentations, Karen told me, were often so dull and dry that she found it hard to concentrate. However, she was so proud when it was James's turn to give his presentation, impressively using the whiteboard to demonstrate the 'life and times of James Scott, firefighter'. He said how his previous employment in the fire service had equipped him well in his new career of property management, as he was used to 'fighting fires daily'.

After keeping the group enthralled with a humorous talk about his time as a firefighter, peppered with many funny anecdotes, he concluded his presentation by removing the 'G-Shock' watch which he had been wearing on his left wrist, and laughed as he went on to regale everyone with a tale about it. These watches, he said, claimed to be indestructible and how true this really was. In the pursuit of the truth, he had tested this theory. He wore the watch for everyday use preferring to keep his designer watches for best. James and one of his White

209

Watch crew had reversed a 20-ton fire engine over this very watch, and here it was in perfect working order. The members of the meeting were so impressed with James's presentation, and the applause was enthusiastic when he finished. They had really lapped up every word they had been told.

How were they to know that James had never even been in a fire engine, never mind having reversed it over his watch? Surely these intelligent people would have queried such a claim it was such a ludicrous story, but they did not. That is one thing I have learned: that people overall have a trusting nature, and if they are told something by someone they respect, they are likely to believe it, no matter how improbable it may seem. If someone tells you something with such certainty and in such a measured and calm way, it is not human nature to distrust or query what you are being told.

At these networking meetings, James was clearly the most popular man there – or that was what Karen told me. These people liked him and trusted him, so much so that James would go out socially with some of the members, as they were so keen to spend more time with him.

I believe that these business networking meetings and all the charity endeavours that took up so much of our time were a smokescreen. We were working such long hours that Karen and I had no time to question anything. We sometimes went to meetings with new business clients who failed to show up, or scouted out new properties for landlords that we much later discovered were fictional, invented by James to distract us from how unsettled and fearful we were both increasingly becoming.

Karen's previous nagging feeling of unease about James and @Scotts had resurfaced. She could see the work that was going into Gemini, and was happy all was well there. But why was

there no movement on @Scotts?

I myself listened to all James's reasons, but truthfully my concerns were starting to mirror Karen's. Our wedding was only two weeks away now, and the house sale had still not completed. Why was it taking so long? I saw the emails and the apologies about the drainage issues and the Council adoption of the road, but was starting to get exasperated with it all.

"I wish we had never clapped eyes on that stupid house!" I told James angrily. I was feeling so stressed with all that was going on, and felt safest in my own home. I just wished that he had left it all alone. James tried his best to reassure me that it would all be sorted very soon. As ever, he would never let me down. He told me just to concentrate on our upcoming wedding, and I agreed that was what I would do. After all, what else could I do?

Chapter 42

Texas and back

The morning of 17 February 2017 finally arrived, exactly a week before our wedding date, and James and I both rose very early. The weather was cold and miserable, but there was excitement in the air in our house. Charlie had just turned one year old, and even he picked up on the atmosphere, smiling and giggling happily in his highchair.

Today James was heading off on the long journey to Texas to meet up with his daughters and bring them back to the UK for our wedding. Jill, his ex-wife, had insisted on James collecting them as she was not happy with her daughters travelling such a long distance on their own. As a mother I totally agreed with Jill, and was just so happy that the girls were due to come. I was so excited that after all this time I would finally get to meet Maddie and Kenzie in the flesh.

I waved James off on his journey to the airport, that cold and frosty February morning, with a beaming smile. James kept Karen and me abreast of his travelling as he always did, with many messages and photos. Our phones often pinged that day with messages from James, distracting us from our work at Gemini.

When his flight was about to take off, James messaged us to say he would be uncommunicative for many hours as his phone would be in flight mode. True to his word, though, once he arrived in Texas his many messages and photographs recommenced. We were both happy to know that he had arrived in America safe and sound.

Over the next couple of days James's messages became far less frequent. I wasn't too concerned at first, as I knew he would be excited to be catching up with his girls, but he would also have to deal with Jill and her animosity. I knew their relationship was strained, so I tried not to bother him too much. The very infrequent messages I did get were rather short and abrupt. So eventually I tried to phone James, but his phone was always switched off and the calls went unanswered.

What was going on? I was really starting to worry. James had been away for a few days, and was due back the following morning with my soon to be stepdaughters in tow, but I'd had no contact whatsoever from him in days. Karen tried her best to reassure me, but it just wasn't working.

I was in a really heightened state of anxiety when I decided to leave the house and head over the road to see my mum. I desperately needed a hug from her and reassurance that all would be well. Mum was understandably concerned too, but tried her very best to comfort me. She was far from happy though. What was James playing at, worrying her daughter like this? As if I didn't already have enough on my plate: Charlie to care for, Gemini and the wedding only a matter of days away.

I spent the next couple of hours with my mum, chatting everything over. I was finding it hard to concentrate though, and was constantly checking my phone and fretting. Mum was tirelessly bringing me endless cups of tea and her home-

made cake and fussing over Charlie; at least Charlie was happily oblivious to all the drama going on around him. I drank my tea, but pushed the slice of cake away untouched: I had no appetite at all.

After I had been at Mum's for a couple of hours, I decided to make tracks home. I was collecting all Charlie's various toys and bits and pieces from Mum's living room floor when I thought I heard Mum's front door opening. She never locked her front door during the day, no matter how many times I scolded her and told her she should. Mum jumped up from her seat and darted out into the hallway, keen to see who was coming into the house.

It was James, and he was alone. He ignored my mum's greeting and questions and walked straight into the sitting room, sinking down onto the sofa with a heartfelt sigh, his head in his hands. I worriedly looked at Mum, seeing concern etched over her face too.

"Whatever's the matter, James?" I asked him worriedly, putting my hand reassuringly on his arm. "I've been going out of my mind worrying about you; I've heard nothing for days – and where are Maddie and Kenzie?"

James turned his head to look me in the eyes, with tears running rivers down his pale face. "They're not coming," was all he answered before collapsing in floods of tears. Sobs were racking his entire body.

I had the worst feeling of dread. What did he mean, they weren't coming? He had travelled all that way to get them, and what did this also mean for our wedding day?

Mum was now standing in the centre of the room with a look of worry evident on her face. She was holding Charlie in her arms and rocking him gently. "What has happened, James?"

she demanded to know.

He continued to sit with his head in his hands, looking terrible. He was pale, his clothes looked unkempt, and he just looked generally dishevelled. My heart ached for him and how wretched he looked, but I needed answers too.

Our wedding needed to go ahead: so many people had made plans that couldn't be changed at such short notice. A lot of money had been spent. My dress was hanging in Mum's spare bedroom, pressed and ready for me to wear, along with James and Ryan's smart navy morning suits and even a little matching one for Charlie.

Still James just sat and sobbed. Again, I pushed him to talk, I was so desperate for answers. Eventually, with a sigh between shuddering sobs, James began to spell out what had happened. His ex-wife Jill, true to form, had once again played her malicious games. She had changed her mind at the last minute, decided their daughters were not to be allowed at the wedding: much too far for them to travel, she had claimed. Jill had let James travel all the way to Texas under false pretences. She had never had any intention of letting the girls return with their father to the UK to celebrate his wedding.

James was heartbroken. Maddie and Kenzie too had been devastated, as they had been incredibly excited about the trip. They had cried and begged their mother to change her mind and let them go, but no, Jill's mind was made up.

At this point James reached into his denim jacket pocket and pulled out a delicate silver bracelet. "This is from Maddie for you, Col: it's a gift she wanted to give you on the day of the wedding; it was to be your 'something new'." His voice was heavy with emotion, and once again he broke down in tears.

I placed my arms around James's shoulders, not really

knowing what to say for the best, but still needing answers.

"It's a terrible thing Jill has done; it's wicked and really unforgivable, James," I said softly. "It's awful that your girls won't be here on the day. I know how important it was for you for them to be there. Maybe we could arrange a wedding celebration party as soon as they're next in the UK? I know it won't be the same as them being at the wedding, but we could still make it special." I smiled at him gently, waiting to hear his response.

James took a deep breath in and exhaled slowly, looking between myself and Mum, and then he uttered the words that deep down I knew were coming from the moment he had walked into the house.

"I'm so sorry, princess, I just can't." He shook his head slowly. "It just wouldn't be right without my girls."

His head was back in his hands, and both Mum and I stared at him in absolute horror. Mum, like myself, tried desperately to talk James around, but he was adamant that the wedding could not go ahead without his two daughters being there on the day.

I felt the whole situation was surreal. Here I was just a couple of months after cancelling my first wedding, and once again James expecting me to cancel this one. People had been so lovely and understanding last time. They had understood that getting wed with a cancer diagnosis hanging over you was far from ideal; but I didn't think people's sympathy would stretch so far this time. Family and friends would lose money, travel arrangements made, hotels booked, time off work arranged. Never mind the mammoth job that would fall to Donna the wedding planner, cancelling all the wedding arrangements again.

"We could just rearrange for a couple of months' time," James suggested expectantly, looking up at me with his eyes bright with tears. Oh no! This was it for me. I was angry and incredibly hurt.

Of course, my heart hurt that his girls could not attend our wedding; but what about me, Charlie, my family? Did we not matter? Two cancelled weddings under my belt and I had never even really wanted to get married in the first place! Railroaded into this farce! The wedding was off once again, but this time I made a stand; it would not be rebooked.

I needed some time on my own away from James, time to lick my wounds and come to terms with the events that had unfolded over the day. I decided to take Charlie and stop the night at Karen and Ryan's house. I felt I needed some space on my own, time to think. James had promised he would contact Donna to cancel the arrangements, and he would let everyone know that the wedding was now off.

My poor mum had the embarrassment of contacting all our family to break the news and tell them the wedding was off. I lay in a single bed in Karen's small spare bedroom that night, unable to sleep. I was fretting, tossing and turning. I felt so many different emotions, and not least embarrassment and humiliation. What would people think? All the fuss that we had made, and all there was to show for it was two cancelled weddings.

Chapter 43

The solace of a sister

Early the following morning, I lay in bed wide awake having barely slept all night. Karen came bursting into the bedroom, flinging the floral curtains open, and announced we were going out.

"Come on, Coleen, you can't just lie moping in bed," she insisted. "I'm taking your mind off all this; we're going out for the day."

Karen told me she had arranged for Ryan to look after Charlie for as long as we needed; she and I were going out for some retail therapy and a few too many cocktails. I smiled at her, my eyes heavy from lack of sleep, but I knew there was no point arguing with Karen when she was in this mood; and anyway, she was right: sitting in the house moping wouldn't achieve anything.

We headed out for the day to the MetroCentre in Gateshead, and the first port of call was to return my bridal shoes to the shop where I had bought them. I wouldn't be needing them, would I?

After that we headed to a cocktail bar, the money from the shoes to be put to good use, drowning my sorrows in Mojitos.

We sat for hours and hours and talked and talked; it really helped me.

As the alcohol relaxed my frantic brain, the realisation took hold that I wasn't now going to become 'Mrs James Scott' in a couple of days, and a feeling of what I can best describe as 'calm acceptance' settled within me. I felt a little bit lighter, deep down. I now know I was relieved the wedding was not to be. I think that after the New Year's Eve events, I had had serious doubts. I loved James, but in all honesty some sides of him were beginning to scare me. Maybe this was all going to be for the best?

After the cocktails were finished, we headed for lunch, both of us a little merry and needing some carbs to soak up all the alcohol. We decided on an Italian restaurant from a popular chain, settled in at our table and began scrutinising the menu carefully. Suddenly the waiter arrived at our table, smiling brightly and carrying a pretty little silver box adorned with a bow. The young waiter passed the box over the table to me.

"This is from the gentleman at the doorway," he informed me. "He asked that I should deliver it to you, and to let you know he loves you." His smile was bright, but he looked a little embarrassed. However, it was obvious he thought I would be overjoyed to receive the gift and message. But I stared at the box blankly, then at the waiter, then back to the box again.

"Thank you," I said, forcing a smile. I took the little box from him and placed it unopened on the edge of the table. I then turned my attention back to the menu and began reading the starters out loud to Karen. The poor waiter turned and walked away hastily, obviously confused by my reaction, but deciding it was best not to make a comment.

I didn't need to look at the door to know that the gift was from

James. I wasn't interested in seeing him or what the gift was that was now sitting neatly wrapped next to the condiments and olive oil.

Karen simply couldn't believe it. James had obviously taken it upon himself to follow us to the MetroCentre and then stalk us on our shopping trip and cocktails. How else would he have known where we were?

I had asked for a little space, a chance to get my head around everything, but quite clearly he couldn't even give me that. James's solution to everything was big showy gestures, gifts and flowers; but on this occasion it wasn't going to work with me. I didn't even look towards the doorway of the restaurant to acknowledge James's presence, and assumed he had then slunk away as we didn't hear from him again for the remainder of the afternoon. However, as we moved from this restaurant to another bar, I couldn't help wondering if he was secreted somewhere out of sight, watching our movements.

Realising that I couldn't remain indefinitely at Karen and Ryan's house and would need to return to my own home and get everything sorted, I decided to bite the bullet and go home the following day.

James and I did talk it out, well mostly him apologising and telling me how much he loved me and me just nodding at him, unsure what to even say. I carried on as best as I could, tried to make myself believe that everything was fine and would return to normal but what even was normal anymore? James had sorted cancelling all the wedding stuff with Donna, and I tried as hard as I could to get back to some sense of normality, but feelings in the house remained tense.

Chapter 44

To Scarborough

A few days later was the 25th of February 2017, the day that should have been our wedding day. James suddenly announced that he was going to take Charlie and me away to the coast for the day: a nice family day out, and an opportunity for us to get back on track and make some good new memories to cherish. A day away from everything, to try to escape the sad feelings he knew I would have at us not being married. I smiled at James and agreed: he was trying to make amends and it would be lovely for Charlie to have a day out too.

Maybe it would be a little cold for a day at the coast, since it was February; we were definitely going to have to dress up warm. James had booked a nice hotel for the night in Scarborough, so we wouldn't need to rush back home. He hoped it would give us a chance to have a really good talk, he told me, away from everyone else and the pressures of home life.

Off we set early that morning with the sun hardly risen in the sky, Scarborough bound. Twenty minutes into the journey my phone began to ring. I fumbled in my brown leather shoulder

bag, desperate to locate it before voicemail kicked in. I saw it was Karen and was surprised to see she was up and around at such an early hour. I managed to answer the call just in time.

Karen was in an extremely agitated state. She was speaking very quickly and insisting she needed to see me urgently, and alone, without James being there. I tried to explain that we were off to the seaside and staying away overnight. Could it not wait until tomorrow? But no, she was adamant it had to be now.

Worry coursed through me; Karen didn't sound at all like her normal self. She wouldn't tell me on the phone what was wrong, just insisted that she needed to see me in person. I agreed to come and meet her as soon as I could. James meanwhile kept taking his eyes off the road as he was driving, glancing my way with a strange, troubled look on his face.

"Give me the phone, Col," James insisted, "let me speak to Karen." He pulled the car over to the side of the road and took my phone from me. He then spoke to Karen, asking her to tell him exactly what the problem was. Karen bluntly told James to mind his own business and return the phone to me. She told him in no uncertain terms that the world did not revolve around him as he clearly thought it did, and what she wanted to speak to her sister about simply wasn't his concern.

James reluctantly returned the phone to me and turned the car around to make a return journey to Chester-le-Street. What in heaven's name was that all about, I wondered. I replayed in my head the conversation I'd just had with my twin sister; something was wrong, but I just didn't know what.

"It's not like Karen to get so worked up," I pondered out loud. "I hope she and Ryan haven't had a bust-up, she certainly sounded very upset."

James seemed to perk up at these words, but feigned genuine concern. Trouble in paradise for Karen and Ryan would certainly suit James very well. It was unlikely, though, that this was the issue, as Karen and Ryan rarely argued.

Ten minutes later I was heading through the doors of the same café where we had had our family powwow just a few weeks earlier. I spotted Karen sitting at one of the booths, urgently waving over; surprisingly for me, Mum and Ryan were sitting with her too. I headed over, unwinding my scarf and placing it with my winter duffle coat over the back of the booth as I joined them.

"Wow, this is all a bit cloak and dagger," I laughed nervously, requesting a latte from the passing waitress. "Please don't tell me anything bad has happened. I think I've had my fill of bad news in the past few days."

Karen's glum face made my heart sink as she nervously twisted the ends of her shoulder-length brunette hair. This was always a sign she was unhappy. I now knew that whatever I was about to hear wasn't going to be good news at all.

Karen said how sorry she was, but her doubts about James had been bubbling over again; and now, since the wedding had been cancelled, she just couldn't shake the anxious feeling off.

Whilst Karen and I were busy with the administrative duties of running Gemini Property Services, James was responsible for sorting out the required maintenance on the rental properties, which included the properties that Karen owned. She had transferred directly to James many thousands of pounds to replace boilers in several of her houses. She had received paperwork confirming the installation of the boilers and James had confirmed that all had gone well. One of the properties Karen owned was currently unlet, and Karen and Ryan had

decided to go to the property to make an inspection. It hadn't been a planned inspection, but for whatever reason something had made Karen feel that this was an important thing to do.

When they both arrived at the property, they checked each room, individually making notes and finally ending up in the upstairs bathroom. Karen opened the wooden cupboard which should have housed the new boiler, keen to see how it looked. She was surprised to see a layer of thick dust there, and asked Ryan how so much dust could have accumulated in only a couple of weeks.

Ryan decided to call the boiler manufacturing company, but when he spoke to a member of staff, he was informed that the serial number on the boiler related to a make of boiler that was at least eight years old and no longer in production. James had taken the money for the new boiler, but the new boiler had never been installed. James had provided paperwork to confirm that the boiler installation had happened. Had he faked those forms? And if so, where exactly was her money?

Karen started to contact the other tenants one by one who had also received new boilers. They were told that no boilers had been replaced, and in fact no maintenance work of any kind had been done in any of the properties in many months.

I just didn't know what to think. Surely there must have been some sort of mix-up. James wouldn't just have pocketed the money. He couldn't have. It would have meant he had stolen the money from my twin sister. Even worse than that, though, it would mean he had endangered the lives of the tenants, many with young children. These properties now had potentially unsafe boilers. He was a firefighter; surely he knew better than anyone the potential dangers the tenants would be in.

I just didn't know what to say to comfort and reassure Karen.

She was on a roll as her words tumbled out erratically. She was worried about all the money she had invested, her life savings. Was it all a lie?

I needed to see James and have it all out with him, to find out exactly what had happened. Sick to my stomach, I called his mobile and asked him to come and meet me in the car. I would wait outside the café. I thought it was best he didn't come in and see Karen in her current state.

Once in the car, I broke down crying. Through my tears, I told James what Karen had told me, and her fears. I told him that I was fearful too. The normally calm and composed James seemed flustered. It was only a second, though, before his composure returned; then, like the flick of a switch, his face darkened and his anger was evident. He grabbed his phone from the dashboard and called Karen. I heard him listen as Karen recounted to him all her fears, and with a cold but measured voice he told her that he had believed that the boilers had been installed and all the work had been done correctly. He too had been let down and he was furious.

"Heads are going to roll over this, you can take my word for it," he angrily told my sister.

James promised to get the boilers replaced as a matter of complete urgency, and he would get to the bottom of why the work hadn't been completed in the first place. James's demeanour then changed from anger to regret. He was extremely apologetic to Karen, telling her in a soothing voice how sorry he was, but blamed it entirely on the workmen.

Karen did not know what else to do, so thanked him and ended the call. However, she was neither happy nor reassured. James had sounded so believable on the phone, but it just didn't make any sense. Why was there completed paperwork? Why

would the workmen have done that? Surely that would be fraud?

Still in the café, Karen looked over at Ryan and Mum with confusion. "What do you make of all this?" she asked.

Ryan shook his head with a concerned look on his face and sighed, "I just don't know."

James and I continued on our journey; but after the upsetting issue with the boilers, I no longer felt like a night away at the seaside. I just wanted to go home.

"No, Col," James argued, "we need some time away; we've packed a bag and it's a shame to just go home. Don't let this silly nonsense spoil the rest of our lovely day."

However, our day was spoiled. I felt sick in the pit of my stomach; something just didn't sit right, and I was beginning to feel really scared.

James now booked us into the Mal Maison hotel on the quayside in Newcastle, not far from where Pravda was located. I was happier to be there than in Scarborough, as it was only a few miles away from Karen.

Karen was clearly having deeper doubts about James's integrity, but I couldn't bring myself to tell him. I didn't want to admit it out loud, that I was feeling the same. Was he hiding things from me?

After checking into the hotel, we left our overnight bags in the tastefully decorated hotel room and decided to go to the bar for a cup of coffee. James was up ordering our drinks when my mobile phone began to ring. I glanced at the screen to see that it was Karen calling yet again. I was half tempted to let the call go to answerphone, frightened by what this call might mean, what she might say next, but I couldn't. She was my twin sister, so I answered it. I really wished I had gone with

my first instinct and let the phone ring. I could have had just had a few more hours of things still being OK; a few hours with just James, Charlie and myself, before reality would blow it all apart.

Karen was talking in an urgent whisper on the phone. She told me to take the call somewhere where James couldn't hear. She really needed to talk to me in private. I looked over at James nervously; he still had his back turned towards me, chatting animatedly to a waitress, her laugh clearly travelling to where I stood.

"James," I called over to them, "I'm just nipping to the Ladies. Would you please watch Charlie for me?"

James nodded his agreement and returned his attention to the young waitress, who was clearly enraptured with whatever tale he was telling her. I looked down at Charlie, happily asleep in his car seat, all cosy and without a care in the world. Oh to be a baby, I thought as I hurried off to the Ladies' toilets.

Once there, I locked myself in one of the small cubicles and sat on the closed toilet seat lid; with a deep breath to steady myself, I called Karen back.

Karen, Ryan and Mum had been extremely busy since I had left them in that café in Chester-le-Street. After I had departed, they had talked at length and had all admitted how concerned they were. So many things were piling up. The boiler story just didn't add up, and Karen couldn't help but worry about all her other money that was tied up in the businesses. If something was awry, she was in very deep financial trouble. She had invested every penny she owned and would be left penniless.

Firstly, Ryan contacted Wynyard Hall, the wedding venue, and discovered that no wedding had ever been booked for James Scott or Coleen Greenwood for that day. In fact no

wedding had been booked for them for the previous December date either. Karen and Mum were completely speechless. How could this be? There was the wedding planner Donna organising everything directly with the Wynyard Hall staff, and they had seen the confirmation emails, the menu choices, the table plan. Not to mention the wedding dress worth over a thousand pounds, neatly pressed and hanging in Mum's wardrobe in her spare bedroom. Mum declared that there must be some mistake, but Ryan shook his head; unfortunately, he didn't think that was the case. They decided that all three of them would go to Wynyard Hall and speak to someone face to face.

Once they had arrived at Wynyard Hall, they met with the Assistant Manager. He was a very kind, helpful man who sat with them for nearly an hour. He brought them tea and listened aghast to the tale he was being told. He was extremely sympathetic, as he confirmed that it was indeed true that no wedding had ever been booked in the name of James Scott and Coleen Greenwood. He shook his head as he told them that the 'Malcolm Mills' who had been sorting all the arrangements for the wedding did not exist. There was no Malcolm Mills working at Wynyard Hall, nor ever had been. The emails from Mr Mills were incredibly sophisticated, as there was a link on them that brought you directly to the Wynyard Hall website.

There was in fact a beautiful wedding taking place at that very moment on the very day I had believed was to be my wedding day. A beautiful bride was having her photos taken with her handsome groom. Karen told me that it broke her heart to see this happy couple, as it should have been me there having my fairy tale wedding. But it would never have been our wedding, could never have been our wedding. My fairy tale wedding was

never going to happen; it was the stuff of nightmares.

"Whatever you do, don't let James know what we've discovered," Karen implored. "Make up some excuse to get him back to our house. I need to confront him; I need to find out the truth."

I started physically shaking as shock and adrenaline coursed through my body, the room spinning around me. I couldn't comprehend what Karen had just told me. My wedding was a lie. It made no sense, it was madness. And how could she expect me to go back out and pretend that I didn't know any of this? I didn't even want to look at James, I felt such betrayal and anger.

My mind was whirring frantically, but I told myself I needed to calm down and get a grip. I took some deep breaths through my nose and slowly expelled the breath from my mouth to calm myself. After a few minutes, and with shaking hands, I splashed some cold water onto my face. On unsteady legs I managed to walk out and back towards the bar where James was enjoying his drink.

"You were a while, princess," James noted. "I thought I was going to have to send out a search party." He smiled, oblivious to my hammering heart and shaky legs.

Taking a deep breath, I answered him in a measured tone. "Karen was back on the phone, and I'm really worried about her. She sounded so distraught. Ryan and she have had a massive fight," I lied. "I need to head home. I really need to check she's all right." I smiled at him. "We can always come back here later, but please, James, I need to be with Karen, She's my twin and I'm worried about her."

I didn't need to ask James twice; he was already on his feet and pulling on his jacket. Karen and Ryan having problems

was a turn-up for the books, but very welcome news for James. Anything that drew focus away from James at the moment suited him just fine.

The journey back to Chester-le-Street was horrible. I was in a terrible state. Who was this man in the driving seat next to me? How many lies had he told? He was sitting there humming away to himself as if he didn't have a care in the world. I couldn't keep my mouth shut. I had to say something.

"James, have you ever lied to me?" I asked coolly.

James turned his face to look at me with shock. "What a funny thing to ask, Col. Of course not, you're my life. I could never lie to you, never have, never could."

I wanted to scream at him that I knew he was lying; that I knew the wedding was a sham. But somehow I managed to swallow down my distress and remain calm and composed in outward appearances anyway.

Then I pushed him again. "You do really want to marry me, don't you?" I beseeched, just wanting the truth from him.

He looked visibly shocked. "Of course I do, Col, there's nothing I want more in this world than for you to be my wife." He looked deeply into my eyes and I was sickened by how sincere he looked. "I could never lie to you, I swear on Charlie's life, may God strike him down dead if I'm lying to you."

I looked at James in utter horror. Not only did I know he was lying, but what a vile thing to say, to swear on your little baby son's life when you knew that every word you were uttering was a downright lie.

I turned to stare out of the side window of the car. I simply couldn't bear to look at him for a moment longer.

Chapter 45

Confrontation

The journey to Karen and Ryan's house seemed to take an eternity. I continued to stare out of the passenger window, barely registering the landmarks at all as we passed them on our journey. Eventually, we got there. I busied myself unclipping Charlie's car seat and carrying him into the house. James was already striding boldly ahead, completely unaware of what was to come.

Once James and I were in the living room, I could see from the fearful expression now clouding his face that the penny was beginning to drop. Ryan was standing in the middle of the room, his face like absolute thunder. Ryan wasted no time in confronting James with both barrels. At six foot four inches in height, Ryan towered over a more diminutive James, who for once seemed to have lost his cocky, confident demeanour. He looked like a little boy who had been caught with his hand in the cookie jar. Beads of sweat began to spring out on his forehead.

In a steely voice, Ryan began to lay out everything that had been discovered that day. First, there was no wedding, had never been any wedding booked; it was all an elaborate pack

of lies.

Then, after leaving Wynyard Hall, Ryan had decided they should drive past the property that James was purchasing for us in Ramside Park. James had been proudly showing everyone details of the refurbishments that were taking place. The interior designer James Richardson had supposedly been working hard in the property; I had seen photographs of the sumptuous soft furnishings and exquisite furniture that should now be in our new home. This design work included removing the large light fitting in the atrium and replacing it with a new chandelier that was more to my taste. It had been fitted over a week ago, I had been told. However, when Ryan, Mum and Karen visited the house, they looked in from the large exterior windows, but no such work had taken place. The property appeared to be empty, the décor not having changed at all in months and the original light fitting very much still in situ.

I sat perched on the edge of my chair, rigid with shock, as I listened to Ryan describe this visit, not quite believing what I was hearing. How could this be right? How many actual lies were there? The wedding had never been booked. The interior design work on the new house was never done. James had been showing photographs of all the changes, but were they just fake? Images he had found on the internet? Surely he had still bought the house, though? He had proved he had the funds to purchase it in his bank account. I had witnessed all the solicitor's emails regarding the purchase, had met the builders to complete the snagging list, had even drunk champagne with the estate agent to celebrate the sale. Plus we had four lifetime passes for the gym and spa. The house sale surely couldn't be a lie as well?

Whilst I sat in shocked silence, James sat meekly with his

head down, staring at the floor, tracing a pattern on the carpet with the toe of his shoe. Ryan continued to vent at him. Where was Karen's money? What had he done with it? Were the businesses even legitimate?

Karen gently took Ryan's arm to stop him mid-sentence, telling Ryan to hush for a moment and let James speak. She and I both wanted to hear exactly what James would have to say for himself.

James turned to me, his face sorrowful and pale. He began to cry and apologise repeatedly, saying how much he loved me and Charlie. The marriage, he explained, could never have happened as his mother would simply not allow it. She was adamant that he was not to marry me, and Maureen was a very powerful woman. James had worried that she would cut him off financially. James pleaded with me to try to understand. He couldn't marry me, but he so desperately wanted to that he couldn't bring himself to admit the truth to himself. I was the love of his life and the only reason that he had concocted this whole charade.

"I'm so very sorry, princess. I know it's unforgivable," he said in shuddering sobs, "but it's honestly only because I love you so much."

He begged me to understand, but I just continued to stare at him. I was shaking my head, my face ashen. I simply did not have any words. I didn't believe what he was saying, what I was hearing.

James's mobile phone rang out around the room.

"Leave it!" Ryan snapped, his face like thunder.

However, James accepted the call and lifted the phone to his ear. Maureen was on the other end of the line. They spoke to each other briefly, for maybe a minute or so, and then the call

ended.

"What the hell did she want?" I demanded to know, spitting out the words. What other lies were about to trip off James's tongue now?

James held his head low, and with a sombre tone admitted that his mother was arranging a flat for James to rent and wanted him to go and do a viewing on it that very evening.

I stared in James in bewilderment. I was so very confused, hurt and angry. I'd just heard him take the call, and could hear the female voice on the other end, but still did not know what to believe.

I had met Maureen, and she had been lovely and welcoming, and appeared to really like me. We had received engagement gifts from her, congratulatory messages. None of this made any sense. Surely the gifts and kind messages would mean she was happy that I was to be her daughter-in-law? I was overwhelmed with emotions and felt sick to my stomach. I felt I was living in some surreal and cruel joke. Everything I thought I knew was now unrecognisable.

My dream wedding had been a lie, and now was my dream home also? What about Karen's investments? The money that she had given him for the boilers and for essential maintenance work at her properties. Where was it all? Was it safe, or was it gone? Who the hell was this man in front of me? Where was the man I loved? Where was my James?

James pleaded with us all to please believe him. Of course Karen's money was safe, everyone's investments were secure. He would instruct his financial adviser from Clifford Chance to speak directly to Karen after the weekend was over. First thing Monday morning, James reassured us, Karen would have all her fears allayed and everything would be made clear.

James now turned his attention fully to me. "Don't worry, Col, I promise our new home is fine; we'll be in it soon."

He went on to admit that he might have got a little carried away with describing what interior work had been completed. James Richardson, he complained, had been a bit 'tardy' time-wise, but swore all the work would be completed within a few days' time.

I couldn't take any more. I couldn't think straight. I didn't know what were lies and what was the truth any more. All I knew was that I had a dark feeling inside me that I can only describe as a mixture of fear and dread.

My attention was suddenly on Charlie: up to this point he had been sitting happily in his car seat, but he was now starting to grizzle. I knew his nappy would need changing and I needed to buy another pack from the shops, along with essential groceries, as the girls would be back home from their dad's by now.

Rising wearily from my seat, I announced that I needed to speak to James alone. We needed to get shopping; the world still continued to turn, even though my entire world appeared to be imploding.

James didn't need telling twice: he was keen to get away from the uncomfortable line of questioning. Anything for him to get the hell out of that house and away from Karen and Ryan's anger and accusatory glares.

The shopping trip to the local Tesco was a very sobering affair. I walked in a dream around the store, throwing random items into my shopping basket as if on auto pilot.

During the journey back home from shopping, I also re-mained silent. James implored me to speak, begging and pleading with me, telling me how very sorry he was. I had

this strange feeling of reserved detachment. I didn't want to talk to him at that moment. I suppose experts would say it was my coping mechanism kicking in, a calm-like serenity, as I tried to understand the situation.

James repeated over and over how very sorry he was. His only crime was to be guilty of loving me too much.

My brown leather shoulder bag nestled on my lap started to vibrate to signal an incoming call from my mobile phone. I thought this strange, as I never normally had my phone on silent, always conscious that I should be contactable by my daughters. Scooping my phone from the depths of the bag, I realised it was Karen calling. There were already several missed calls from her, so she must have been trying to contact me while we were shopping.

I answered the phone half-heartedly, but within a second Karen was screeching down the line at me, telling me that everything was lies. James was a liar. James was a fake.

Ryan had been doing some more investigating since we left their house. He had discovered that there was no Clifford Chance law firm located in Newcastle as James had stated. Yes, the firm had many branches around the world, but none in Newcastle where James so often stated he was at meetings. No one from the Newcastle branch was going to contact Karen on Monday to put her fears to rest. I listened to my sister in horror.

"We're on our way up to your house now!" she ranted.

The phone abruptly went silent and I turned to face James. Since Karen had been shouting, he had clearly heard every word of our conversation.

"What have you done?" I demanded.

James didn't reply, his mouth set in a thin line. He drove

at high speed into our street and pulled abruptly onto the driveway before throwing his car door open. He jumped out of the car and hurriedly rushed over to open the boot. Grabbing the shopping bags into his arms, he carelessly dumped them all over the drive, their contents spilling out. I got out of my side of the car and gawped at him in complete shock.

James reached into the back seat and struggled with the belt on Charlie's car seat. Cursing to himself, he grabbed Charlie from his seat and hauled the crying child under one arm. He then shoved him through the open downstairs lounge window to Katie, who accepted her squirming little brother in both arms with a look of shock plastered over her face.

James leapt back into the car with me shouting after him, but the door had already slammed.

He shouted at me through the open window, "I just need a little time to think, Col. I'll be back in a few minutes, please don't worry." And with that he zoomed off, passing Karen and Ryan's car as they turned into the estate.

To this day, Karen will always recall that last moment she locked eyes with James Scott as he raced away from my property. He had looked directly at her with a huge smug smile on his face, and had given a little cheery wave. Karen felt it was the equivalent of giving them the middle finger. It was clear that he was getting a thrill out of the fact that they had nearly caught up with him, but not quite. If they'd only been a minute earlier, they would have caught him.

As Karen and Ryan pulled up outside my property and leapt from their car, I was still staring at the bags of discarded shopping on the drive.

It was clear that Karen was concerned for me, as she took in my dazed expression and the mess of shopping bags at my

237

feet. She came over to me and pulled me into a big hug.

"Don't worry, Coleen," she reassured me, "we'll find him and get our answers."

As I hugged my sister, I looked up and down the quiet, darkening, suburban street, desperately wishing James would reappear, not knowing that would be the last time I would ever speak to James myself. The man I loved was gone, he had never really existed.

Standing on that driveway, shock coursing through my veins, this was just the start to the next chapter in this incredible story.

II

Part Two

GREG

Coleen Greenwood, victim impact statement, read by DC Chris Bentham, April 2020:

"*Saturday 25 February 2017 should have been my wedding day (to James Scott) at Wynyard Hall. Instead, after being confronted with the truth, James deserted me and our child, handing him through a window to my daughter and driving off saying he would only be a minute. Our baby and I have not seen him since.*

The complete devastation, to discover that my whole life and plans for the future were built on deceit and lies, is heart-breaking. The following days I found it almost impossible to carry on and I barely ate or slept. The minimal sleep I did get was filled with horrendous nightmares. As time progressed and reality set in that James Scott, the man I loved, never existed felt to me like a bereavement..."

Chapter 46

Greg who?

"**G**reg Wilson?" I was slowly shaking my head, repeating the name that Ryan had just told me. "No, I've never heard that name before. Who is he?"

Karen and Ryan had just returned from Durham police station, where they had spent the last couple of hours. Once James had absconded, unsure what the best course of action was, they had taken themselves to the police station, fearful that James had stolen all of Karen's money and that he was a fraudster.

Ryan too was shaking his head thoughtfully. "We don't know who Greg Wilson is, but James's car was registered in that name."

I racked my brain, trying to recall ever hearing this name, but I was convinced I had not. "Maybe he was a friend of James that he had never mentioned?" I mused. "But why would the car be registered to him?"

When James had driven off at speed from our house, he had told me that he would only be gone for a few minutes. But hours passed, and he was not answering his phone or replying to my frantic messages. I tried contacting his family via Face-

book messenger and text messages, and rang the telephone numbers I had for his mum, but no one was answering.

The police officer was concerned about the large amount of money that Karen was claiming James had potentially defrauded, or as she felt stolen, and an investigation would commence. He had excused himself and left the small meeting room for several minutes to speak to a superior officer, and Ryan had taken this opportunity to phone Darlington fire station where James had initially worked. James had been stationed there for many years and was still in contact with all his old colleagues. If Ryan could speak to one of his old mates, maybe they could get in touch with him and shine some light on where he might have gone.

It was a very brief conversation. Ryan managed to speak to the station manager, who confirmed with complete certainty that no James Scott had ever worked at Darlington fire station; he had never heard that name before. Ryan also enquired about Greg Wilson, but the station manager had never heard of that name either.

Ryan ended the call and turned to Karen with complete confusion clouding his face. "What is going on? Who is James?"

Karen was dumbfounded. Surely he had to have been a firefighter, he simply had to. We'd witnessed him in his uniform smelling of smoke. We would all overhear work-related calls from the fire station. I was his next of kin in case of emergency, and I had received emails concerning this. His White Watch colleagues had sent the lovely fire engine toy box for Charlie's christening, and the firefighter teddy. Was this all fake too?

I could not believe what Ryan and Karen were telling me.

James always said that being a firefighter was so important to him, and all he had ever wanted to be. He had told me on more than one occasion how it defined him. He loved to help people, like the little boy he had rescued from the burning building, breaking his back in the process. Surely that was true? Now I was not too sure.

"Right," I said, my voice sounding decidedly steadier than I felt, my teeth chattering with shock; I felt like I might be sick at any moment. "We'd best find out who this Greg Wilson person is; maybe he knows where the hell James is."

We all looked at each other, not having a clue where to start. Laura and Katie had been listening to the whole conversation quietly as it unfolded, but Laura had a suggestion to make.

"You've got a name – Greg Wilson. James's car was registered to him at an address in Darlington. We could start googling and looking on social media and see if anything comes up." Laura already had her iPhone in her hand and was tapping in details.

I sat silently watching my daughter, and every few seconds glanced at my own phone, willing it to ring and be James. I wanted him to be on the line, telling me everything was OK, it was all a big mistake; but sadly my phone remained silent.

Laura drew a blank: she had found a few Greg Wilsons but nothing significant, and nobody near Darlington.

After an hour or so and with no luck whatsoever, we widened the search and just looked for anyone with the surname Wilson living in the Darlington area. One profile on Facebook that came up was for a Rachel Wilson.

Laura passed the phone to me with a nonchalant shrug. "There's a Rachel Wilson here, but I reckon it's another dead end," she stated dismissively.

I studied the grainy image of this Rachel Wilson and dismissed it too; however, I continued to scroll down the screen as the settings were open to the public and I could read the posts. Nothing out of the ordinary struck me: pictures of her three young sons on holiday and just general everyday stuff, until I read a post about a new woolly hat Rachel had bought for one of her sons and I recognised the name.

"Hang on a minute!" I stopped scrolling for a second and turned my attention to everyone in the room. "One of her sons has the same name as one of James's nephews, which surely can't be a coincidence: that name's too unique."

I frantically returned to scrolling through her posts, keen to discover any further information. There were posts berating her husband Greg and his thoughtlessness, and more mention of her three children. My blood ran cold as realisation dawned on me that these were the names of James's nephews. These were the names of his sister Bronwyn's kids.

I felt sick as I clicked on her photos and started desperately looking for any faces I recognised. It did not take me very long. I had seen pictures of James's nephews in the past, and these were the same pictures of smiling boys that I was now seeing on Rachel Wilson's Facebook, described as her sons.

I continued searching through the posts and photos, a feeling of shock and confusion engulfing me, until I was stopped dead in my tracks. I was staring wide-eyed at a family photo depicting a typical day out in the country. A mum and dad were smiling for the camera with their three happy sons. It was Rachel and Greg Wilson, but the man smiling confidently out from the photo was none other than my fiancé James. James Scott.

I dropped my phone, my hands shaking as it clattered to the

wood floor. All eyes turned towards me.

"It's him!" I declared in a shocked voice. "He's Greg Wilson!"

Karen reached down to retrieve my phone from the floor, clearly confused. "Who's Greg Wilson?"

I stared at her, stunned disbelief on my face. "James! James is not James, he's Greg!"

Soon everyone had grabbed their own phones and were busy on Facebook, confirming what I had just told them. Yes, James was indeed a man called Greg Wilson, with a wife Rachel and their three sons.

"I've found James's mum," Laura announced. She had found Maureen, as she was listed as one of Rachel's friends; and there was the woman I knew to be James's mum, smiling out with John from her own Facebook account.

I studied her personal info: it stated that Maureen was a retired nursery nurse, and not the sports agent I had been led to believe. But then I had believed that Maureen was not on Facebook or any social media platform: it was beneath her, James had told me.

Laura also discovered pictures of James's supposed daughters, Maddie and Kenzie; however, it now became clear that these images were of daughters of friends of the family, and not his own dearly loved children.

As things began to sink in slowly, my head was spinning and I felt ill. I now understood that my fiancé and the man I loved was not who he had purported to be. He was not James Scott, firefighter and doting father to Charlie; he was Greg Wilson, a married father of three boys. I could not take any more in, and once the tears started, I didn't think they would ever stop.

Karen took me gently by the arm and guided me upstairs,

where she tucked me into bed. I was in an almost catatonic state. I lay awake and numb, staring at the bedroom wall all night, unable to sleep, but also unable to get up and do anything productive. I just felt as if I was rooted to my bed and unable to make any sense of what had happened. What about me? What did this all mean? And what did it mean for Charlie?

Downstairs Karen, Ryan, Laura and Katie continued talking in hushed whispers into the night. Ryan emailed the police officer he had met, to pass on the information uncovered by our social media investigation. The police confirmed that someone would be out to see Karen and me on Monday morning, but Ryan felt he needed to do something. We just all felt so useless.

A few hours later, Karen knocked gently on the bedroom door; she wanted to check on me, thinking I was asleep, so was shocked to see I was still wide awake and staring off into the distance. She asked if I was hungry: would I like some fish and chips? They were going to get some for themselves and the girls, as none of them had eaten anything all day and nobody was in the mood to cook a meal.

Food was the very last thing on my mind: I just wanted to be left alone. Karen nodded her head, understanding how difficult it must be for me. She quietly shut the bedroom door and returned downstairs. She had already decided that she and Ryan should stay for a few days to support me, so we could all come to terms with what was unfolding.

Sleep evaded me for the majority of that first night, but somehow I must have eventually fallen off to sleep: a sleep filled with James and our life together, confused dreams permeated with anguish and turmoil. James was Greg, there was no James, never had been; I had to realise that.

The following morning, I awoke with a start to the sound of

Charlie crying in his bedroom. Confused and disoriented, I had a few seconds of normality before the memory of the horrors of yesterday came crashing down on me. I dragged myself out of my warm bed and stumbled into Charlie's room. Scooping my little son into my arms I hugged him tightly, my tears making a damp patch on the back of his little blue pyjamas.

How could anyone do this to an innocent little soul like Charlie? Lie and cheat, run off when your lies begin to be exposed and it all started to unravel. What kind of man was he? I knew then, looking down at my beloved son, that I might want to shut the world out, go to bed and never get up again; but the world would keep on turning, and I just had to find a way to carry on. Charlie had only one parent to rely on now, and I would not let him down. I had to try to stay strong, no matter how hard it would be. Charlie needed me, and we both needed answers.

When Charlie was finally dressed and changed, I carried him downstairs and placed him gently into his highchair as I prepared his breakfast. I glanced around the kitchen, taking in the greasy fish and chip cartons and the empty bottle of champagne discarded next to the sink. I didn't hear Karen come in the room.

"Sorry about the mess and drinking your plonk; we really should have cleaned up better," she admitted sheepishly as she began quickly shoving the empty wrappers in the already overflowing kitchen bin. "We all needed a drink after the shock of yesterday," she continued. "We couldn't find anything but that bottle of champagne, but it helped wash down our fish and chips." She gestured to the empty bottle.

Nothing mattered now! I smiled at Karen as I took in her unkempt appearance, her messy hair sticking out at all angles

and day-old make-up smudged under her eyes.

"You're welcome to the champagne: it's not like I have anything to celebrate. I'm glad you drank it when we discovered what we did about James, since it was a present for our wedding." I laughed bitterly, exhaling deeply as I tried to control the flood of thoughts desperately fighting for space in my brain. I realised in that moment that I had to stop thinking of James as James now; there was no James, there was only Greg.

That day my family were wonderful. I know that Karen was beside herself with worry about all her money: where it was, what Greg had done with it and what the future would bring. But she tried not to show this, supporting me the best she could. We all just came together as a family and tried our best to be strong for one another; not really knowing what to think or how to feel, just the realisation that we had to remain strong. My daughters, Karen, Ryan, Yvonne and mum were all together and united. We decided we must try to refer to James as Greg now, not give his fake identity any life, but it was difficult. I had loved James, he was my life, but he was 'dead' now.

Chapter 47

Falling apart

K aren and Ryan stayed at my house for over a week to support me. Maybe they were scared that I wouldn't be able to cope on my own, but for whatever reason I was so thankful that they did.

I was trying my hardest to go through the motions, caring for Charlie and trying to keep things as normal for him as I could: getting up in the morning and going to bed at night; just existing, barely eating, living on endless cups of tea and coffee. My weight plummeted and the heartbreak diet proved much more successful than my previous early morning visits to the gym and luxury spa.

A couple of days after we discovered the truth about Greg, the police came to my house to talk to us. If I remember correctly, it was a police constable and a sergeant, both nice men, kind and sympathetic, but obviously they had never dealt with anything like this before. They were really struggling to get their heads around what they were being told by Karen and myself.

We collected everything that we could relating to Greg and the businesses for the police to take away and aid them in their investigation. I also gave them my phone, happy for them to

see all the information stored on it, all the messages from Greg, the emails, the lies.

"Is that all you need then?" I questioned the two officers. "Are you going to arrest James...I mean Greg now?"

Sometimes I slip up and still call him James, and my family are quick to correct me, to remind me that there is no James. I know that James Scott never existed, but to me he did, and in a weird way he still does. I loved James Scott, but I never knew Greg Wilson; he was a stranger to me.

I cannot come to terms with the fact that on that miserable evening in February 2017, James Scott just failed to "be" anymore. It was like a bereavement to me. I needed to grieve.

The police officers laughed at my naivety. "If only it were that easy," one of them told me kindly; "but this investigation will take time, a lot of time."

I stared at them, shocked. I honestly thought that would be it: he had committed a crime, so they would go and arrest him and bring him back in handcuffs. I knew nothing then of the justice system, and believe me, it is a very slow-moving machine.

I needed to confront Greg, needed answers. I needed to ask him why. Had he ever even loved me? Had he loved Charlie? But I would not get the luxury of asking. I would never get any answers from Greg, not then and not now.

The following day I arose early. Another day of going through the motions, counting down the hours until I could once again return to my bed, pull the covers over my head and escape the world. Not that I ever slept well, and when I did manage to drop off, my dreams were plagued with anxiety-filled nightmares.

However, I knew that for my own well-being I needed to take back a sliver of control over my life and get some of the answers

I desperately needed. I was not going to get any response from Greg, so I needed to try a different approach. I decided that his mother Maureen might be the best place to start.

Chapter 48

Maureen

The telephone number I had been given by Greg for his mother just constantly went to answerphone. I had received many text messages from Maureen on this number before, but now, when I desperately needed a reply to my text messages, they all remained unanswered.

Facebook was the answer, I then decided. Thanks to Laura, I now had Maureen's Facebook details. Quickly I typed in a message to her and clicked Send, desperate for her to respond. In the message, I said I was having difficulty contacting her by telephone, but I would really like the opportunity to speak to her. Minutes later my mobile phone pinged with a reply. Maureen was so pleased to hear from me, but confused as the number I'd been trying was not her number and never had been. She gave me her real number; I took a deep calming breath and started to dial.

"How lovely to hear from you, Coleen," Maureen answered brightly. "How are you, and how is little Charlie doing? It would be lovely..."

I interrupted her pleasantries. "Sorry, Maureen," I said, "but before we go any further, can I just ask you one question?

What is the name of your son?"

Maureen was obviously confused and laughed nervously. "What an odd thing to ask, Coleen! Of course you know he's Greg."

Again, I interrupted her. "No, no, that's not the name I know him as. I know him as James, James Scott."

I heard an audible gasp from Maureen as she shouted for her husband John. I could hear the muffled voice of John in the background asking Maureen what it was, and I heard Maureen's reply to him, her voice fraught with fear.

"Oh no, John, he's done it again!"

Answers were what I'd wanted, and answers were most certainly what I got during my hour-long telephone conversation with Maureen Simms: answers that I found hard to stomach, but they were answers nevertheless. Maureen had two sons, Neil and Greg. However, the two boys were not close at all and never had been, even when they were children. Greg was married to Rachel; they'd been married for a long time, having got together in their teens. They had separated recently, Maureen informed me, but remained close and still in each other's lives to some degree. Maureen had three grandsons from Greg and Rachel, and these boys were Charlie's half-brothers. I asked if she knew why Greg had called himself James Scott. Maureen divulged that James was Greg's middle name, and Scott was his father-in-law's surname.

Greg had never been a firefighter: that had been his father and grandfather before him. His father was a serving firefighter for his entire career, and Greg often hung around the fire station when growing up. Maureen surmised that this is how Greg would have got all his knowledge about the fire service.

Greg had in fact been in the army for a few years, but he retired in his early 30s due to ill health, with a sizable settlement and pension. Maureen claimed that Greg suffered from bipolar disorder. I am still not sure if this is the truth or not, as I never saw him take any medication.

Maureen went on to tell me that Greg was now unemployed. He had led her to believe that his only work was helping to manage my, and my sister Karen's, properties. She believed that my sister and I were the wealthy, successful property owners, and not in fact her.

I felt numb as I listened to this history unfold. Clearly Greg did not work at all: he certainly didn't work as the hero firefighter that he claimed. He had told me that his only desire in life was to save lives and help people; it would now appear that the only person he liked to help was himself.

Maureen said she married John many years earlier, not in the last year as Greg had stated; and in fact John was the main father figure when Greg was growing up, bringing both Neil and Greg up as his own sons, as well as having his own biological son Alex. Greg's own father had actually left Maureen when he was a very little boy, after it was discovered he'd been unfaithful to Maureen: he'd had an affair with her best friend and run off with her, leaving Maureen to cope alone with two young sons. Once she was left as a single mother with two boys, she struggled financially. She worked part-time as a nursery nurse, never being the wealthy sports agent that I had believed.

Did Greg not want me to know that his father ended up as a cheat? He was certainly not the upstanding moral man that Greg had always insisted he was. Maybe the truth was a little too close for comfort; as the saying goes, "The apple doesn't

fall far from the tree."

As it turned out, Maureen had desperately wanted to get to know me, pushing Greg to let her see me and form a relationship, just as much as I had wanted with her. She too would be fobbed off with many excuses. Too often these excuses mirrored the ones I was receiving. I was too busy, too work-orientated, a little distant and cold. But Maureen did spend time with Charlie: so all those times when I was harassing Greg, wanting Charlie to spend time with his grandparents, Charlie already knew them very well.

Reeling from what I was learning, the depths of Greg's deceit, I felt so deeply sorry for Maureen too. She had been lied to, duped, manipulated by her very own flesh and blood. We left the conversation, with arrangements to meet properly face to face. Maureen and John would come to my house the following Thursday, spend some time together and maybe somehow, on some level, make sense of it all.

I suggested that I should send Maureen a friend request on Facebook: she would then see all the photos of Charlie on my posts, see our life together. Maureen quickly shot this suggestion down. No, she felt it was best left until we could see each other in person. Her daughter-in-law, Rachel, Greg's real wife, was on her friends list. If Rachel realised who I was, she could make my life a living hell. Rachel and her brothers were bad news, and Maureen really didn't want any trouble for me. I understood and thanked her: more trouble was the very last thing I needed now.

The next day I received a text message from Maureen: Alex, her stepson, and his wife had been at Maureen and John's house for dinner, and they had been discussing everything: all about Greg's alter ego James Scott and the web of lies that

he had spun. Understandably, Alex was incredibly shocked to learn everything and wanted to speak to me too; he wanted to help, and I agreed that Maureen could pass on my telephone number to him. With that I took my telephone up to the privacy of my bedroom and waited for the call. Alex spoke to me for about half an hour or so. He was a serving police officer at Chester-le-Street police station, and his relationship with Greg had not been close.

Alex tried to fill in blanks for me, and it was easier for him to be more impartial than Maureen. He was able to look at the situation more objectively than Maureen could. After all, she was discovering that her son was a liar and a fraud and that had to hurt, even though it was clear from her initial reaction that this pattern of behaviour was not new to Greg.

Alex told me that Greg had still been in a relationship with his wife Rachel for most of our relationship together, but Greg had participated in affairs behind Rachel's back during their entire marriage. Rachel chose to turn a blind eye or to forgive him. Greg had led me to believe that he hated all cheats; he often questioned how anyone could do that kind of thing to the person they loved, claiming he had only ever slept with three people in his entire life. Monogamy had appeared to be everything to Greg, but in fact he was a dirty, devious manipulative serial cheat, only ever caring about his own wants and needs.

Alex tried his level best to comfort me, but I was shocked to my core, feeling an idiot and a gullible fool. How could I have believed Greg's lies? This man that Alex was describing was so far removed from the man I loved and thought I knew. Alex told me to call if I needed anything, and again warned me not to try to contact Rachel or any of her family.

"Believe me, Coleen, that family is bad news," he told me firmly. "They won't understand that you're a victim, so just be really careful."

After the call ended, I sat on the edge of my bed staring blankly into space. My cheeks were wet with the many tears I had shed. This was like some twisted joke, and it was all of Greg's making. He'd gone straight from his wife's bed to mine. Had he been laughing all along at my stupidity? The shifts he had worked, the trips to America to see his beloved daughters, all lies, just excuses to be with his wife and sons, and in all probability other women as well.

Why would his wife Rachel and her family hate me so much? I was a victim too after all, but twice now I had been warned to keep my distance from them and I did not need telling again.

But there was a whole new event that day. Several minutes earlier, a bulging jiffy bag had been delivered in the morning mail. Mum was gawping at the package.

"Look, Coleen." She pointed to the back of the package. "It states here the sender is James Scott."

Greg must have posted this parcel to me not knowing that I had discovered the truth about his identity. Clearly at this point he had not yet spoken to his mother or his stepbrother, did not know what I now knew. Mum picked up the envelope, which had money stuffed inside! I stared blankly at the small envelopes strewn across my coffee table, all stuffed with cash, not knowing how I should react.

"What do you think it all means?" Mum asked thoughtfully.

I took the envelopes from her and looked at each one individually: there was one for Charlie and myself, one for Karen and one for Mum.

I shook my head, confused. "I really don't know, Mum;

maybe he thinks he can still come back, and he's trying to build bridges by sending us a few hundred pounds in cash. As far as he knows, we're still in the dark about him."

Maybe Greg was waiting for the dust to settle to come back and try to talk us all around, using his legendary charm.

"Just let him try," Mum fumed. "I wouldn't mind having a few choice words with Greg myself!"

I knew it would be only a matter of time before Greg would find out that I knew the truth. He only had to speak to his mum or stepbrother, or for the police to contact him, and the game would be up.

Whatever his reason for sending the money, thank God that he did. Although it was only a few hundred pounds for me and Charlie, it kept the wolf from the door for those first couple of weeks at least. Although I'd always prided myself on my independence, within a couple of days I had become unemployed, with no income and three children to support. Times became extremely hard extremely quickly.

I now began to dread the daily arrival of the postman: his cheery whistling as he strolled up the drive and the thud of the post landing on the doormat sending waves of fear coursing through me. Unpaid bill after bill arrived. Greg had always been the one to collect the post from the mat every morning, but now that I had access to everything that was delivered, it was extremely worrying.

James Scott, or I should say Greg Wilson, was in demand yet again, but this time not for his charm, wit and charisma, but for the many thousands of pounds he owed. Metro Radio, Newcastle Falcons, the office rental, car insurance, loans taken, solicitors and on and on – the bills and demands kept coming. I relayed my pitiful story to all of them the best I

could, explaining what had happened. Initially, I often received animosity, but upon hearing the whole story this would quickly change to sympathy and support for me. I could only tell them what I knew and provide them with the crime reference number the police had given me. I kept the unpaid bills and demands on my kitchen table to pass on to the police as evidence; and boy, did that pile keep on growing!

However, even worse than the bills arriving was the wedding invitations that were now being returned to me daily, all marked 'address unknown'. Another reminder of Greg's lies – the wedding invitations sent to fictional people at fictional addresses that in due course were finding their way back to my very real home.

As time passed since Greg had deserted me and Charlie, I tried my best to pick up the pieces of my life and put them back together. This was made all the harder as I would constantly face disbelief and distrust from the people who'd known 'James'. His friends and business colleagues, who had got to know him well, or so they thought, could not believe what I was telling them.

Some even found it easier to blame me. "No, I don't believe it!" I would hear time and time again. "Not James, he's such a good bloke, you must have got it all wrong."

I even heard rumours that I had been the one cheating on him, and that's why he was no longer on the scene: I was lying to protect myself. However, one by one their minds had to change as their phone calls and messages to James remained unanswered, their bills unpaid. Eventually they had to believe what I was saying: they had no choice but to see the truth for themselves.

Little Charlie was not coping well with his father's sudden

disappearance from his life. I may have been struggling, but at least I knew why I had anger as well as despair. But for Charlie, he had simply been abandoned by the most important person in his life. Separation anxiety hit the little boy hard, and if I'm honest, to this day it still does. As I'm writing this, Charlie is now approaching seven years of age; but when I go to pick him up from school, I still see his anxious little face looking out, waiting for me. He's always worrying that one day I might not be there and will abandon him too. It really breaks my heart.

Back then, though, and just turning one year old, Charlie would not let me out of his sight for a second. He would scream constantly, and I could barely even leave him for a minute to nip to the toilet. Many a night when Charlie awoke fitfully from his slumber, I would end up sleeping on his bedroom floor. I was beyond exhausted, but any attempt I made to leave his room would make him scream to the point of actual vomiting. Every trip to the doctors brought the same diagnosis: separation anxiety. The doctors gave me tips and leaflets with help and advice on how to break the cycle. I really tried hard to help Charlie cope with the situation. I took him to toddler groups to try to get him to interact with other children, but I ended up having to sit on the floor for the entire time with Charlie and the other children, as every time I tried to move away, to have a chat and coffee with the other mums, he would scream the place down and be sick.

This did improve eventually over time, and once Charlie started nursery he was better able to be away from me for short periods. The staff were always helpful and incredibly supportive, but my little boy is still left with traces of this anxiety, even now.

Trying to cope with the devastation that Greg left in his wake

unsurprisingly messed with my mental health too. I would often believe I saw Greg out and about wherever I was. I would see him driving a car, in front of me in the queue at Tesco, walking a little Yorkshire terrier. Of course it never was Greg: he was long gone. It was just my mind playing tricks on me. I was suffering from anxiety, and PTSD I was told. Back then both Charlie and I had our demons to overcome.

Chapter 49

Rachel

Early one morning, about three weeks after the fateful day that Greg disappeared and my world fell apart, I received a telephone call from Karen. She was flustered and apologising profusely. The previous night she had been out with Ryan and had enjoyed a few alcoholic drinks. In her inebriated state she had worked herself up into anger about the situation we were in. She was furious about what Greg had done to me, frightened about the future, her career gone, all her money stolen, and she wanted more answers. Impulsively she had sent Rachel, Greg's wife, a friend request on Facebook, wanting to discover more about him, where he might be and what he might be up to.

Karen told me she had almost instantly regretted sending the friend request, but before she could retract it, Rachel had messaged back. I was feeling the icy grip of fear. This could not be good: both Maureen and Alex had warned me to stay well clear of Rachel, as she and her family were trouble. I felt my body begin to tremble.

"Why would you do that, Karen?" I implored her, terrified. "They'll be out for me, now that they know who I am."

"No, Col, calm down," Karen reassured me with a steady voice. "She already knew all about you…"

Karen then proceeded to tell me that Rachel had accepted her friend request, and Rachel had seen the photographs on her Facebook feed, including ones of family occasions with Greg – her husband. Karen then spent several hours messaging Rachel and in a telephone conversation with her, which had proved very illuminating.

Rachel had asked Karen if she knew Greg Wilson, her husband; or rather, did she know his false identity of James Scott? She already knew he was living in the Chester-le-Street area under a false name and was having an affair.

What was this? I was stunned; I could not make sense of what Karen was telling me, in all honesty too scared to make sense of what I was hearing.

Rachel had known about me all along, had done so since my waters had broken in November 2015. Why hadn't she contacted me? Even if it was just to shout and scream. Didn't I have the right to know the truth too? She actually knew he was living with me under a false identity, even told Karen in her iMessages that she had my postal address, had found it on paperwork hidden in Greg's belongings, but she chose never to come to my door. What manipulation had Greg subjected her to? I now understand that she too is a victim, but if she had only made contact, some of the events could have been avoided. Nothing would have stopped the devastation to me, the heartbreak of facing life as a single mum, but at least Karen would have been saved from financial ruin, being forced into a bankruptcy that could so easily have been averted if only we had known the truth.

Initially I felt angry at Rachel. I felt she could have stopped

everything in its tracks, stopped Greg, exposed his false identity to the world. But as Karen forwarded me message upon message from Rachel, my sympathy for her began to grow.

Rachel told how she had been with Greg for 16 years and married for 13, and they shared three sons together. She had found out in November 2015 that he had been living a double life and having an affair with a woman and had made the woman pregnant. Rachel's world had fallen apart, and her children were deeply affected. Greg had told her that although his mistress was pregnant, he doubted very much whether the child was his as the woman was promiscuous and an alcoholic. Rachel and Greg had separated once she discovered the affair in November, but then they had decided to give the marriage another go in the New Year as she felt her boys really needed their father. He claimed he had demanded a DNA test from the woman on her new-born son Charlie, and this had confirmed he was not the father.

Rachel had tried to make the marriage work, but Greg repeatedly failed to provide the DNA proof that Charlie was not his son. With this and his ongoing lies and deception, she kicked him out of her and their children's lives in December 2016, thirteen months after first discovering her husband had been cheating and the woman was pregnant.

I felt completely sick to my stomach. Greg may have admitted to Rachel that he had had an affair, but that was the only truth he told her. He'd had to tell her something, as that was when he was moving in with me.

As I sat and tried to fathom out what I had learnt, I began to realise how despicable the man I'd loved was: what depths that he'd sunk to, with his own interests and needs the only

ones that ever mattered. He'd trampled over everybody to get what he wanted.

He may have tried parting from Rachel on that bleak November day in 2015 when I was in hospital after my waters had leaked. He admitted to her about his relationship with me, but this was not through any sense of guilt or decency on his part, but purely because juggling his two lives had become too problematic. He had to be with me more as I was at home on bedrest; but having two lives was proving a bit too much like hard work for him.

Greg soon realised within a couple of weeks that maybe this decision had been a little too hasty. My current medical condition meant that Rachel could offer him the one thing that I couldn't – sex. Greg had an extremely high sex drive, and he was not a man to put his needs on hold. He had an itch that needed scratching and scratch it Rachel would.

Within a few weeks, his double life was in full flow again. Greg had gone back to Rachel with his tail between his legs, full of apologies. He had been such a fool, he told her; he had made a mistake but, as he admitted, he had also been duped. I, the woman he was having the affair with, had manipulated him. I was a ruthless woman, hell bent on having an affair with him, not in the least bothered that he was married with three young sons; he said I even got a kick out of it, enjoying the feeling of power from having stolen another woman's man. Of course he would not have given Rachel my real name: too dangerous that she might have found me on Facebook. I shuddered to think about how he had described me, and how different this was from the truth of who I am. Rachel believed I was this hard-faced, hard-drinking, husband-stealing bitch.

Greg claimed that the results of the DNA test had come back

and the evidence was there in black and white, proving that Charlie was not his son; there was a zero percent chance he could be the father. He had then confronted me, he said, with my many lies and had then left; all he wanted was to be forgiven and back home with his real family and the only woman he had ever loved – his wife. To prove his devotion, they both got matching tattoos – the three worlds with the halo above.

Tears ran down my face as I began to see Greg for what he really was – a truly twisted, evil man. Even discovering from Rachel that his back injury supposedly sustained from heroically saving a child's life was actually caused on the waltzers during a day at the funfair. Why Rachel had decided to take him back was beyond me. She told Karen in messages about his previous affairs: one when Rachel had just given birth to one of their sons and was on bed rest. The poor woman had been with him for most of her life, so I can only imagine the mental damage he had inflicted and the control he had over her. She confided to Karen in one message that Greg was an abusive bully who had been destroying her for many years.

I knew it was breaking Karen's heart to watch me reading all the messages that Rachel had sent, to watch my face crumple a little bit more with every new revelation, but I insisted that I needed to know it all: the whole truth, no matter how much it hurt.

During those difficult weeks running up to Charlie's birth, when he and I both nearly died, Rachel believed that Greg was back in a committed monogamous relationship with her. All that time, he told her terrible lies about me. While Charlie, barely a couple of days old, was gravely ill in James Cook hospital, my little boy, as I had feared, had been left on his own, not visited by his dad, as Greg was much too busy playing

happy families with Rachel and his boys.

Rachel told Karen that Greg never did provide any evidence of the DNA test to prove that Charlie was not his. He was always making excuses to her and playing for time. Karen laughed bitterly at this, surprised that Greg had not just faked the results: history had shown that he had a flair for forgery, whether it be boiler installation details, fake bank balances or a false nil sperm count. However, he never showed her any proof, forged or otherwise. Despite this, Rachel continued with the relationship, even though Greg's absences became more frequent and longer than before.

All the times when Greg was with me, Rachel believed he was working for a friend of his called Lee Walker. Of course the lies he told Rachel about his whereabouts were different to what I was being told; she was never led to believe he worked in the fire service. The story for her was that he was working for Lee Walker in an administrative role, which often called for him to work long hours and accompany Lee on overnight business trips. Lee was an extremely successful businessman that Greg had met through golf: a former professional footballer turned entrepreneur.

I also found out the appalling background to Greg's fire service impostures: Rachel said that she and Greg had bought a used fireman's outfit from eBay to introduce into the bedroom and spice up their sex life. I felt sick: this was clearly the same outfit he would wear around my family, claiming he had just finished a shift at work.

Rachel believed that she had formed a friendship with Greg's employer and friend Lee, through the many texts and emails they exchanged. She was told that Lee's wife Julie had breast cancer, so Rachel baked cakes and made gifts for Julie. These

cakes and gifts were in fact given to me, straight from his wife to his lover.

Rachel knew that Lee Walker did exist, but she only later discovered that rather than being friends and working together, Greg had met Lee just twice, both times during golfing tournaments at Rockcliffe Hall. Greg liked to base his lies on real people; it was a recurring theme with him. Rachel's best friend was a lawyer called Bronwyn, with a husband called Mike and a daughter Jodie: all names I knew only too well, the names Greg had used for his fake family.

Rachel had given us so much information about Greg, filling in so many blanks, but she had no idea where he was now. Nor did she know how she could find Lee, since Greg had never worked for Lee and they were not, and had never been, friends, only having met a couple of times. The friendship she had believed she had with Lee was based on emails and telephone messages constructed by Greg. Greg had actually stolen Lee's identity and had committed fraud posing as Lee on at least one occasion prior to coming into our lives. The only information that Rachel had about Lee was his full name, and that he lived in the Durham area.

Karen leaned over and gently took my mobile phone off me and put it on the mantelpiece, out of my reach. "I think that maybe it's time to try and meet Lee Walker, to see what he's got to say about everything. Clearly we weren't Greg's first victims."

I nodded my head in agreement, keen that we should dig deeper and find out the truth. We had all been living in the dark for far too long; we needed to know what was real and what was fantasy.

The police investigation was meanwhile underway, Karen,

Ryan and I having given written statements and interviews through numerous visits back and forth to Chester-le-Street police station. We were all more than happy to do whatever we could to ensure that Greg was brought to justice. However, the case seemed to be moving terribly slowly, assigned to only once police officer, DC Christopher Bentham. Chris was incredibly supportive, working diligently and tirelessly on the case, but he was only one man and there were only so many hours in the day. For my own mental well-being I needed answers.

Chapter 50

Lee

K aren was searching for anyone in the Durham area called Lee Walker. On Facebook she had found a couple of likely candidates and had sent them both messages. Within an hour we had some of the answers we needed.

A Lee Walker had messaged Karen back, confirming that he was the Lee we were looking for. He had met Greg only twice, and boy did he have a story to tell us. He invited us to come to his house at 7 p.m. the following day, which was a Sunday, and he would have the kettle on and biscuits ready.

The following day we rang the doorbell of Lee Walker's house, not knowing what to expect and what we would discover next. I was definitely apprehensive, already reeling from all I had learnt, but I needed to know the truth, no matter how hard it became.

As we waited nervously, Ryan cast his eye over the impressive modern detached home and the Aston Martin parked up in the drive.

"Would you look at that?" Ryan laughed sarcastically. "Lee even has the same car in the same colour as Greg lied that his

mother had. Coincidence? I think not." I had to admit that this house would have been just up Greg's street; it would have suited him perfectly.

The door swung open, and we were greeted by a tall, muscular man in his mid-forties, with a pleasant handsome face and a wide welcoming smile. Lee warmly invited us into his home, and once we all had a cup of tea in hand, we headed into his spacious sitting room. Lee's house was beautiful – modern and minimalist. It was like an interior designer's dream, reminiscent of the Ramside Park house that Greg was so keen to purchase as our dream home.

Once settled, Lee began his story of how he knew Greg Wilson. He had only ever met Greg a couple of times: on both instances he seemed a pleasant enough guy, but quiet and unassuming. This description did not match the vivacious force of nature that we had known.

Lee had become suspicious when he found that his business had been invoiced for a charity event in Middlesbrough, an event that he knew nothing about, for a women's charity called Her Sister's Place. A confused Lee had taken it upon himself to contact the name on the invoice to sort out the error. The conversation that Lee then had with a lady from the charity had left him reeling. Initially she greeted him on the phone as if they were old friends, thanking Lee for attending the event and his generosity and what a wonderful night it had been. He had no idea what the woman was talking about.

"Can I just ask you what I look like?" Lee had asked her, stopping her words mid-flow.

The voice on the other end of the phone had laughed nervously. "What an odd thing to ask, Lee, but of course ... well, you are maybe about five foot nine, fair hair, medium build.

I'm just confused why you're asking. Have you not got a mirror in your house?" She laughed again.

"I'm asking," Lee answered, "because that is not me. I don't know who the hell you spent the evening with, but as a six-foot-three ex-football player with dark brown hair, I can assure you that it wasn't me."

The phone line had gone silent for a few seconds before she continued in a flustered voice. "I don't know what to think," she said before pausing for a few more seconds, "but now that I cast my mind back, there was a rather odd thing happened that night. One of my staff heard your lady companion call you Greg, and she was confused."

Lee then told us that when he heard the name Greg, the penny had dropped. The only person he knew called Greg who fitted the description physically was the quiet, seemingly shy Greg Wilson that he had played golf with. However, this Greg Wilson, who was passing himself off as Lee, was apparently the life and soul of the party, charitably offering use of his Aston Martin and his villa in Nice as raffle prizes. I stared at Karen and Ryan aghast – the Aston Martin, the villa in France, these were all things that Greg had us believe his mum owned.

As Lee continued to talk for the next couple of hours, we couldn't help but see the similarities between him and the James that we'd known. In appearances they could not have been more different, but in personality, confidence and enthusiasm, it was uncanny.

Lee was the one who owned the flash cars, had the villa, had the money. He was well liked and well regarded in the community. Had the persona of James Scott been based on Lee Walker? There were too many similarities for it to be a coincidence. And then when Lee told us that despite liking

the odd Guinness, his drink of choice was an orange and soda water, we knew that even down to this little detail, James was based on Lee. Greg had been living a life that he had aspired to and admired, the life of Lee.

Rachel had told Karen of the friendship she believed she had with Lee, and that he was married. Lee was indeed married, but not to a woman called Julie who was suffering from breast cancer; and Lee had never ever heard of Rachel.

It seemed too bizarre to be real, but real it was. Quite clearly the act of stealing Lee's identity had been so thrilling that, rather like a story in a book or film, Greg Wilson had just decided one morning to become James Scott: a man based entirely on Lee Walker. He revelled in the role of being a gregarious millionaire, receiving popular adoration as he told his many, many lies.

Once Lee had finished the telephone conversation with the woman from My Sister's Place, he had immediately gone to Chester-le-Street police station and given a statement about the fraud against him perpetrated by Greg Wilson. For whatever reason, he was never contacted by the police to follow up on this, and he never heard of any ongoing case or its outcome.

Lee was such a lovely chap, it was understandable why if Greg wanted to emulate someone, it should be him. He has been incredibly supportive towards us and a great help to our recovery; he still is to this day.

Chapter 51

Iain

While the police investigation was still underway, frustratingly there was nothing we could do but wait. We now had to put our faith in the justice system and somehow try to get our lives back to some semblance of normality.

I was taking life one day at a time, just putting one foot in front of the other; and life did, as it always does, go on. I was still traumatised by everything, having nightly dreams about Greg, still thinking that I would see him when I was out and about. Money was very tight for Karen, Ryan and myself, because of what Greg had done; Karen and I no longer had employment. And with Charlie suffering from severe separation anxiety, even part-time work was out of the question for me.

Karen threw herself into managing the houses she owned, but with no funds left in her account and no income, she heartbreakingly couldn't manage any more. After a lifetime of hard work and commitment, thanks to Greg she was forced into bankruptcy.

To make ends meet I sold everything I could, anything that

Greg had given me, as I couldn't bear to have any reminders of him in my home. The Louboutin shoes I duly sold and gave the money to Karen: it was only a couple of hundred pounds, but every little helped. I did the same with my engagement ring. I was hopeful that the flashy diamond solitaire would get me a good return, since people were always telling me you could tell it was quality: "you get what you pay for", and it turned out that I did get what Greg paid for it − £12, the going rate for a ring as fake as the man himself.

My £1,200 wedding dress was still hanging in my wardrobe, and I just couldn't bring myself to sell it, not wanting people coming round to my home, potentially excitedly trying it on. Greg had made so many false promises to charity that I felt it fitting to donate my dress to a worthy cause. It was a stunning dress, and I liked to think that a struggling bride would have it for her perfect day and some good could come out of the mess.

I was spending a lot of my time with Karen and Ryan, all of us supporting each other. We had been through such a terrible ordeal, but if anything we were stronger, closer as a family, our bond one that Greg Wilson could not and would not destroy.

One afternoon, a month or so after Greg had left, Karen was around my house, checking up on me as she so often did. We were having a coffee and she was giving her nephew Charlie lots of cuddles when her phone pinged to alert her to a new message. Karen put her coffee cup down on a coaster and studied her phone screen.

"I've just got a message from someone called Iain," she said. "He knows Greg, and apparently he wants to help us."

I turned towards her, curious to hear more, and waited for her to finish the message so that she could fill me in on all the details.

Iain Stevenson was Rachel's older brother, Greg's brother-in-law. He had heard from Rachel what we had gone through; and Iain, along with his family, wanted to reach out and offer their support.

Karen turned to me. "He's suggesting that we meet up," she announced, "go around to their house and have a chat. Let's hope he can maybe answer more of our questions. He sounds genuine, he just wants to see if he can help."

I took Karen's phone from her and read the message from Iain. Karen was right: it did seem genuine and caring and definitely not someone to be fearful of.

"I'm happy to meet him if you are," I answered with a shrug. "What have we got to lose now?" I laughed hollowly. "And it doesn't sound as if there's much love lost between this Iain and his family towards Greg."

It was agreed we should all meet. The following weekend we set off to Iain and his wife Arlene's home: Karen and Ryan in the front of Ryan's car, and Charlie and me in the back. Again, I felt apprehension swelling up in my chest, but I was eager to discover more.

Iain and Arlene were an absolute tonic: a lovely couple in their late thirties, living in a warm, pleasant home with their two children – Greg's real family. They couldn't have been more welcoming or friendly. They were nothing like the family that I had feared, after being warned off by Greg's mum and stepbrother.

Their distrust of Greg was palpable from the start: they knew he was a liar from the very first time they had clapped eyes on him, but had tolerated him as he was in a relationship with Iain's sister. On hearing what crimes Greg had committed and the devastation he had caused to our entire family, they felt

sympathy for us and would help in any way they could; like us, they wanted justice to be done.

We all got on like a house on fire. We may have only met because of one man's lies, but we remain firm friends to this day. They have been such a support to us all and have welcomed Charlie into their family as one of their own. We talked at that first meeting for many hours. Iain and Arlene told us everything they knew of Greg: his lies over the years, his cruel treatment of Rachel, his infidelities and his many false promises and big stories.

Iain believed that Greg was trying to flee the country: to go to Germany and meet up with contacts he had from his army days. We felt we were finally getting more of an insight into the brain of Greg Wilson, the man we knew so little about.

As we left that afternoon, a date was set to meet for a barbecue the following weekend. There were promises from Iain to do more digging and see if he could discover any more information about Greg and what his next plan of action might be.

"No harm in helping the boys in blue find the poisonous bell-end," Iain said, shaking Ryan's hand firmly. "I still can't believe what he's done to your family."

Iain and Arlene are such good people: they have provided us with much support from that very first meeting, through the highs and lows and every step of the way. It was a friendship formed in our darkest days, but shining bright to this day.

Chapter 52

His Girlfriend

S pring rolled into summer and then on into a golden autumn - though it riled me that Greg was still free, living his life as free as a bird and doing God alone knows what. I had begun to pick up the pieces of my own life, and things were getting better. Charlie had joined a local nursery, and despite his very vocal protestations every day when I dropped him off, his anxiety still very much present, he was thankfully starting to improve. This gave me the opportunity to secure some much-needed part-time employment - only 16 hours a week in a homeware shop - but enough to give me some independence and to help pay the bills. Life now seemed less bleak. I began to smile again; I was finally feeling like the old me was rising from the rubble that had been my life. Greg was still very much in my thoughts, but no longer dominated and controlled them.

Until, that is, I received a message on 19 August 2017, at 11:02 a.m.

This message was from a young woman. She apologised for contacting me out of the blue, but was desperate to speak to me. She needed answers. She had been in a relationship with Greg

Wilson for four months, and they were happily living together. The previous evening Chris Bentham had turned up at their front door and arrested Greg for theft and fraud, and he had been taken away in handcuffs. Chris had told the young woman what Greg had done to me and my family. She was devastated, heartbroken, and felt that I was the only person who could help her, and the only person who would understand how she felt.

This had been my greatest fear: that Greg hadn't lain low, ashamed of his actions, but had instead just moved on, left his old make-believe life behind. What lies might he have told her? Could this story get any worse?

At first I was reluctant to contact her. She had given her number, but I felt unsure whether I should message her. My life was just starting to get better, and even the thought of revisiting those feelings, talking about it all again, left me fearful.

"You need to speak with her, Coleen," Karen urged. "You could help her; it's the right thing to do, and who knows, it may answer more questions for us."

I nodded at my twin, knowing she was right. This poor woman was only in her early twenties. God only knows what Greg had told her, what lies she had believed. I hoped not, hoped that for once maybe he had been honest. However, I greatly doubted it. The following day I swallowed my fears and rang her.

After the phone conversation ended, I turned towards Karen, who had been sitting patiently across from me, curiosity clearly etched on her anxious face.

"Go on then, Sis, fill me in," she prompted, slowly taking in the dark angry look that was now evident on my face.

"The evil bastard." I spat the words out angrily. "He's done

it all again. We must stop him now. That man needs to be behind bars where he can't hurt anyone else."

Karen's eyes flashed angrily. "Go on then, tell me, but I don't know why you're surprised he's done it again; the man is a sociopath. I don't think he could tell the truth if his life depended on it."

Greg's girlfriend and I had spoken for many hours. The poor woman's heart was broken. I knew exactly how she felt. I tried my very best to comfort her, support her, telling her that she would be OK, and life would go on. But her story had knocked me sideways.

She already knew of me and Charlie: Greg had even shown her pictures of us together, and told her he was keen for us all to meet up. She, however, did not know that I had been his fiancée or that Charlie was his biological son. No, the big-hearted Greg had adopted baby Charlie, Charlie's real dad having tragically passed away. Greg and Charlie's dad had been best friends, and as a mark of genuine love for his deceased friend, he had adopted Charlie and was raising him as his own son: taking on the role of dad to this poor fatherless child, even boasting of a charity walk he would do in memory of his dear friend. He told his girlfriend it would be lovely if we could all get together to celebrate Father's Day, but it never happened; there was always a last-minute excuse, a reason why plans made would fall apart.

Greg had told her about his poor broken back: again the story about him being injured while being a hero, not this time as the hero firefighter, no; this time he'd been in the SAS! He'd related many stories of his career: how one of his colleagues was named God, as he was known as the best sniper in the UK. He would come home to her with blood on his shirt, black eyes

and sporting pots on his wrists.

"What the actual fuck?" Karen's face was a mixture of shock and fury as she interrupted me. "Do you think those were real injuries, or maybe a jealous boyfriend or husband got hold of him and gave him a good kicking?"

I shook my head slowly. "Who knows? Maybe it was someone he conned. I really haven't got a clue."

I sat for a second, thoughts spinning around my head. Maybe he had faked the injuries again, using make-up; or perhaps he had even inflicted them on himself for the sympathy vote. I honestly didn't think at that point that anything would shock me. I took a deep steadying breath and carried on relaying what I had learned from the young woman.

Greg liked to splash his money around in this new life too. He had ordered a brand-new Range Rover, and booked a luxury holiday for them both to St. Lucia; she'd given him her hard-earned money towards the trip. And of course they were also buying a flash new house together: they'd been for viewings, signed the paperwork, but surprise, surprise, delays kept happening.

"Bloody hell," Karen exclaimed. "There's a running theme to his lies," she snorted. "At least he's consistent, I suppose."

I laughed too. "Wait until you hear what he told her: apparently he can't lie, it's impossible for him to lie, he never could, he's the world's worst liar."

Although it was an inappropriate time to laugh, Karen and I had tears running down our faces as we struggled for breath. He was even lying about the fact that he could never lie!

I continued relaying the sorry tale that his girlfriend had told me. She wasn't interested in Greg at first, believing him to be gay because of his high-pitched voice and effeminate

mannerisms. However, with his attentive nature, lavishing gifts and attention on her, he had soon won her over. His mum, this time, was a nursery nurse, not a sports agent, but was still extremely wealthy. When his dad had died, Greg, his mum and his brother had inherited a small fortune and Maureen had treated herself to an Aston Martin.

She, like me, had been pushing to meet Maureen, but always faced the same barriers, received the same excuses that I had. The property lies had started in this fake life too. The young woman, dreaming of being a property developer, had been bowled over, swept along when Greg told her he was buying her a house to renovate so that she could realise her dreams.

Karen again laughed at this. "He should have offered Gemini Property Services, to manage it for her." Despite myself, I couldn't help but laugh too, but I was stunned at all I had learned.

"I've given her Rachel's contact details too," I told my sister, "so she can speak to Rachel if she wants to; maybe they can support each other."

"Poor girl," Karen said. "How does she feel about James, I mean Greg, now she knows the real truth?"

"She's devastated, obviously, but she told me she's going to the police to give a statement," I answered. "She hopes he gets a very long time in prison."

His girlfriend did indeed go straight to the police to give a statement. We kept in touch for a few weeks: I sent her messages, checking up and seeing if she was coping, telling her to stay positive, as things would get better given time.

However, after a while my messages went unanswered and then my number was blocked. I was confused: maybe she just wanted to get on with her life? I had helped her, but she now

needed to be on her own, put it all behind her, move on and move forward with her life. I understood this.

What I couldn't understand is that when Chris rang a week or so later with an update on the case, he told me that she had been in touch and had now withdrawn her statement; she was not to be contacted ever again. She and Greg were very much back together, they were in love, and she was standing by him. And they're still together, as far as anyone knows, to this very day.

This woman is of course a victim of Greg's too. I realise that. God only knows how he managed to talk her round. How had he manipulated her? However, she knew the truth, all of it, a luxury I never had. She knew the depths that man had sunk to; his lies, his treatment of my family, his neglect of his son Charlie and his criminality. Despite all this, she still wanted to be with him. It really beggars belief.

Chapter 53

Chris

Once Greg had been arrested, Chris Bentham, the investigating officer, got in touch with me to keep me abreast of everything. Greg had been escorted in handcuffs away from the home he shared with his girlfriend as she looked on, and he had been interviewed under caution. Greg had answered every question put to him with a "no comment" reply. So once the charges were read to him, Chris had no option but reluctantly to release Greg on bail until his case was heard at the Magistrate's Court.

Chris told me that this was normal procedure, but because of the severity of the crimes, he would be referred in due course to the Crown Court. If Greg pleaded not guilty, we would then have to wait for a trial date. Chris warned me not to expect anything to happen any time soon. Yet again, Greg was free to carry on his life, while we were left in limbo. His words sadly rang true: Greg fled from our home in February 2017, was arrested in August 2017, but the trial was not set until 20 January 2020, just shy of three years since Karen and Ryan first contacted the police.

Greg had to appear at court on several occasions in the run-

up to the trial, and given the chance to put forward his plea. His plea was always the same – not guilty. Although we were unable to be in the court during these times, we would still go, often accompanied by Iain, Arlene and Lee. It felt important to us that we were involved in the process, that Greg knew we weren't going anywhere, that we wanted our justice.

In one plea hearing, Greg again pleaded not guilty but went on to state that he was in fact called James Scott, having been living as James Scott for many years after legally changing his name. He claimed that he was in fact the victim, and I instead was the criminal: I was a fraudster, coercing him into stealing from my own twin sister and other businesses. Even though this was ludicrous, it still hurt me deeply. How could he feel so little towards me and Charlie? Stoop so low? No doubt it was all for his girlfriend's benefit, portraying himself as the victim. The man really was contemptible.

Chris found it hilarious. "Don't give it another thought, Coleen," he said. "The whole station had a right laugh at his audacity when they heard this. I mean, come on, that man is Greg Wilson, his bank account is in the name of Greg Wilson, your sister's stolen money was traced to that very account."

I knew that what he was saying was right, but it still made me so sad: the man I'd loved so much sinking even lower.

The months slowly crept into years: although Greg's legacy was still impacting on our lives, he was taking more of a backseat where he belonged, like a bad dream that we'd have to revisit at times, but best not to dwell on, not deserving our time or attention.

As January 2020 approached and the trial loomed, I was scared. I knew that I was the victim, but the thought of standing up in court and being cross-examined filled me with

utter dread. Karen too was uneasy, neither of us ever even having set foot in a court room, all our expectations gleaned from what we had seen in films and on TV.

The trial was due on Monday 20 January, and on the previous Friday our entire family decided to go out for the day, partly to spend quality time as a united front, but mostly to give us something else to concentrate on instead of dwelling on what was to come. We went to a little café in a nearby village and chatted along together, keeping it light, trying not to let Greg monopolise the conversation.

Karen's phone began to ring. She looked down at the screen, where was displayed a number she didn't recognise. Who could be calling her on a Friday afternoon at nearly 5 p.m.? She put down her cup and pressed the button to accept the call. Her face was unreadable as she spoke to the person on the other end, her only word being "unbelievable". All the family were waiting to find out who the caller was. Karen put her phone down and turned to address everyone with a bewildered look upon her face.

"That was Victim Support," she announced slowly. "Greg has changed his plea: he's now pleading guilty to all charges on Monday."

The table sat in stunned silence, barely believing what they had just heard.

"But why now?" I stuttered. "He's always known he's guilty, so why only admit it now?" I really didn't understand.

"Col, isn't it obvious?" Ryan replied. "The bastard's time has run out. The trial is set for Monday. There are no more adjournments, no more playing for time. He's as guilty as sin, everyone knows it – especially him."

I broke down crying, mostly from relief. Now I wouldn't

have to stand up in court, be verbally torn apart. But how could Greg have put us all through this torture of thinking we'd have to? He really didn't care for anyone but himself. Why had I even thought it might be different?

"Well, I for one think that's the best news ever!" Mum held her coffee cup aloft. "Here's to Greg Wilson, hoping that come Monday he gets everything he deserves, may he rot in jail."

When Monday did come, it was a dark, gloomy day befitting the man's crimes. We were supported in court by Arlene, Iain and Lee. Chris was there also. Everyone attending was hoping to see justice served.

Greg's girlfriend was also in attendance, standing faithfully by her man until the bitter end. She actually spoke to us in the courtroom, demanding to know why we couldn't show any compassion for Greg. Karen turned to her in disbelief. This man of hers had ruined her financially, played God with her twin sister's life, manipulated everyone in his path.

Karen stared her down, her face stern and her jaw set in anger. "Take my advice," she warned her coldly, "you need to run, get as far away as fast as you can from that man and stay away, he will ruin you."

Greg's girlfriend glared at Karen in anger, but my sister still had more to say to the young woman.

"That man is nothing but a grubby little thief."

Greg's girlfriend turned her head away angrily; Karen winked at me and shrugged. "Well, you can't say she hasn't been warned; but there's just no helping some people."

I smiled at my twin sister: sadly, like Karen, I would never understand how his girlfriend could justify Greg's actions to herself. How she could accept them? I did feel sorry for her, but this was her choice. My choice was to see Greg behind bars,

where he couldn't hurt anyone again.

Durham Crown Court is an impressive building, constructed in the early nineteenth century. It has cells below the court-room for male prisoners and those on remand. Some of these prisoners have committed the most heinous of crimes.

Never having been in a courtroom before, I wasn't quite sure what to expect. You form an opinion in your head, but this is nothing like encountering the real thing. In my mind I was expecting Greg to be in the dock, with us sitting elevated on seats behind him. I thought that Greg, the barristers and the judge would all be in full view. I wanted to be able to look at him, stare him straight in the eye, let him see I was strong and he hadn't broken me. I had survived and I knew what he was. He would see the strong woman in front of him, flanked by her loyal family on both sides, supportive friends – many being his own family members. However, this wasn't the case.

As we entered the court and took our seats, Greg was already in the dock with his back towards us. He never turned his head once to look at me. Too much of a coward.

The hearing did not last long. The many charges were put before the judge. My barrister painted a dark, detailed picture of my life with Greg, and the crimes myself and my family had endured. Conversely Greg's barrister tried his best to defend his client, but in all honesty what defence was there?

He stated that Greg was sorry for his actions, but his mental health had impaired his grip on reality. He was ill and couldn't be held accountable for his actions. The judge vehemently disagreed: mental health couldn't excuse Greg's level of cruelty, his planning, his manipulation. But he had to agree to adjourn sentencing until a full psychiatric report was prepared. The judge voiced his annoyance that if this was Greg's only

defence, why had the report not already been done?

It does make you wonder: all the times he had repeatedly pleaded not guilty, no reports had ever been presented in Greg's defence. I know what I believe: that Greg had run out of time. Eventually he realised he couldn't go to trial as he didn't have a leg to stand on. He'd receive an even lengthier sentence if he continued to plead innocent, but if he was bailed while they undertook the psychiatric evaluation, he would be 'free' again. Perhaps this would be his opportunity to disappear – after all, that was his talent. He could reinvent himself and start all over again.

Unfortunately for Greg, the judge had other ideas. Yes, he would set a new date for sentencing, but Greg would be remanded until that day: locked up where he belonged.

I gasped, turning to Chris. "Does this mean he's off to prison now?" I asked, barely believing what I had heard.

Chris smiled broadly. "It certainly does. It might have taken a while, but we've finally got him."

The judge began to speak in a loud, authoritative voice, the words echoing around the high-ceilinged courtroom. "Take the prisoner down."

I may have not been able to look Greg in the eye that day, as I had hoped, but I certainly heard his loud sobs as they led him in handcuffs away from the dock.

Chapter 54

Coleen

L ife was good. Finally, I could breathe again. I no longer felt I was always looking over my shoulder, worried what Greg was doing, where he was and who he might be hurting.

On 8 April 2020, over three years since my family and I had realised the truth, it was finally sentencing day. We all now lived in a very different world, an unsettled place. The previous month the whole country was forced into lockdown due to Covid 19. Greg's sentencing would now have to be done via a video link. My stomach twisted into knots of apprehension as I logged onto my computer that morning.

My video camera was turned on. I wanted Greg to see me as I was now – strong and independent – even if it was only on screen. I wanted to see him too, needing that closure. But Greg wouldn't even allow me that minor triumph, as he refused to turn on his video link. I could hear his voice, but couldn't see his face.

Our prosecuting barrister read aloud mine and Karen's victim impact statements. My chest was tight as I listened to the words: my feelings and suffering laid bare for the world

to hear.

Judge Adkins was presiding, and now had Greg's full psychiatric evaluation laid in front of him. He gave it the disdain it rightfully deserved. There was nothing in the report that excused or explained any of Greg's actions.

The conclusion was that Greg had known exactly what he was doing, was aware of everything. It was he and he alone who had made his choices. He had chosen to be manipulative and cruel, only admitting his crimes when he felt it was in his own selfish best interests. He had not once shown compassion to any of his victims.

"Six years and a lifetime restraining order. So you can never contact Coleen Greenwood or Karen Crear again," Judge Atkins said in a loud, clear voice. "They need to be able to heal, where they have no fear from you." It was all over.

We had a weird celebration that afternoon. Of course I was elated that justice had been finally served. I hugged Charlie close to me, my little boy now four years old, who made me so very proud every day. The elation of the day was however tinged with sadness that it had had to come to this. Charlie's father was now locked away through his own criminal actions. Let's face it though, I knew Charlie was long forgotten by Greg anyway. As Karen always said, we were all just characters in Greg's game, we were all expendable.

I drank champagne with my family as we celebrated that afternoon. It had to be via a Zoom call, but we made the best of it. It had been a long-drawn out fight, but we had done it. I was so proud of us all. How strong we were in our love for each other. At the end of the day family is all that really matters.

Greg Wilson was locked away for years to come. I hoped with every part of me that prison would reform him, give him time

to think on what he had done. I believe that everyone is capable of redemption. I just hoped he would serve his time and never hurt anyone again...

It was surreal that evening as I watched the news on the TV: seeing my face, Greg's face, hearing our story. News of Greg's crimes hit every paper, the story reaching the far corners of the globe.

My phone was beside me on the arm of my chair and it began to vibrate gently. I distractedly picked it up, my focus still on the news item on TV. The message was from a woman's name I did not recognise, but I felt the familiar sense of dread that I was hoping had become a thing of my past...

"... Hi, I hope you don't mind me messaging you, but I've just seen the news. I'm in a relationship with Greg, and he's been phoning me from prison. We're engaged and he's supposed to be taking me to Dubai next week ..."

THE END

Printed in Great Britain
by Amazon

40860677R00172